Margaret Drabble

MARGARET DRABBLE:

GOLDEN REALMS

Edited by Dorey Schmidt

Associate Editor: Jan Seale

LIVING AUTHOR SERIES NO. 4

Pan American University

School of Humanities

Edinburg, Texas

LIVING AUTHOR SERIES

No. 1: Larry McMurtry: Unredeemed Dreams

No. 2: James Dickey: Splintered Sunlight

No. 3: Edward Albee: Planned Wilderness

No. 4: Margaret Drabble: Golden Realms

Cover Art : Sonia Garcia
Portrait : Nancy Moyer Prince

Book Design : Dorey Schmidt
Paste-up : Dorey Schmidt
Jan Seale
Typesetter : Hermelinda Drewry

ISBN-0-938738-03-8

Printed in The United States of America

Pan American University Print Shop

Edinburg, Texas 78539

CONTENTS

Preface

Previous volumes of the *Living Author Series* have commemorated the visits of writers to Pan American. Although Margaret Drabble was unable to come, as originally planned, this festschrift celebrates her work.

Dorey Schmidt

Pan American University
1982

Margaret Drabble's Golden Vision

Nora F. Stovel

The reputation of the contemporary English novelist Margaret Drabble has been growing steadily on both sides of the Atlantic since she first began writing in the early Sixties. Author of nine successful novels, four critical books, several stories, plays and editions, and innumerable articles, Drabble has clearly become a major figure on the contemporary literary scene.[1] Her fiction has been acclaimed primarily for its realistic presentation of distinctly contemporary people and predicaments. Joyce Carol Oates has praised Drabble's work in these glowing terms:

> It is doubtful that there is any single American writer who represents the diversity and near-chaos of our culture, as Drabble represents the tone of contemporary English culture. Her imagination is both refined and robust; slyly satirical and profoundly moral: there is no one quite like her writing today, and her work is especially valuable because it shows with what grace the uniquely contemporary personality can deal with traditional and timeless subjects.[2]

This emphasis on the uniquely contemporary personality in Drabble's work has inspired a predominantly sociological and feminist response from critics who praise her fiction for its convincing portrayal of the new woman in her novel role. Bernard Bergonzi asserts, "It is Margaret Drabble's particular contribution to the contemporary novel to have devised a genuinely new kind of character and predicament."[3] And it is her accurate rendering of these modern characters and situations which has led critics to acclaim her most highly as a social realist. Angus Wilson has praised her skillful handling of "the realist mode" and declared that "she is an outstanding social novelist."[4]

Enthusiasm over the high recognition level of Drabble's social realism, however, has blinded most critics to the poetic imagination beneath the surface verisimilitude. The true artistic excellence of her writing lies in what she has called "the transfiguration of the everyday . . . this quality of writing about an everyday incident and making it profoundly emblematic."[5] The fact is that Drabble is a symbolist as well as a realist, and all her novels are distinguished by evocative imagery as well as true-to-life detail. Her use of symbolism is the key to the other side of her genius, the poet beneath the realist, and raises her fiction above the level of mere social realism to the realms of poetry. Of course, rooting the ideal in the

3

real is what makes her vision so convincing. A double first in English literature at Çambridge University, Drabble appears to use symbolism consciously. In her first novel, *A Summer Bird-Cage* (1963), she wrote, "people choose their own symbols naturally."[6] And she commented in an interview on her own thematic use of image patterns in fiction: "naturally all the leaves on the tree are the same kind. . . . You start with the tree and the leaves grow from it."[7]

Each of Drabble's novels centres on a dominant symbol which presents the major theme of the work through a skillful pattern of imagery. The symbolism connects the literal and figurative levels of experience and clarifies the conflict between the internal world of the imagination and the external world of actuality in the novel. Moreover, in every case, Drabble selects the dominant symbol as the title for her novel. She has said, "The titles of my books are like the names of my children; it's impossible to imagine having called them anything else."[8]

When one considers the symbols in the titles of her novels, it is clear that there is a significant connection between *Jerusalem the Golden* (1967) and *The Realms of Gold* (1975). The connection lies in the image of a golden world, an important concept in Drabble's work. Sir Phillip Sidney wrote in his *Defense of Poesy* that Nature's "world is brazen, the poets only deliver a golden."[9] The concept of a golden world is certainly central to Drabble's thought; it connotes an ideal realm of the imagination. Drabble has observed that "in a sense I was brought up in too good a world to understand the real world."[10] Her symbol of a golden realm is the embodiment of her ideal world of the imagination, a projection of the artist's inner vision.

Drabble clarifies this concept of a golden realm in her recent critical work, *A Writer's Britain: Landscape in Literature* (1979).[11] The final chapter of this study is entitled "The Golden Age;" in it she offers a detailed discussion of the idea of a golden world which is so central to her two novels. The "Golden Age" refers to the "golden past" of England and of childhood, as it is presented in modern English literature. In this study Drabble celebrates the lost innocence of idyllic childhood passed in the Edenic countryside of England's Golden Age. Her discussion of the Golden Age in *A Writer's Britain* throws interesting light on her presentation of a golden realm in her two novels. It will be the purpose of this paper to clarify Drabble's vision of a golden realm and define the connections and distinctions between the three major works in which it appears as the title and dominant symbol: *Jerusalem the Golden, The Realms of Gold*, and "The Golden Age" in *A Writer's Britain: Landscape in Literature*.

"The Golden Windows" provides the first clue to the meaning of Drabble's own golden vision. The heroine of *Jerusalem the Golden* is deeply impressed as a child by the moral fable of "The Golden Windows,"

because it symbolizes so perfectly the contrast between her view of the grey world of reality and her vision of a golden Jerusalem:

> the title story told, with some charm, of a little boy who saw from a hillside while out walking a house whose windows were all of gold. He searched for this wonderful house, but could not find it, and was returning home disappointed when he realized that the house was his own house, and that the gold was merely the reflection of the sun. The moral of this story, was, she assumed, that one must see the beauty in what one has, and not search for it elsewhere; but it carried with it, inseparably, the real sadness of the fading windows, and the fact that those within the house could never see them shine.[12]

Margaret Drabble knows from her own first-hand experience the moral truth of "The Golden Windows" allegory, for she had a parallel experience herself, while writing *Jerusalem the Golden*, as she recounts in *Arnold Bennett: A Biography* (1974):

> I had a startlingly similar experience when writing *Jerusalem the Golden*, which I had based on my childhood memories of Sheffield. I wrote the book from memory, and then decided I'd better go back and check up that I'd remembered right, so I went up for a night, arriving after dark and staying in the Station Hotel. In the morning I was expecting to look out of the window and see those soul-destroying grim industrial perspectives, but in fact I looked out, the sun was shining, the hillsides were glittering, green fields fringed the horizon, it was all bright and sparkling and beautiful. I felt as though I had maligned the place completely in my memory. After the flat dull overbuilt sprawl of London, it was Sheffield that looked like Jerusalem.[13]

This is the secret of the golden realm: Jerusalem the golden is always somewhere else. It can never be attained. The golden radiance is only visible from the vantage point of distance, and the vision fades like a mirage as one approaches the reality. Perspective is all, and illumination is a matter of point of view. The poignancy of the golden windows allegory lies in the fact that the radiance can only be seen from without, never from within. So it cannot be experienced in reality, but only envisioned in the imagination. The golden realm is not a real world, then, but an imagined ideal—the world not of the social realist, but of the visionary poet. Drabble's golden ideal suggests both the vision itself and a way of seeing which transfigures the actual.

Drabble creates two perspectives through which the visionary can perceive the realm of gold: the vision can be viewed through the rose-coloured glasses of anticipation of the future of through the twilight haze of nostalgia for the past—as opposed to the harsh glare of the here and now. For even if the golden is present in the here and now, it cannot be seen in the present, but only in anticipation before it is attained, or in retrospect after it is lost. Drabble shows that envisioning the golden world in the future is very different from viewing it in the past, as a comparison between *Jerusalem the Golden* and *The Realms of Gold* will illustrate.

Jerusalem the Golden is Drabble's first dramatization of her golden vision, and it is the only time that she locates the realm of gold in the future. The heroine of the novel, Clara Maugham, is a denizen of the stony ground of industrial northern England—like Margaret Drabble herself. Finding her actual environment in the repressive Puritan society of provincial Northam so repellent, Clara escapes grim external reality by turning inward to "golden childish worlds" of the imagination: "The world of the figurative was Clara's world of refuge. The literal world which she inhabited was so plainly hostile that she seized with ardour upon any references to any other mode of being" (31).

Clara searches for golden windows through which to view her own vision. She finally discovers the perfect formulation of her ideal in the hymn "Jerusalem the Golden." Drabble quotes the first verse of the hymn, since it provides both the central image and the title song of the novel—in accordance with her practice of selecting the major symbol of a novel for its title.

Jerusalem the Golden
With milk and honey blest
Beneath thy contemplation
Sink heart and voice oppressed
I know not, oh, I know not
What social joys are there
What radiancy of glory
What light beyond compare.[14]

This vision of a radiant heaven provides a figurative expression of Clara's own dream. The poetic language suggests to her young mind "some large and other world of other realities" (31). The image of a golden Jerusalem focuses and enflames her desire for "a grander world:" "The combination of the words and the music of this hymn could unfailingly elevate her to a state of rapt and ferocious ambition and desire" (32). So "Jerusalem the Golden" comes to symbolize for Clara her own "vision of some other world" (29). Through Clara's own imagination then, the hymn generates the novel's dominant symbol pattern, providing celestial images of heaven and luminous imagery of a golden world radiant with light. This is indeed a fitting image for Clara, whose own name signifies brightness.[15]

"Jerusalem the Golden" provides not only the major motivation and dominant symbol pattern of the novel, however, but also its main irony, for Clara misinterprets the hymn. The prayer clearly bespeaks a spiritual heaven, but Clara, deceived by the ambiguous word "social," envisions a secular paradise: she pictures, "not the pearly gates and crystal walls and golden towers of some heavenly city, but some truly terrestrial paradise, where beautiful people in beautiful houses spoke of beautiful things"

6

(32). This false picture germinates in Clara's young mind and consolidates her burning desire to escape her humble provincial origins for just such a social heaven. She blatantly ignores the spiritual values which the hymn really signifies for the social goals which it apparently suggests. The omniscient narrator points carefully to the key word to ensure that the reader understands both the real meaning of the Jerusalem the Golden symbol and Clara's misinterpretation of it: "It must have been the word 'social' that created for her this image, a word judiciously expunged from later versions of the verse" (32). The ambiguous word 'social' clearly refers to communal joys, but Clara misinterprets it as high society. This little angel even finds a divine, golden-haired Gabriel to escort her up the Jacob's ladder to her social heaven. Clara takes the heavenly image literally then, and hopes to discover a real Jerusalem in England's green and pleasant land—not a golden City of God, but a gilt metropolis.

So Drabble offers us an ironic vision in *Jerusalem the Golden*, because the heroine misinterprets the golden ideal as a social rather than a spiritual goal. Drabble conveys the ironic vision through the symbolism, and her narrative technique reinforces the irony generated by the symbolism by emphasizing the gap between the true significance of the golden Jerusalem ideal and Clara's misinterpretation of it. While all of Drabble's novels are autobiographical, *Jerusalem the Golden* is in fact the closest to the author's own origins: she has written that Clara's "background contains more of my own than any of the others."[16] Whereas all of Drabble's other protagonists are approximately the same age as their creator, however, Clara is the only one who is several years younger, and at a distinctly earlier stage of life. So Clara represents a retrospective view of a past phase of the author's life, a throwback to an immature persona of the novelist, long since outgrown by her creator-- one which Drabble views in an ironic light and judges in a moral sense. Symptomatic of this dissociation of sympathy with her protagonist is the fact that *Jerusalem the Golden* represents Drabble's first use of omniscient third-person narration, as opposed to the confessional first-person narrative of her first three novels: *A Summer Bird-Cage* (1963), *The Garrick Year* (1964), and *The Millstone* (1965). Moreover, Drabble includes the point of view of another character than the protagonist for the first time in *Jerusalem the Golden*--a male character's this time: in chapter seven she gives us Gabriel Denham's viewpoint, encouraging the reader to view Clara from outside, less sympathetically. The increased objectivity and distance afforded by this narrative technique allow the novelist to be ironic in her treatment of her protagonist and to invite moral judgement of Clara's choices and actions. Through ironic symbolism and narrative technique, then, Drabble suggests the falseness of Clara's golden vision.[17]

In the course of *Jerusalem the Golden*, Clara is allowed to fulfill her

social ambitions: she escapes her provincial origins, travels to her earthly paradise in London and Paris, and is educated academically, socially, and sentimentally. Upon returning home to her mother's death-bed, after her educational travels, Clara is vouchsafed a revelation of her "true descent" (197). She discovers her true golden realm in her own family origins when she unearths, in photographs and verses in a bottom drawer, her mother's youthful self as the young May before she became Mrs. Maugham. One of her mother's poems envisions a bright world which mirrors Clara's own radiant dream and reflects the luminous image in the hymn "Jerusalem the Golden:" "O let us seek a brighter world/Where darkness plays no part" (196). Clara is deeply impressed by this parallel and by the discovery of a kindred spirit in her own mother. This revelation proves the truth of "The Golden Windows" allegory and Drabble's own experience on returning to her native Sheffield: the true golden realm lies not in future goals, but in one's past roots, in the home which one has left behind and returns to with a shock of recognition.

Clara willfully rejects this illumination, however, and refuses her chance for salvation in caring for her dying mother. She deliberately refuses to learn or grow as the result of her travels, experience, and discoveries: Drabble writes, "she had learned nothing, she could not give" (198). Although she has recognized the difference between her materialistic goal and the true ideal, between false future ambitions and past truth, she persists in her pursuit of a false golden Jerusalem. She persists in misinterpreting "The Golden Windows" parable as signifying that the grass is greener on the other side of the fence. And so she continues to seek greener pastures, rather than to cultivate her own garden. We leave Clara at the conclusion of the novel still anticipating with selfish and shallow delight her "celluloid paradise" of pop stars in the gilt heaven of London society (115):

> a tender blurred world where Clelia and Gabriel and she herself in shifting and ideal conjunctions met and drifted and met once more like the constellations in the heavens: a bright and peopled world, thick with starry inhabitants, where there was no ending, no parting, but an eternal vast incessant rearrangement. . . . (206)

Brazen as ever, Clara prefers gilt to gold.

Most critics have seen only Clara's superficial success in achieving her social ambition and have failed to perceive her moral failure in rejecting the spiritual ideal, because they have not taken sufficient account of Drabble's symbolism of a golden realm.[18] But it is quite clear that the author disapproves morally of Clara's persistence in seeing her golden Jerusalem in future social conquests rather than in her past family origins. Drabble has been very explicit in interviews about her moral condemnation of Clara's false vision and mistaken choice: "I very much

mistrust her. She's the worst side of one's nature."[19] "She's going to turn into something fearsome, I think. I rather dread her future."[20] In discussing "the conflict between feeling a loyalty to one's past and a desire to escape from it" in *Jerusalem the Golden*, Drabble has commented:

> if you become cultured and leave your roots, have you betrayed something in yourself that can never be reborn? Have you killed a vital part of yourself? And I think when I say that Clara was getting harder and harder throughout the book, I'm suggesting that she was killing something in herself.[21]

Drabble makes it clear that she values the principle of communal heritage over Clara's selfish ambition of emancipation from her origins:

> The concepts (freedom and liberation) have little meaning for me. We are not free from our past, we are never free from our past, we are never free of the claims of others, and we ought not to wish to be. (Existential thought, and emphasis on the *acte gratuite*, has always seemed to me a very inadequate way of looking at life.) We are all part of a long inheritance, a human community in which we must play our proper part.[22]

In *Jerusalem the Golden* Drabble shows that the golden vision can be dangerous if taken too literally and misinterpreted as a social goal rather than a spiritual ideal. Clara's goal is materialist, even mercenary, and so is in fact the very opposite of the Jerusalem ideal. In her discussion of "The Golden Age" in *A Writer's Britain*, Drabble makes it clear that she believes the golden realm lies in the past. The danger of locating the vision in the future is that one may, like Clara, think that it is literally attainable in a material sense. Drabble's personal statements quoted above make it clear that she believes people should seek their golden age in their inheritance from their own background, rather than in rejection of family origins for the sake of superficial future success.

In *The Realms of Gold*, Drabble provides an answer to *Jerusalem the Golden*. The heroine, Frances Ollerenshaw, begins like Clara Maugham by rejecting her family's provincial origins in favour of professional success. As an archaeologist, Frances searches for golden worlds in her excavations in the Sahara. But she ultimately locates her true golden realm in her own family's rural environs. Frances discovers a golden age of England in the very heart of the idyllic countryside. So Drabble reverses the motion of *Jerusalem the Golden* and resolves the conflict between loyalty to one's past and the desire to be free in *The Realms of Gold*. This progression from a personal goal in *Jerusalem the Golden* to a communal ideal in *The Realms of Gold* parallels Drabble's own development in fiction from the psychological emphasis in her novels during the Sixties to a broader social interest in her novels of the Seventies which employ

multiple points of view. Whereas *Jerusalem the Golden* was ironic in portraying a selfish protagonist pursuing a false goal, then, *The Realms of Gold* is sincere in depicting a mature protagonist who discovers a true golden age.[23]

As a child, Frances saw the garden of Eel Cottage, her grandparents' home in the fen country of the Midlands, as heaven: "For Frances, at first, it was like paradise, like the original garden" (102). The major fascination for Frances lies behind the cottage garden in a newt-filled ditch, the spawning ground that inspired her father to become an eminent biologist and thus lift the family from rural obscurity to professional renown. These ambitious Ollerenshaws desire, like Clara Maugham, to escape their provincial origins and succeed professionally: they "had struggled out by their wits and climbed perilously up from the flat land, up the bean stalk of the grammar school, to the golden world above"(274).

In fact Frances develops a theory about hereditary landscape, which she calls "the Midlands sickness" (96). She theorizes that the very ditch water of her family's fen country is to blame for the suicidal depressiveness of the Ollerenshaw clan: "What a sour and tiresome and quarrelsome lot the Ollerenshaws were, they had sucked in some poison with the very water of Tockley, it had poisoned their brains, that unnatural ditch water" (266). Frances expounds her theory of "environment landscape"—the idea that "one can inherit a landscape:"

> the Romantics took all this seriously, even if we don't. They understood the effects of landscape on the soul. . . .we are all the products of mixed environmental heredity. . . . I've often thought that there must be something in the *soil* there, in the very earth and water, that sours the nature. I often think that in our family—we've got some heredity deficiency. Or excess. . . . And that, combined with the flatness of the landscape, was what did it. . . . there must be something positively *poisoning* the whole of South Yorkshire and the Midlands, or they wouldn't all be so bloody miserable up there, and live in such *appalling* conditions. (95-96).

She concludes that the cantankerous Ollerenshaw clan must have "A bad case of the Midlands."

Frances, an archaeologist, sees her own pursuit and that of her lover, Karel Schmidt, an historian, as a search for a golden age in the past which might redeem the present by providing an ideal blueprint for charting the future:

> The pursuit of archaeology, she said to herself, like the pursuit of history, is for such as myself and Karel a fruitless attempt to prove the possibility of the future through the past. We seek a utopia in the past, a possible if not an ideal society. We seek golden worlds from which we are banished, they recede infinitely, for there never was a golden world, there was never anything but toil and subsistence, cruelty and dullness. (120)

But to her own surprise, Frances, the archaeologist, ultimately un-

earths her golden realm, not in her excavations of exotic Tizouk, but in her family home in humble Tockley. May Cottage, the overgrown home of her deceased relative, mad old Aunt Constance Ollerenshaw, is "The Real Thing" (293) for Frances—a symbol of England's golden age. Her "wild surmise" on first looking into May Cottage is not unlike Keats's own in the sonnet whose first line, "Much have I travelled in the realms of gold," provides the title and major symbol of Drabble's novel. Frances views the cottage in idealized fairy-tale terms:

> It was like Sleeping Beauty's terrain. . . . An intense stillness, a trance, hung over everything. And there stood the cottage itself, ancient, decayed, dank, dark, beautiful. . . . It even had a feeling of home. It was contained, it was secret. It had none of the rural bleakness of Eel Cottage, none of that open struggle. Nature had gently enfolded it, had embraced it and taken it and thicketed it in, with many thorns and briars; nature had wanted it, and had not rejected it. (292-95)

At the interment of Aunt Constance near May Cottage, Frances and Karel (a survivor of the Nazi purge) have a vision of England's golden age symbolized by this sylvan setting:

> Karel, raising his eyes from the too open earth, and staring at the middle distance where the cows browsed, peacefully, as though in another age, reflected on his own passion for the rural England he saw so rarely, his haven, his place of exile, his unknown land, his subject, his livelihood: and on Frances, who came from this land. The eighteenth-century cows munched on, undisturbed, in their golden age, by the still waters, by the bending willows, in the autumn light. (330)

So entranced is Frances with May Cottage as a symbol of England's golden age, that she decides to make it her home at the "happy ending" of the novel (347). Through her discovery of this "good place" in the very "heart of England," Frances also rediscovers an estranged branch of the Ollerenshaw clan. As a result she finds a complementary personality in her housewife cousin Janet Bird née Ollerenshaw, a professional colleague in her geologist cousin David Ollerenshaw, and a kindred spirit in the memory of her reclusive Aunt Con, whose home she inhabits. By going home again in this way, Frances reverses the motion and resolves the conflict of *Jerusalem the Golden* by rediscovering her origins. And perhaps more important, in doing so, Frances, the archaeologist, has excavated her own true nature from beneath the superficial layers of civilization. In the process, she has also unearthed "the memory of a golden past" in England's Edenic countryside. *The Realms of Gold* refers to a golden age of England. Frances and Karel's vision of England's pastoral beauty is parallel to Drabble's discussion of the pastoral ideal in "The Golden Age" section of her book on literary landscape. She develops and clarifies this ideal vision in her critical study.[24]

Drabble selects "The Golden Age" for the title of her concluding chapter in *A Writer's Britain: Landscape in Literature*. This chapter is about modern British writers' nostalgic view of the past as "a land of lost content" (266), a paradise lost. The "Golden Age" refers both to lost childhood innocence and lost rural beauty. These writers view old England as "another Eden, demi-paradise." And they recreate an idyllic picture of innocent childhood in England's Edenic rural landscapes—an "image of rural England and of the Golden Age of boyhood" (259). Drabble introduces her chapter on "The Golden Age" with Wordsworth:

> Heaven lies about us in our infancy, wrote Wordsworth, and his words are true in more ways than one. In the first place, many children destined to spend their adult lives working in the city are brought up in the country or sent there either for holidays or schooling, in obedience to the faith of Wordsworth and Rousseau. The country gives a better start in life, it protects the growing spirit from contamination, and nature is the best teacher, or so the Romantic theory goes, and many still believe it. Secondly, adults writing their fictional or factual memoirs tend to look back on childhood as a golden age, and its heavenly aspects are inevitably reinforced if childhood was indeed spent in the country; the landscapes of infancy acquire a particular radiance which the passing of time brightens rather than dims. And thirdly, those children who live in towns can travel to the country in works of the imagination: children's books are strikingly rich in evocations of idyllic landscape. . . .
>
> For all these reasons, we tend to associate a certain kind of remembered landscape with childhood, and it is no accident that some of the best-sellers of our day are accounts of country childhood. We seem through them to glimpse a world that is rare, precious, vanishing. (247)

Drabble defines pastoral poetry in her 1966 book entitled *Wordsworth:* "This feeling that the golden age is only just over, that everything was wonderful just a few years ago, is entirely typical of the usual kind of pastoral poetry."[25] In "The Golden Age" of *A Writer's Britain*, Drabble defines the themes of the pastoral genre as "nymphs and the Golden Age, a patriotic version of British history, praise for unchanging rural ways, fear of change, deep nostalgia, Merry England" (263-64). In her essay on "Hardy and the Natural World" in her 1975 edition of *The Genius of Thomas Hardy*, Drabble acclaims Hardy primarily for his recreation of England's golden age:

> Hardy was well aware that on one level he was recording a dying England, dying customs, vanishing landscapes. Nostalgia, a harking back towards a perfect Golden Age, has always been evident even in the most powerful of nature poets. . . . Thomas Hardy re-creates Eden, and of all his many achievements as poet and novelist, this seems to me his greatest.[26]

In *Landscape in Literature* Drabble explains the magical appeal of such pastoral visions of England's golden age. She offers the "vision of Pan, the spirit of the countryside who transforms the landscape with mystical

12

significance" in Kenneth Grahame's *The Wind in the Willows* as an outstanding example. Her comment on this visionary passage is eloquent:

> Pantheism, pseudo-religion, mysticism, a search for the lost Golden Age of innocent childhood—however this passage is interpreted, it represents a powerful strain in English literature of this period, and it is in some way connected with the English countryside and the landscapes of childhood. . . . (Children) are doomed to forget the visions that come to them during their moments of illumination; the songs fade, the presences vanish. The lament is for lost insight, as the shades of the prison house begin to close around the growing boy— but it is also for lost England, and these writers, at the beginning of the twentieth century, are consciously and unconsciously lamenting not only the death of their own innocence, but also the imminent death of a landscape. (257)

However, Margaret Drabble believes that our contemporary society needs the writer's idealized vision of a golden age more urgently than ever before—now when two successive world wars have destroyed so much of England's past, and materialistic modern culture has eroded so many of the values that it stood for. In her second latest novel, Drabble portrays the Golden Age of England freezing into a second age of ice, symbolized by this central image from *The Ice Age* (1977):

> A huge, icy fist, with large cold fingers, was squeezing and chilling the people of Britain, that great and puissant nation, slowing down their blood, locking them into immobility, fixing them in a solid stasis, like fish in a frozen river.[27]

Drabble also characterizes contemporary society in her latest novel, *The Middle Ground* (1980). For the middle ground *is* the present—the golden mean, so to speak, between the golden haze of the past and the golden glow of the future. And the middle ground itself, the title and major image of the novel, is a giant sewer, symbol of contemporary society:

> At the end of the road ran the sewage bank, which led in one direction towards the Blackridge works, in the other towards the marshy wastes of Pinstead; this grass-covered bank, about twenty feet high, was a secret thoroughfare, a walk through the backways of Romley, the scene of many childhood games and excursions, a green spine through the surrounding brick industrial wilderness, a link with scrubby open space which counted, to the children of the district, as countryside.[28]

Given her view of contemporary British society as a giant sewer or a giant paralyzed by a second Ice Age, Drabble believes that the modern writer is driven now more than ever to recreate a Golden Age in literature, She concludes her study of "The Golden Age" in *A Writer's Britain: Landscape in Literature* with this eloquent expression of her own belief:

13

For most of the inhabitants of Britain, the Golden Age can never have seemed as remote as now. (270) . . . yet never have poets been more drawn to write of landscape, of England, of the unchanged and changing places. . . . lovingly, carefully recreating in words the contours of the countries of the heart . . . our obsession with landscape persists. Minor and major writers alike are moved by the same love. The Golden Age never existed, but by the same token it will never die, while there is a writer left to embody our desire. (277)

Both *The Ice Age* and *The Middle Ground* confirm Drabble's celebrated ability to present a stringently realist view of contemporary society. The critics are quite right to praise her social realism. Indeed, it is precisely this rooting of the ideal in the real which makes her golden vision so convincing. As an artist and as a critic, she is conscious that the crasser the actual, the more crucial the ideal. Drabble the social realist has held the mirror up to contemporary society, and Drabble the idealist has painted a vision of a gold realm to judge it by.

NOTES

[1]Margaret Drabble's novels include *A Summer Bird-Cage* (1963), *The Garrick Year* (1964), *The Millstone* (1965), *Jerusalem the Golden* (1967), *The Waterfall* (1969), *The Needle's Eye* (1972), *The Realms of Gold* (1975), *The Ice Age* (1977), and *The Middle Ground* (1980). Her full-length critical studies are *Wordsworth* (1966), *Arnold Bennett: A Biography* (1974), *For Queen and Country: Britain in the Victorian Age* (1978), and *A Writer's Britain: Landscape in Literature* (1979). Drabble is currently re-editing *The Oxford Companion to English Literature*.

[2]Joyce Carol Oates, "Bricks and Mortar," a review of *Arnold Bennett* by Margaret Drabble, *Ms.* 3 (August 1974) No. 2, p. 35.

[3]Bernard Bergonzi, "Margaret Drabble," *Contemporary Novelists*, 2nd ed., Ed. James Vinson (London: St. James, 1976), p. 372.

[4]Angus Wilson, Review of *Arnold Bennett: A Biography* by Margaret Drabble, *Times Literary Supplement*, July 12, 1974, p. 737. See also Angus Wilson, "Literary Landscapes," a review of *A Writer's Britain: Landscape in Literature* by Margaret Drabble, *The Observer*, October 1979.

[5]Diana Cooper-Clark, "Margaret Drabble: Cautious Feminist," an interview with Margaret Drabble, *The Atlantic Monthly*, 246 (November 1980), No. 5, p. 72. Drabble's first phrase refers to Wordsworth and the second to Yeats.

[6]Margaret Drabble, *A Summer Bird-Cage* (Harmondsworth: Penguin, 1963), p. 70.

[7]Nancy S. Hardin, "An Interview with Margaret Drabble," *Contemporary Literature*, 14, No. 3 (1973), p. 291.

[8]Margaret Drabble, in an interview with Nora Stovel in her home in Hampstead, London, on May 17, 1980.

[9]Phillip Sidney, *An Apology for Poetry*, Ed. Forrest G. Robinson (New York: Bobbs-Merrrill, 1970), p. 15, (also known as the *Defence of Poesy*).

[10]Margaret Drabble in a letter to Valerie Grosvenor Myer, dated October 26, 1974. I wish to acknowledge Valerie Grosvenor Myer's generosity in placing her correspondence with Margaret Drabble at my disposal.

[11]Margaret Drabble, *A Writer's Britain: Landscape in Literature* (New York: Knopf, 1979), p. 247. Further references to this work will be documented within the text.

[12]Margaret Drabble, *Jerusalem the Golden* (Harmondsworth: Penguin, 1967), p. 34. Further references to this work will be documented within the text. Ellen Cronan Rose delivered a paper entitled "Golden Windows: The Archaeology of the Self (Margaret Drabble and Arnold Bennett)" at The English Institute at Harvard University in 1978. I wish to acknowledge Professor Rose's generosity in giving me this unpublished paper which forms the basis for one of the chapters in her forthcoming book, *The Novels of Margaret Drabble: Equivocal Figures* (London: Macmillan, 1980). Although the title of Dr. Rose's paper "The Golden Windows", suggests that it deals with Drabble's vision of the golden, in fact it does not. Rather, it is a very perceptive discussion of the influence of Arnold Bennett on Margaret Drabble, particularly in *Jerusalem the Golden*.

[13]Margaret Drabble, *Arnold Bennett: A Biography* (London: Weidenfeld and Nicholson, 1974), p. 5. It is interesting to note that Drabble began *Jerusalem the Golden* the year she went to Paris on a travel grant to research her biography of Bennett, as she remarks in an interview with Iris Rozencwajg in *Women's Studies*, 6 (1979), p. 345.

[14]The hymn "Jerusalem the Golden" was translated from the Latin of Bernard of Cluny (1145) by the Reverend John Mason Neale in 1851. In 1859 Neale revised his translation, emending the line in question to read, "What joys await us there," omitting the misleading word 'social,' as Drabble points out.

[15]Valerie Grosvenor Myer, *Margaret Drabble: Puritanism and Permissiveness* (London: Vision, 1974), p. 153; in her discussion of *Jerusalem the Golden*, Myer mentions this point concerning the name Clara as signifying "bright light," and comments on the central image of the golden: "The word 'golden' is associated with light, sunshine, value, and the glories of heaven . . . the central image of radiance" (152). In an article entitled "Literary References in Margaret Drabble," Myer comments on the imagery of light in *Jerusalem the Golden:* "The predominant image in the book is that of light, and every possible exploitation and play on the word and its implications is made" (p. 2). I wish to acknowledge Valerie Grosvenor Myer's generosity in allowing me to see this essay before its publication in an anthology of critical articles on Margaret Drabble edited by Ann Rayson and Lorna Irvine. Ellen Cronan Rose comments on Drabble's use of imagery in *Jerusalem the Golden*, in her paper "Golden Windows," pages 9-11:

images of color and vegetation are developed as a running commentary on the action and on the moral development of Clara Maugham . . . Drabble uses light imagery, for instance, to define Clara's aspirations and then undercuts them by associating with the dominant light imagery a verbal motif of coinage, which underscores Clara's ruthlessness in the pursuit of her golden dream.

Unfortunately, Myer and Rose do not go on to develop these interesting ideas about the imagery of golden radiance in *Jerusalem the Golden*.

[16]Margaret Drabble in a letter to Valerie Grosvenor Myer, dated October 26, 1974, in response to reading Myer's book, *Margaret Drabble: Puritanism and Permissiveness*.

[17]This increase in artistic distance and objectivity afforded by the use of omniscient third-person narrative method and by the inclusion of the viewpoint of another character besides the protagonist has been observed by Francois Bonfond in "Margaret Drabble: How to Express Subjective Truth Through Fiction," *Revue des Langues Vivantes*, 40 (1974), 51: "It is in this novel that Margaret Drabble has gone the longest way towards a non-subjective handling of her subject matter." Ellen Cronan Rose also observes in "Golden Windows," that "the narrator, even when restricted to Clara's point of view, is not Clara herself. This enables Drabble to make the narrator's language characterize Clara, revealing things about her which she either does not know or would not want to reveal."(10).

[18]Most critics see only Clara's social success and fail to perceive her moral failure: even Virginia K. Beards, in her intelligent article, "Margaret Drabble: Novels of a Cautious Feminist," *Critique*, 15, 1 (1973), p. 43, judges Clara successful in gaining "deliverance from her humdrum provincial background." The only critic to comprehend fully Clara's moral failure is Ellen Cronan Rose, who observes in "Golden Windows" that:

in her progress Clara carefully avoids any lessons that may truly educate her, that may cause her to call into question her narrowly selfish goal . . . Drabble suggests that her refusal to learn from her experience, to reappraise her values, is a short-coming rather than a virtue . . . that adulthood does not mean freedom but responsibility, and that it is wrong to attempt to transcend one's essential nature, which is largely determined by heredity and environment. (pp. 14-16).

[19]Bolivar Le Franc, "An Interest in Guilt," *Books and Bookmen*, 14 (1969), p. 20.

[20]Nancy S. Hardin, "An Interview with Margaret Drabble," p. 278.

[21]Valerie Grosvenor Myer, "Margaret Drabble in Conversation with Valerie Grosvenor Myer" (London: British Council, 1977), p. 16.

[22]Margaret Drabble, "The Author Comments," *Dutch Quarterly Review of Anglo-American Letters*, 5 (1975), p. 36.

[23]Margaret Drabble, *The Realms of Gold* (New York: Popular Library, 1975). Subsequent references to this work will be given within the text.

[24]The undocumented quotations in this paragraph are from Margaret Drabble's *A Writer's Britain: Landscape in Literature*, pp. 264 & 266.

[25]Margaret Drabble, *Wordsworth* (London: Evans, 1966), p. 31.

[26]Margaret Drabble, "Hardy and the Natural World," *The Genius of Thomas Hardy,* ed. Margaret Drabble (London: Weidenfeld and Nicholson, 1975), pp. 168-69.

[27]Margaret Drabble, *The Ice Age* (Harmondsworth: Penguin, 1977), p. 62. The image of Britain as a giant echoes this passage from Milton's *Areopagitica,* 1644, which Drabble uses an epigraph for *The Ice Age:*

> Methinks I see in my mind a noble and puissant Nation rousing herself like a strong man after sleep, and shaking her invincible locks: Methinks I see her as an eagle mewing her mighty youth, and kindling her undazl'd eyes at the full midday beam: purging and unscaling her long abused sight at the fountain it self of heavenly radiance; while the whole noise of timorous and flocking birds, with those also that love the twilight, flutter about, amaz'd at what she means, and in their envious gabble would prognosticate a year of sects and schisms.

Drabble's other epigraph to *The Ice Age* is drawn from Wordsworth's sonnet, "London, 1802:"

> Milton! Thou shouldst be living at this hour:
> England hath need of thee . . .
> > We are selfish men:
> Oh! Raise us up, return to us again;
> And give us manners, virtue, freedom, power.

In *The Ice Age,* Drabble also parodies Shakespeare's Edenic description of England as a "semi-precious stone set in a leaden sea" (215), to convey the contrast between the past ideal and the crass contemporary reality.

[28]Margaret Drabble, *The Middle Ground* (London: Weidenfeld and Nicholson, 1980), p. 14.

An Interview with Margaret Drabble

Joanne V. Creighton

At Drabble's home in Hampstead,
September 4, 1979, supplemented by
follow-up correspondence.

Q: *What traditions do you see yourself writing within? Do you sense affinities to particular writers?*

A: Well, not really to contemporary writers very much. I think I feel affinities to the people I must have been influenced by, people I read when I was younger and indeed do still read and reread.

Q: *Nineteenth century novelists?*

A: Nineteenth century novelists, yes. And of my contemporaries, I tend to reread the older ones like Doris Lessing and Angus Wilson, both of whom I feel affinities with of a certain sort.

Q: *In your essay on the Brontës ("The Writer as Recluse: The Theme of Solitude in the Works of the Brontës,"* **Brontë Society Trans.,** *16 (1974), pp. 259-69) you said that as children, you and your siblings felt affinities with the Brontes. Do you now as a writer?*

A: Oh, yes, very much.

Q: **The Waterfall** *has many references to Charlotte Brontë.*

A: Well, Charlotte was a very neurotic and highly strung writer and that is a very neurotic book; I think there are certain similarities, yes.

Q: *Also,* **The Realms of Gold** *has a kind of obtrusive, genial narrator, a rather anachronistic convention for the 1970's. Did you mean for it to be seen as such? Do you think of it in that light?*

A: Not really. A lot of writers do it nowadays. Doris Lessing does it quite a lot. She does so much else that people tend not to notice it. It seems to me a natural way to write. I tend to look upon everything else as the deviation. Everybody knows the writer is there—why shouldn't he say so? It seems very artificial, in a way very pretentious, to pretend that there is no writer, that everything is occurring. Of course, there is a writer, and the writer is a person, and to obliterate the writer from the frame seems to be rather odd. You could say it is not anachronistic; you could say it is like a cameraman showing bits of the camera or showing the other camera. I'm surprised it's not done more, because it seems to me such a natural way to tell a story.

Q: *Who do you think of as your audience? Whom do you write to or for? Or do you write for yourself? Do you have a particular segment of the population that you address?*

A: No, I don't. When I started writing I had no vision of an audience at all,

and I certainly don't think of a particular section, because I'm always surprised by the people who own up to reading my books.

Q: *Are you particularly aware of your friends or the academic community as your audience?*

A: No, I can tell by now, naturally I can tell, which bits the academic community is going to like more than other people, and which other people are going to like more than the academic community, but while I am writing, this is of no interest to me at all. It is just that afterwards I could write their comments; I could certainly do a parody of the comments that I'm likely to get, but while I am writing it doesn't particularly affect me one way or another. I suppose if I am aiming at anything, I'm aiming to write right in the middle of something.

Q: *Can you characterize the responses you get from readers?*

A: It's very varied. I get a lot of academic comments, but I also get a lot of letters from people who have just enjoyed the books, or who have had similar experiences and want to compare them, or even who want to ask advice about what to do about certain things that they recognize in the books that have also happened to them. I even get letters from people who've suffered from heart illness like one of the characters and want to know what to do.

Q: *Do you feel that you should respond, or do you feel that is a violation of the terms set up?*

A: I think it can be a gross violation of the terms because it stands to reason that a book is read by many thousand people, and if everyone of those thousand wants a personal response, then the writer is never going to write another book. Some people can be extremely intrusive and very time wasting . . . I've just been reading the last volume of Virginia Woolf's letters; she was plagued by people who seemed to have no sense at all of the fact that there was more than one of them and they wasted more books of Virginia Woolf's than one would like to think of, but obviously that's an extreme. There are other people who are extremely sensitive in the way they phrase themselves and the way they don't wish to waste time or intrude, and I find that perfectly acceptable, and indeed very rewarding. It's very nice to feel that your books are being read and that people care about them. It's a question of tact as it is in a personal friendship. I mean one has personal friends who are an absolute nuisance because they never know when to leave and other friends one is delighted to hear from because they have a sense of relationship.

Q: *Do you feel that your fiction reveals vulnerable aspects of your personality? Do you feel that you're susceptible to being psychoanalyzed through your fiction, that as a writer you necessarily forgo some privacy?*

A: Well, I perhaps do in fiction but not in my private life, for it is up to me to shut the door. If I don't want to see people in person, then that's my choice. What I expose in fiction is fair game for anyone to comment on in

19

psychoanalysis or criticism or anything they wish to comment. I don't think that the fact that I've exposed certain aspects of my personality gives people a right to want to relate personally to those aspects of my personality, but they can comment on them to their heart's content.

Q: *Are you familiar with phenomenological or reader-response criticism, the theory that the reader creates the text, that the meaning or significance does not reside in the text, but rather it's the reader and the text coming together, and in that sense every reader would have a different response and create a different text.*

A: That's surely true, yes, I think that it is true. I don't think that that means that a text can be made to mean anything legitimately. I don't believe that. I think one can misread books. I think I've been conscious of misreading things myself and then coming back ten years later and seeing where I've misread them, and I'm not giving the one and only reading, but I've certainly corrected certain errors of ignorance that I had when I was younger.

Q: *Does it bother you to be blatantly misread or misunderstood?*

A: Well, I don't like it, but there are very few occasions where one can point to a misreading so gross that one really takes exception to it. I can think of an example which was that at a meeting I once read a passage from **The Millstone** in which the narrator describes her sister not allowing her children to play with the girl next door because she was a common little girl who used bad language and so on. At the end of the reading somebody came up to me and, assuming that I had taken the sister's rather than the narrator's point of view, said, "I do agree with you, however broad-minded you are, you can't let your children play with anybody." Now, that I thought was a misreading of the tone and the intention of the passage. I thought it almost impossible that she could have misunderstood that.

Q: *But nonetheless you think that most texts, if not all texts, allow for a variation of responses.*

A: Oh yes, it is a very dull text that doesn't. And I think a really interesting text is full of ambiguities that are unresolved even in the writer's own intention because that's why he's writing about them, because he's deeply perplexed by certain issues, is not quite sure what it signifies, or where the balance should lie, and naturally enough, any reader will have a slightly different balancing point. That's what makes it interesting.

Q: *Yes, I think what I find most fascinating about your work is that ambiguity or irresolution.*

A: I'm only interested in writing; I don't quite know how it's going to come out.

Q: *I wondered about that. Do you feel superior to your characters in the sense that you understand them better than they understand themselves?*

A: No, no, I wait to see what they're doing. I don't understand them. I

wait and see what they do. I don't feel superior because I'm sort of mystified; I present them with certain problems, which is the plot; the plot is the problem they're presented with, then they have to resolve it, and quite often I don't know whether I admire them or go along with them, or think they should have tried harder, I just don't know. As one doesn't know when a friend makes a decision; you don't know whether she should have left him or she should have had the baby; you don't know.

Q: *You speak of the characters as having a kind of autonomy.*

A: I think they do. I don't look at them as puppets in the sense that I manipulate them. And in that I think I am very different from the nineteenth century novelists, or from some of them. Rereading Trollope or Thackeray, it is quite clear that they knew the outline of the plot. In fact, **Vanity Fair** is a very interesting example of a novel where obviously he knew the plot and he knew what his characters were going to do and where they were going to end up, and yet he didn't quite know the pulling power that Becky Sharp would have. He meant her to be attractive. Did he know how attractive he meant her to be? He didn't mean her to be admirable. There is enough that is totally contemptible for us not to like her wholly, but nevertheless she has a great attractive power. That's the area that is so interesting. He was drawn to write about her. He completely manipulated the events of her life, but there's an element that escapes manipulation.

Q: *In* **The Realms of Gold,** *there is the sense that the narrator is manipulating the plot.*

A: That's true. That's true, partly because it's the only one of my books that I would describe as a comedy, and you're allowed to plot in comedies.

Q: *Why a comedy?*

A: Well, it all works out all right. Nobody suffers very much.

Q: *For most people.*

A: For most people. There's a bit of a subplot, but most people end up fine, and this can only be achieved by dismissing the elements that don't resolve themselves. And so I suppose there is a tone of conscious manupulation. And that's manipulation. In that, yes.

The first-person narratives, the earlier works, are fascinating from the perspective of knowing where you stand in the relationship to the narrators. You said at one point that you wrote about characters who are "intelligent about themselves" (interview conducted by Barbara Milton, **The Paris Review,** *74 (Fall-Winter 1978, 57). And it's true that characters like Emma and Rosamund and so on have a certain awareness, but on the other hand, there's a great deal that they repress, or don't know about themselves. They don't analyze themselves. They aren't very perceptive about all of the complexity of their motivation. Do you expect the reader*

to pick up on that, or are you comfortable, as they seem to be comfortable, with the rationalizations they make? For example, Rosamund in **The Millstone** says, "There's nothing I can do about my nature, is there?" at the end of the book.

A: I agree with that. Yes, we are far too easily led to think that we can change things by understanding them.

Q: So that you think it is better for people to accept their idiosyncrasies because they can't change them anyway?

A: Yes, it depends whether the idiosyncrasy is debilitating or disabling. Hers weren't. She was a perfectly functioning person. She was happy as much of the time as most people are. She had a good life. Why should she investigate? I think that by investigation one can actually snap things and stop one's self from behaving at all. Also, I think she was quite self-investigative. She was rather cool about it, but she was. I think it is true that it is very difficult to change one's nature, if not impossible . . .

Which is what I think is the limit of freedom—you can change, but not very much, and if you set yourself to change a great deal, you're going to cause yourself a lot of violence.

Q: Do you feel the same way about Emma in **The Garrick Year?**

A: Emma's a different case, because she's doing much more of a show in the novel. She's displaying herself; she's not telling the truth most of the time. She's much more of a performer. No, I wouldn't take her word about anything. She's saying it for effect most of the time.

Q: Well, Rosamund is also very fond of projecting an image which isn't true.

A: Yes, but she's not doing it in the book all the time, whereas Emma is. Emma's got this tone which is her way of talking, which is her way of presenting herself. She is very interested in style and appearance, whereas Rosamund isn't. Rosamund is genuinely interested in the truth, but only the truth that she finds acceptable.

Q: Some male readers have complained that you don't create real male characters, especially in your earlier works, for example, George, and James, and David . . . Do you feel that your male characters are one-dimensional because the narrators can't see them any other way?

A: Yes, certainly in the early novels, that's true. George is deliberately one-dimensional. I mean, she (Rosamund) only met him once or twice. I know far, far more about that man than she does. That's an interesting case where I know far more than the narrator. But it's a given fact of the story that she can't know anything more about him or she wouldn't have behaved like that.

Yes, I don't think I was necessarily conscious of that when I was writing the book, but I certainly knew that telling the story through her there were things that I couldn't say about him that I knew perfectly well but that couldn't go into that book; it would have to be a non-first-person

book. I think David, actually, in **The Garrick Year** is perfectly okay. He doesn't feature very much, but he is perfectly real to me, a very familiar type of man. James in **The Waterfall** is one-dimensional. Again, to me he is very real. He's deliberately one-dimensional because he's seen through the eyes of passion which only sees one aspect of a man. And when he does something which doesn't fit in with her (Jane Gray's) view of him, then she can hardly bring herself to say he did it.

: *She's deliberately creating a kind of fiction!*

: Yes, but in a way it's not creating a fiction, it's simply missing out everything else. All the things that he (James) was described as doing and being, he did and was, but she doesn't bother to tell you all the other things he did and was, which would have made him a full person. That's a characteristic of most romantic fiction, that characters don't do the things that would undo the romantic fiction. She (Jane Gray) does it for herself. She tells the reader about things that are nothing to do with romance, herself, in her own character, but she doesn't do it for James. Although she says at the end that she could have done it if he had been telling the story. She says, " I can't speak for him." So, in a way, I think that the reader ought to assume that James is a real person, but that he's been reduced if you like; his qualities have been reduced to one set of qualities, as though he could have done ten things and she describes him as only doing two of the ten.

?: *Simon Camish in* **The Needle's Eye** *enjoys making self-serving images of others such as his wife and his mother.*

: Yes, it seems to me that in a first-person novel you can have only one full person and that's the first person. It's part of the technique that you can't make the other people into round characters. In **The Needle's Eye,** which is a third-person novel, I certainly was attempting to make Simon a whole person and to make Rose a whole person and to show these two whole people not comprehending each other wholly and being surrounded by a lot of other people whom they only partially comprehended, but who were hinted at, with degrees as being real people. I think I wanted to imply that they were all real people, like the couple you meet at dinner, Nick and Diana, but they have a little part in the story, so you don't bother to make them into real people for the whole of the plot; you indicate that they have a life off stage but it is of no concern.

?: *But Simon knows he is distorting his view of other people.*

: Yes, in order to tell your wife that she can't have any money next week, you have to build her into an ogre and spendthrift and all the rest of it, in order to get the words out, and he's always doing that.

?: *Do you find personal or moral problems in using pieces of other people's lives!*

: I could easily do so, but I have been remarkably discreet, and I've not used many a good story because I thought it would be intrusive. I do

23

think it is very wicked to use some stories while the people are still alive and therefore I've been very careful not to. And all the incidents that I have used that people would recognize I think are, on the whole, ones that they would be glad or pleased or amused to note. I think it is a terribly difficult area, and obviously there are many good things that one would like to deal with but for various reasons one never could. I find that there are things that are too close, or that are too painful, or that are too personal, or that would be treachery to another person, and you can't use them, however good they are. I suppose you could wait until the characters die . . .

Q: *Do you feel that Rosamund in* **The Millstone** *was remarkably equitable about Lydia's use of her?*

A: I suppose she was, no . . . I think that she was deeply shocked but that also she was such a proud and vain woman that she didn't even want the reader to know she was shocked. Therefore, she preserves this veneer which she does all through the book of not being too deeply distressed by anything. I think she was pretty shattered by it. Although proud, she was also fairly self-critical, so she presumably thought that whatever Lydia said about her was fair. And the combination of pride and modesty kept her very calm, which I suppose is fair enough. I think that is probably how I would act if I were betrayed in that particular way.

Q: *Do you see Octavia's ripping up of the manuscript as an example of Rosamund's unconscious wishes? She did leave the door open.*

A: She left the door open on purpose, oh yes, it certainly was. On the other hand, it was also meant on the prosaic level to illustrate the difficulties of living with a small child in a flat with a person who was writing. In those years on a simple prosaic level I spent my life trying to snatch manuscripts out of the hands of toddlers, so it was a subject so much in my mind . . . I had to use the incident. Similarly, in **The Garrick Year** there's the incident where the child falls in the water; this was just something that was so much on my mind all the time that I had to use it. And anyway, the things which occur to you that could go wrong, that seem to be about to happen every day, fiction is a perfect place to get rid of them; you exorcise them. It is very nice to imagine the worst, put it in a book, and see it from the outside.

Q: *Do you feel that you are used by others? Do you find yourself in others' books, I'm thinking particularly of your sister's (A.S. Byalt) work; for example,* **The Game** *is about two sisters.*

A: It's a long time ago since I read it, but I thought that she had made both characters herself in some strange way. If I'm right there's an academic sister and a more social one. It is very interesting, because my sister is both more academic than I am and also, I think, more sociable. So she sort of put herself into the two, which I think writers always do; they split their characteristics up and give little portions to their characters.

24

And certainly the character in **A Summer Bird-Cage** bears no resemblance to my sister at all. In fact, I made her as deliberately unlike my sister as I possibly could, which is a natural instinct.

Q: *Your remark about dividing your personality up into different pieces and putting it into different characters is interesting. Is that what you're doing in your later books, after you no longer use first-person narrators?*

A: Yes, you spread your point of view and your different impulses into a range of characters.

Q: *There seems to be a turning point with **The Needle's Eye** and **The Realms of Gold** where you no longer write as explicitly about women's issues. Do you feel this to be true? Are you less interested in women's issues per se?*

A: It's very hard to say, because I didn't think of myself in those early novels as being interested in women's issues at all. I was just writing about what was under my nose. And people didn't talk about the women's novel in those days; it was considered bad form to mention that people were women at all.

A: *Nonetheless, the characters are working out problems that turn out to be specifically women's problems, whereas in the later books there's a reaching out into other areas.*

A: I didn't think of the problems as being women's problems at all when I was writing those books; I thought of them as being the problems of a specific section of women that I happen to know about, middle-class women with ambition, in other words. They all want to do something and they find conflicts in their family . . . All the people I knew were in this kind of predicament and it seemed to me just normal. I didn't think about it in general terms at all.

Q: *It seems to me that your early fiction, in particular, is very mother-centered, about women in relationship to their mothers, to mother-surrogates, to their roles as mothers.*

A: That was because I had three small children—the reasons are not very far to see. I quite honestly didn't think I was writing novels in those days. I was very naive and straightforward. I wrote about what was in my mind and it turned into a novel. I didn't think about it in general terms; I didn't think about how it related to anybody else in the world, apart from perhaps one or two people I'd been talking to. So naturally it was about what I was thinking about; it was about my own children and my own spot in time.

Q: *That's what is so delightful about your work!*

A: It's amazing that I had the nerve to do it, really. That to me is the surprising thing, that I had the confidence to think that was under my nose was interesting, which it was to me, and it still is quite interesting.

Q: *And to millions of others!*

A: Well, millions of others were in exactly the same position, but I didn't

think about that at the time. I just thought about me, about my own babies, and as my babies grew older I got less interested as people do, thank God, and you can then get your nose out of the kitchen and go off and talk to other people.

Q: *You don't write very much about teenagers, except for* **The Ice Age.**

A: I've got a few teenagers coming up, I think. Well, they've only just begun to be teenagers, really; they've just hit the teenage scene. Though that becomes more difficult. I found writing about babies is very easy because babies don't read books, but as they get older there is the problem of confidence. As I was saying earlier, there are some subjects that one would never use because of betraying confidence and this applies to one's own children and their amusements and their lifestyle. One doesn't want to put the whole thing down—it would make a marvelous novel—but I don't feel I have a right to intrude too much into what they're doing. I can use them as a decor.

Q: *Was Jane in* **The Ice Age** *based on any teenager you know?*

A: She was slightly, yes. She was based on a combination of complaints I've heard from other people about their children.

Q: *She's a very unpleasant character.*

A: Iane? She's awful, awful. If I'd have had children that age when I wrote that novel, I wouldn't have been quite so nasty about her, because my children are so lovely now that they've reached that kind of age, so sweet, maybe I would have been more indulgent. Well, it is a slightly caricatured part, a satirized part.

Q: *Did you feel particularly singled out among your siblings for achievement?*

A: No, I think so. We were all expected to work very hard which we all did. We've all stuck at it.

Q: *Did you in fact create stories together as children as the Brontës did?*

A: We didn't do stories, we did plays. We used to write plays every Christmas and indeed more often than that. We used to invite the family up to the attic, and they would have to watch us perform.

Q: *You still write plays, don't you?*

A: Well, occasionally, with very little enthusiasm. I can't remember what plays I've written, but they have all been terrible, so we'll talk no more about them. I only write them when people suggest I ought to. Every time I agree to do something like that, I think well perhaps it won't be so bad this time, but it's always worse. I warn people that I don't like doing it and can't do it. In another five years I suppose I'll agree to write some script or other and regret it.

Q: *Do you feel that way about short stories too? You haven't written very many as far as I know.*

A: I haven't, no. I quite like doing short stories; it's just that they tend to blossom into novels if I get interested in them. I'd rather do a literary artile because somehow fiction is such a commitment, such an imaginative

26

commitment. It seems hardly worth getting yourself in for a short story; you have to come out as soon as you get in there.

Q: *Do you write poetry?*

A: No, not at all.

Q: *You write about Wordsworth and your sister writes about Wordsworth as well. Is this connected to something in your shared background?*

Well, I wrote mine because I was asked. That's not quite true. I wrote it because I was given a choice. I didn't like Wordsworth at all at school. I'd been marking A-level papers and they all hated Wordsworth, and I started rereading and decided that he was wonderful. And I was asked to write a book in a series and I said, well, why don't I do Wordsworth? My sister is really more of a Coleridge person than a Wordsworth person. I'm not nearly as interested in Coleridge. It's curious, when I was at university I was very interested in metaphysics and philosophy and now I've lost nearly all my interest in it, and she is the reverse and has become much more interested in it; I don't know why that should be.

Q: *Yes, in your book you don't emphasize Wordsworth's philosophy, but much more his realism.*

A: Yes, well, the book was written for schoolchildren. I think the realism is more attractive than the philosophy. I was trying very hard to sell Wordsworth to the unwilling, because he is a very difficult poet for people under a certain age. I think he is rather a middle-aged poet. And I was trying to present the more attractive side of his character.

Q: *Nonetheless, in your book on Bennett as well you are very attracted to a writer's ability to create real characters and situations more so than the craft, would you say?*

A: Yes. What's technique for except to do something with, not an end in itself . . . I think structure is the support of what is being done or said. I'm not saying I'm blind to structure by any means in other people's work. Anybody can create a structure; it's what you put in it. Anybody can make a space; it's the shape of it and what's in it that's interesting, I think. You can impose a structure on anything. It is to create a natural structure that looks natural, that looks organic, that's difficult and that's worth doing. So it's got to look organic; it's got to look as if it's part of the thing and, in a way, the more you can see it, the less a part of the body of the work it is.

Q. *Do you expect structural devices in your books to be noticed by the reader? Do you expect responses to your craftsmanship?*

A: No, I rather hope not, because if they're obtrusive, then in a way you've failed. Also, I'm sure that some of them I don't even notice myself, because I don't know what I'm doing, and I'm quite often surprised when I reread something to see how it's made because I never plan these things; they just occur, or don't occur as the case may be. In a way I'd rather that they weren't immediately apparent. What I like best is the

27

reader who reads to see what's going to happen rather than a reader who is self-conscious about craft.

Q: *A remark I found funny and interesting was Sarah's in* **A Summer Bird Cage:** *"You can't be a sexy don. It's all right for men, being learned and attractive, but for a woman it's a mistake. It detracts from the essential seriousness of the business." Did you at one time feel that way about women in academics? Some of your characters, many of them, experience a kind of split between their social self and their professional self.*

A: Yes, it is quite a problem. I think it still is a problem actually. It was particularly true in those days when there were far fewer women dons, that if you chose to be a sexy don then you created havoc. I knew a few women like that. Because there were so few around they were extremely conspicuous. And the women who were more interested in work put on protective coloring and went about their work very, very quietly. It was as though you couldn't do both. And I think that that's still true in some walks of life.

Q: *You don't talk about your years at Cambridge very much. Was that a good time for you?*

A: Oh, it was wonderful. It was marvelous.

Q: *You got starred first?*

A: Yes, in English literature. It was such a good time, that's why I don't write about it. I don't like these nostalgic novels about how glorious it was when I was young. That seems to me a very easy and rather shoddy way of writing. I was so happy there. It was wonderful. There were so many marvelous people. Most of my good friends I made there, I suppose. It was physically such a beautiful place to work in and a marvelous combination of reading and living in an institution which I adore. I rather hanker after institutions some times. It would be marvelous to get up in the morning and know that there was breakfast downstairs and there's a meal if you want it. I loved it.

Q: *That reminds me of a comment about houses in your book on Bennett: "To Bennett, as to Lawrence, houses expressed souls. People were not disembodied spirits, and the houses that they built were as much a part of them as their bodies." Do you feel that way about houses? Your characters have such strong attachments, I'm thinking of Rose.*

A: Oh, very much. I'm not saying that some people aren't very indifferent to where they live, but that's very interesting. That's very revealing about them. The fact that some people don't really care what decor is like and what the house is like is very revealing; it says a lot about them.

Q: *In regard to religion or philosophy, you have Anthony Keating in* **The Ice Age** *wanting to justify the ways of God to man, and some statements that you made have a religious implication, for example, you said, at one point (interview by Barbara Milton, p. 65) "I have this deep faith that it*

*will all be revealed to me one day. One day I shall just see into the heart
of the whole thing" referring to randomness and pattern, fate and acci-
dent. Could you clarify that a bit more; do you feel that you are moving
toward a religious view or that there is some sort of implicit order within
things?*

A: Yes, I think I've always believed that and I think I would call myself religious up to a point.

Q: *There's a great deal of what I would call retribution in your books—maybe it's serious, I don't know.*

A: Well, I don't believe in retribution and punishment very much. I believe in grace and salvation. I believe in the good side of it all. No, retribution on the whole is comic.

Q: *Often in the form of car accidents?*

A: Yes, well, that's a Freudian retribution. I mean things do go wrong when people are doing the wrong thing, because they become careless and things go wrong then. Also because people are dreading that things will go wrong and then they do. I don't think that has anything to do with God. I don't think God thinks of that at all. God, on the contrary, wouldn't permit that kind of thing to happen; that's why people don't very often die in the car accidents. God steps in and saves them.

Q: *There is a strong sense of fate in your works.*

A: Yes, I think God is on the other side of fate. I mean I think we can evade fate by religion, avert fate by a certain amount of religious obliga-
tion. I find it very hard to describe what I mean in this area, because I cer-
tainly don't belong to any church and I don't have any creed or dogma.
But I nappily say that I'm not a materialist. I don't believe that this material world is all. I can't bring myself to think that that's even a sensi-
ble way of looking at things. And I'm not a total determinist either. I'm an almost total determinist, but there's a small area where grace operates, and prayer and will operate.

Q: *Do you concur with Jane in* **The Waterfall** *when she says, "the ways of
regarding an event, so different, don't add up to a whole; they are mutual-
ly exclusive: the social view, the sexual view, the circumstantial view,
the moral view, these visions contradict each other; they do not supple-
ment one another, they cancel one another, they destroy one another.
They cannot co-exist."*

A: That's very interesting. No, I don't. Well, sometimes that seems to be true and from Jane's point of view this was true, that she was in a very ex-
treme emotional situation and the different ways of looking at it didn't make sense, and I think this can be true. I don't know if there is a final truth in Freudianism or in religion or in Marxism or in any of these inter-
pretations or creeds. I don't know if any of them are a final truth. It's much easier to interpret the world if you believe in one of them and one only, but as you have probably gathered, I dabble in all of them and

29

believe in little bits of all of them. And whether they add up to a whole truth or not I would love to know. I'm hoping I'll find out one day. But certainly if you listen to an adherent of any faith, they do cancel one another out, they don't add up, they're directly contradictory to one another.

Q: *But you suspect that they might work out?*

A: I think that they must add up. Well, I think that the religious interpretation says that they could all add up in a way to a whole truth and that's what I would like there to be. And certainly I don't find myself able to commit myself to a line of interpretation that excludes the others.

Q: Your remarks seem to indicate that you have an incipient religious view.

A: Yes, I'm hoping it will all be made clear, yes. There are certain social problems that it seems to me can only be solved by a religious attitude. There are certain problems such as loving the unloved and unlovable that can only be solved by a religious devotion to the task. The Darwinian view says get rid of them. The Marxist view says they should be made okay so they don't exist in that form at all. The Freudian view says that they're beyond help, and the only person who says that they can be helped in any way is the person who says that you must love them. And, as far as I can see, this is what some people are quite good at doing, and it is the only answer. And there are certain areas of care where religion is the only thing that can answer, and that seems to me to be the best bet so far. That's not saying much.

Q: *In a short essay called "Money as a Subject for Novelist" (TLS (24 July 69), 792-93) you say that money is a very difficult subject for a novelist. Was* **The Ice Age** *an attempt to write about money as a subject?*

A: It was partly, yes. I remembered having written that article, and I thought, why not have a go at it, especially since it just seemed an extremely topical subject. Everybody was talking about it in the mid-seventies.

Q: *Do you share Anthony Keating's faith that England will come out all right through its crisis?*

A: Yes, I think it depends what you mean by all right. I'm sure it will come out with its character intact. Whether it will come out as wealthy as it was before, in comparative terms, I think is neither here nor there. I mean, who wants to be the wealthiest nation in Europe?

Q: *Why are you so sure its character will be preserved?*

A: I just have great faith in the British nation. One becomes patriotic under pressure, and I do think that there's a wonderful sense of solidarity and a dislike of pure materialism in this country which I like very much. A lot of the union trouble was caused not so much by pure greed as is alleged, as by a sense of brotherly solidarity and wanting to stick by our own sort of people and this is not a bad thing at all. I mean if thereby they

30

earn less than Germany then that's their choice. I think that although we're a nation of grumblers, we're not a nation of defeatists.

We just keep on going. We don't have revolutions, and we don't throw people in the barricades; we don't become violent on the street very readily, and I can't see this changing. I know that there are terrible threats, and I know we've been very bad on racism and the National Front is a menace and so on, but I do feel the British attitude to controlling these things is very admirable; I think we should have faith in it. There's nothing else to have faith in. I also feel that when I wrote that book Britain was in a worse economic situation than many other countries. Now everybody's in the same boat, and you see that it wasn't unique. At the time we thought it was a unique problem and that this country had really had it. Now we see that the whole system has had it. Maybe we will score better because we don't panic so much when we lose what we haven't got. I mean, we don't mind going without our cars and we quite like queuing for bread. If everybody's going to be doing it, we'll probably do it better than countries that aren't used to it. There is a low expectation in this country which is maddening in many ways; it infuriates Anthony Keating, but nevertheless it is a great safeguard, because you don't start throwing yourself out of the city windows when things go wrong. You just accept and carry on.

Spots of Joy in the Midst of Darkness: The Universe of Margaret Drabble

Mary H. Moran

British author Margaret Drabble's fiction portrays a bleak, often menacing universe, ruled over by a harsh deity who allows human beings very little free will. This curiously old-fashioned view appears in a fictional world which is otherwise contemporary. Most of her protagonists reflect this paradox: they are intellectual, often cynical people living in a society of existential choices and situational ethics, and yet they use concepts such as providence, sin, and grace in contemplating their lives. In this respect the characters resemble their author. She, too, lives a sophisticated contemporary outer life while guided by an inner life replete with Bunyanesque notions, symbols, and fears.[1] While unsure of her exact theological stance, she continues to be influenced by the religious teachings of her childhood.[2] She grew up in the Yorkshire area of northern England, where Methodism, with its emphasis on "bleeding wounds and fountains of blood and loads of sin," had prevailed since the eighteenth century.[3] Although her mother eventually rejected religion and became an atheist, Drabble as a child was heavily exposed to her maternal grandparents' hellfire-and-brimstone beliefs.[4] She was also, as Valerie Myer demonstrates in *Margaret Drabble: Puritanism and Permissiveness*, influenced by the pervasive Puritan climate that has lingered on in the more provincial regions of England.[5] She was affected not only by Puritanism's secular attitudes—hard work, frugality, an acute sense of personal responsibility—but also by its belief in fate and predestination.

The general influences of Puritanism and Methodism are revealed in a number of ways in Drabble's fiction, ranging from the fatalistic universe she portrays to her characters' habits of spiritual introspection and ruminating on Biblical stories.[6] However, the question of exact causes is always a difficult one to answer, and I do not wish to insist that Drabble's metaphysic is entirely the result of these religious influences. They are doubtless significant, but they may be effects rather than causes. That is, it may be that Drabble's innate temperament, her deep-seated need to perceive a divine plan at work in the universe, attracts her to any religion that answers this need.[7] For example, in *The Ice Age* she implies her attraction to the medieval Christian views of Boethius. And in her interview with Nancy Hardin she revealed her affinity with the fatalistic

religion of pagan Greece: "I'm kind of Greek with a Greek view of the gods, I think. I mean, better keep on the right side of them because although they're not very nice, they're exceedingly powerful. One had better appreciate it."[8]

Drabble's fatalistic world view may have literary as well as religious antecedents. Her outlook bears some striking similarities to Thomas Hardy's. Both novelists emphasize the way fate usually works against the individual's earthly happiness, a situation which causes them to suspect the existence of a malicious deity who delights in thwarting and playing tricks on human beings. Drabble, like Hardy, is highly sensitive to the cruel ironies and accidents of life that would seem to imply such a deity, and her works are filled with such incidents. In fact, John Updike has accused her of being "shamelessly dependent upon coincidence."[9] However, for Drabble this reliance is not a handy plot device but a reflection of her belief in a divine meaning behind all accidents.[10] The attitude expressed by Rosamund Stacey, the protagonist of *The Millstone*, undoubtedly reflects Drabble's own:

> I thought for some time about life's little ironies, for the truth was . . . that they always moved me out of all proportion to their significance in any respectable philosophic scheme. I have always been stirred, sometimes profoundly, by newspaper comments such as Killed While Adjusting Safety Belt, or Collapsed Night Before Wedding.[11]

Because Rosamund is ordinarily a rational person, she is perplexed by her occasional gravitation toward "some absurd belief in a malicious deity" (*M*, p. 74), a belief which causes her to fear that misfortune may descend upon her at any moment. For this reason she will never "tempt fate" (*M*, p. 158) by making plans or harboring hopes that could be knocked down by the whim of such a deity.

Many Drabble protagonists display similar superstitious leanings. They frequently ponder whether random events are true accidents or the result of a divine plan. Emma Evans of *The Garrick Year*, for instance, reads with fascination a newspaper article on survivors of a disastrous airplane crash because "it is interesting, to know what people think who unexpectedly survive death, whether it seems to them to be coincidence or providence" (*GY*, p. 124). She believes that "there's a providence in the fall of a sparrow" (*GY*, p. 112). Several characters of *The Ice Age* wonder why life is filled with so many undeserved evils and misfortunes—whether these are a divine "joke, a trial, (or) a punishment" (*IA*, p. 182). Jane Gray of *The Waterfall*, perhaps because she is the most passive of all the protagonists, is the most firmly convinced that all accidents and ills are the result of a divine plan. She believes that there is "something sacred in her fate that she (dares) not countermand by effort" (*W*, pp. 3-4) and that "providence (can) deal with her without her own

assistance" (*W*, p. 4). However, she is acutely aware that this divine plan is usually at odds with human desires and well-being and that we live in a "hostile, ill-ordered universe" (*W*, p. 182). And so Jane reflects, "Perhaps I could take a religion that denied free will, that placed God in his true place, arbitrary, carelessly kind, idly malicious, intermittently attentive, and himself subject, as Zeus was, to necessity" (*W*, p. 56).

Drabble herself is subject to the same sense of doom that haunts many of her characters. She has described feeling "all the time that the axe is about to fall and whenever I'm particularly happy, I'm more than ever afraid."[12] This sense of imminent disaster, the feeling that happiness and security are fragile, ephemeral conditions, runs through all Drabble's books—even her relatively sunny novels such as *The Realms of Gold*—and culminates in the doomsday vision of *The Ice Age*.

A major way Drabble creates an ominous atmosphere is by showing the importance of the newspaper in her characters' lives. In her early novels, where the protagonists are absorbed in their own personal experiences and private worlds, the newspaper serves as a connection with external reality, and this is filled with disasters, accidents, and injustices. Rosamund Stacey's fascination with newspaper articles demonstrating life's cruel ironies has already been mentioned. Janet Bird, of *The Realms of Gold*, and Emma Evans, housebound young mothers, hungrily read newspapers in their spare moments, and are struck by the prevalence of disaster in the world. Alison Murray of *The Ice Age* is also drawn to disaster stories: horrified but compelled, she reads a gruesome account in *The Times* of a woman being blown to pieces by a bomb. Kitty Friedmann, also of *The Ice Age*, is moved to tears by newspaper stories on human suffering. In the *Evening Standard* she reads an article

> about a baby who was suffering from a rare bone disease: his mother was appealing for a donor, for new bone marrow. Kitty Friedmann's eyes filled with tears. Poor little lad. Poor woman. Beneath the article about the baby was a brief report of an old man who had been kicked to death and robbed of forty pence on Wimbledon Common. She read this too. She continued to cry. (*IA*, p. 58)

Although Kitty has "always had the greatest difficulty in believing in the existence of ill luck," occasionally "faint shadows of doubt reached her: how, in this day and age, could a child die, slowly, publicly, foredoomed, of an incurable disease, how could an old man be kicked to death?" (*IA*, pp. 58-59). Frances Wingate of *The Realms of Gold* is similarly moved to tears by a story in *The Times* about a baby whose father battered it to death.

The newspaper figures heavily in Drabble's novels undoubtedly because the author regards it as a particularly powerful reminder of life's evils and the randomness of fate. She has claimed to be "so susceptible to

horror that reading the newspaper is enough for me: when I actually see the news on television it makes me feel terrible for days."[13] Simon Camish of *The Needle's Eye* holds a similar attitude:

> On Saturday morning, Simon decided that he would do some gardening. He had depressed himself so thoroughly by reading the newspapers that he felt he had to do something. The newspapers, for a holiday weekend, had been full of unimaginable disasters. An earthquake in the Middle East had killed tens of thousands, and cholera was breaking out amidst the survivors: There was an account of a trial in the States over an alleged massacre in Vietnam. Three men in an iron works in Yorkshire had been killed by molten slag from a mobile ladle. A child in a mental home had fallen into a bath of scalding water and had died five days later of burns. There had been a twenty-car pile-up on the M1. Mr. Calvacoréssi said that it would cost his wife a fortune to reclaim her baby. So Simon dug his garden. (*NE*, p. 270)

In addition to using newspaper headlines and articles, Drabble also draws attention to life's evils by presenting a gallery of miserable human predicaments. The ill, the poor, and the downtrodden appear in her books and illustrate how painful life is for vast numbers of human beings. The unfairness and horror of their conditions is underscored by the fact that most of them are highly undeserving of their cruel fates. Many are innocent children: the autistic youngsters that Sarah Bennett of *A Summer Bird-Cage* views in a television documentary; the small working-class child in *The Millstone* who receives a taste of life's bitter unfairness at an early age when she is deprived of playmates because the fastidious middle-class parents in the neighborhood will not allow their children to associate with her; Rosamund Stacey's infant daughter, who suddenly develops a mysterious, pernicious heart disease that will shadow her for life; the severely retarded child of the protagonist in Drabble's short story "Crossing the Alps";[14] Alison Murray's daughter Molly, mentally and physically crippled since birth with cerebral palsy. The misfortune of Kitty Friedmann—random IRA terrorism has killed her husband and crippled her—also seems highly undeserved, for she is an exceptionally good woman, who has never harmed anyone in her life. And it is particularly cruel that Alison Murray's sister Rosemary, who has always lived in the shadow of Alison's beauty, should become disfigured by breast cancer while Alison maintains her lovely figure into middle age.

Drabble gives an affecting portrait of those bowed down by poverty and illness in *The Millstone*. Rosamund, having grown up in an upper-middle-class environment, has been sheltered from the spectacle of poverty until her pregnancy, when she begins attending a National Health clinic in a working-class neighborhood. Here she is "reduced almost to tears by the variety of human misery that presented itself" (M, p. 64). She witnesses anemic, exhausted women, worn out by numerous pregnancies and children and by the endless effort of trying to make ends

meet, reduced to an attitude of passive, stoical endurance. Rosamund is deeply disturbed by this exposure to "facts of inequality, of limitation, of separation, of the impossible, heartbreaking uneven hardship of the human lot" (M, p. 77). It convinces her that life is not fair: "It is unfair on every score and every count and in every particular, and those, who, like my (Fabian Socialist) parents, attempt to level it out are doomed to failure" (M, pp. 93-94).

Rosamund's acute awareness of life's basic unfairness is shared by many of the protagonists and by Drabble herself, who has said, "Equality and egalitarianism preoccupy me constantly, and not very hopefully."[15] Sarah Bennett is obsessed by the blatantly unequal distribution of life's goods. She senses that there is something very wrong with a world in which she has been given so many physical and intellectual gifts while her dowdy cousin Daphne's share is so meager. And she is appalled by the fact that "some people are born to a smooth life" (SBC, p. 96), like her happily married friend Stephanie, whereas others, like her poor friend Gill, whose husband has left her, are destined for a rocky, tearful course. Although Sarah tries to justify these discrepancies by reminding herself of the "Greater gifts—greater duties to society" maxim, this answer strikes her as inadequate. Her query, "Why do you think God made people like Daphne?" (SBC, p. 180), is a variation of the same basic question that haunts many of Drabble's characters and runs through all her books. Karel Schmidt of The Realms of Gold puts it this way: "There was no justice in life, why seek for it or try to create it? What justice could ever have given to him and Frances such years of loving, and to others, no loving at all?" (RG, p. 217). Again and again Drabble's characters come up against the hard fact that life's fortunes and misfortunes are doled out unfairly.

Besides the unequal distribution of human happiness, another cruel condition of life that preoccupies Drabble is the inevitable disappointment of youthful dreams in the face of adult realities. Her analysis of Wordsworth's "Immortality Ode" reveals a great deal about her own attitude. Whereas most readers find in Wordsworth's poem an argument that the philosophical joys of adulthood are compensation for the loss of the intense, spontaneous joys of childhood, Drabble finds, on the contrary, an attitude of acute loss:

It is essentially a middle-aged poem, and for Wordsworth it is something of a swan song. He does his best to close it on a note of optimism and hope, but nevertheless what comes across most powerfully from the poem is a feeling of anguished regret for what is lost. However nobly he resolves to bear his loss, resolution itself can never make up for what is gone, and he knows it.[16]

The label "middle-aged" may equally well be applied to Drabble's own vision, for in many of her works she focuses on the compromises and

disappointments of adulthood, especially resignation to the fact that one's youthful dreams will never be realized. Although in her later novels she presents certain middle-aged characters who have learned to be content with "life's modest satisfactions" (*NE*, p. 219), the protagonists of her earlier works and some of the younger characters in her later works are acutely distressed by the deflation of these dreams.

The experience of coming to terms with the bleak realities of adult life is most fully developed in Drabble's first novel, *A Summer Bird-Cage*. The action, which takes place during the year after the protagonist comes down from Oxford, consists of a series of experiences that open her eyes to the discrepancy between her undergraduate dreams and the real world. While at the university Sarah had envisioned a life of moral and aesthetic beauty, friendship, love, and equality, but the life she encounters as a working girl living in a London bedsitter is a far cry from this. Her friendships, in college so lofty and generous, now easily become threatened by petty bickering, for she and her friends find it hard to remain above meanness and irritability when they have to worry about money and scraping along. She is also dismayed by the education she receives about marriage. At Oxford she carried on a sublime, idealistic love affair and is still involved in it long-distance while her boyfriend is spending the year on fellowship at Harvard. However, her ideals regarding marriage are dealt a severe blow by her exposure to the inadequate marriages of various friends and relatives, many of which deteriorate because of lack of money, a sudden pregnancy, or misunderstanding about roles. But, most important, she discovers that life after college is inevitably a downhill course for women of her generation. Although the novel's action takes place in the early 1960s, women think in terms of either a career or marriage, but not both. Yet Sarah, intensely alive both intellectually and emotionally, wants both: "I should like to bear leaves and flowers and fruit, I should like the whole world" (*SBC*, p. 77). She explains to someone who asks her why she has not embarked on an academic career, "You can't be a sexy don" (*SBC*, p. 198). She therefore postpones making a commitment to either marriage or a career as long as possible, for she knows that as soon as she chooses one she will have to relinquish her dreams of the other.

In many novels Drabble offers portraits of young women who have made the choice of marriage and suffer bitterly from the ensuing constriction of their horizons. Emma Evans, a young wife and mother, forced to give up the prospect of an interesting career in London and move to the provinces because of her husband's job, grimly reflects,

> I could hardly believe that marriage was going to deprive me of this too. It had already deprived me of so many things which I had childishly overvalued: my independence, my income, my twenty-two inch waist, my sleep, most of my friends . . . and many more indefinite attributes like hope and expectation. (*GY*, p. 11)

Janet Bird and Jane Gray have also been sorely let down by marriage and its accompanying restrictions. They have consequently grown indifferent toward life. Emma sums up this feeling of lost possibilities when she muses,

> what had happened to me, that I, who had seemed cut out for some extremity or other, should be here now bending over a washing machine to pick out a button or two and some bits of soggy wet cotton? What chances were there now for the once-famous Emma, whose name had been in certain small exclusive circles the cause for so much discussion and prediction? (GY, p. 139)

Drabble's theme of the disappointment of youthful dreams is particularly poignant when she applies it to working class characters. In her short story "The Gifts of War," the protagonist's adult life, which consists of penury, hard work, and a violent marriage, is a grim contrast to the future she had envisioned as an adolescent. With bitter irony the woman recalls the hopes she and her girlhood friends once harbored:

> (she was) penniless then as now, but still hopeful, still endowed with the touching faith that if by some miracle she could buy a pair of nylons or a particular blue lace blouse or a new brand of lipstick, then deliverance would be granted to her in the form of money, marriage, romance, the visiting prince who would glimpse her in the crowd, glorified by that seductive blouse, and carry her off to a better world. She could remember so well how hopeful they had been: even Betty Jones, fat, monstrous, ludicrous Betty Jones had cherished such rosy illusions. . . . Time had taught Betty Jones: she shuffled now in shoes cracked and splitting beneath her weight. Time had taught them all. The visiting prince, whom need and desire had once truly transfigured in her eyes, now lay there at home in bed, stubbly, disgusting, ill, malingering, unkind: she remembered the girl who had seen such other things in him with a contemptuous yet pitying wonder.[17]

Eileen Sharkey, Rose Vassiliou's nineteen-year-old neighbor in *The Needle's Eye*, is another working-class girl with similar notions about escaping her squalid, tedious existence. She dreams of being a "Spanish duchess, or a wicked woman, or a make-up girl at the B.B.C." (NE, p. 157). Mistakenly assuming, as does the protagonist of "The Gifts of War," that love and marriage will effect the glorious life she desires, she hurls herself into an affair and gets pregnant. But the man won't marry her and she is left facing her dreary life, stuck in it forever, she realizes, now that she is saddled with a baby. Rose, gazing at Eileen's glum, depressed countenance, sadly observes, "There she sat, nineteen, finished, excluded for ever from what she might want to be" (NE, p. 252). Rose further reflects on what a terrible moment it is when

> one abandons possibility. Gone was Eileen the wicked lady, driving around in taxis, wearing fur coats, drinking cocktails: gone was Eileen the make-up girl with false eyelashes and a pink overall: gone was Eileen the garage man's girl, taking trips up the motorway in a fast car. (NE, p. 253)

Drabble, then, repeatedly emphasizes the powerlessness of human beings against the inimical conditions of life. While this concern appears in all of her fiction, it does not become the central focus of a work until *The Ice Age*. Drabble here makes use of the medieval wheel-of-fortune concept, presenting a wide range of characters who have recently plummeted from fortunate to unfortunate situations. Anthony Keating has suffered a sudden, premature heart attack and lost a great deal of money in the recent property slump. Alison Murray's teenage daughter has been imprisoned and sentenced to hard labor for her part in a fatal accident in a Balkan communist country. Kitty and Max Friedmann were dining in a Mayfair restaurant when an IRA bomb exploded, killing Max and maiming Kitty. Len Wincobank, a fallen real-estate tycoon, has been banished to prison for having bribed a town councillor in an effort to redeem a property investment. The particular woes of the individual characters are set against the background of the public woes of contemporary Britian: the collapsing economy, workers' strikes, problems with Ireland, and Britains' shrinking international prestige and power.

As in earlier novels, but here more explicitly, the question of why undeserved evil occurs is raised. The narrator reflects that "it was puzzling that so many dreadful things had happened in so short a space of time. Why Kitty, why Max, why Anthony Keating? And why had the punishments been so unrelated to the offenses?" (*IA*, p. 6). Appalled by the thought that human beings have no control over their own happiness, Alison in a moment of desperation attempts to convince herself of the existence of free will by inventing an ingenious theory to prove that we "make our own ordering" of happiness or sorrow. The narrator sympathizes with her need but implies that she is deluded: "who can be surprised that one so subject to the blows of circumstance should attempt to see in them a possibility of self-will, freedom, choice?" (*IA*, p. 247).

Of course, ultimately Alison cannot accept her own theory: "Facts belied it. There is no comfort, no sustenance" (*IA*, p. 247). Indeed, so convinced has she become of the existence of a malicious deity that she has grown to expect the worst and is surprised when any happiness does come her way. When she and Anthony are granted an evening of peace and unalloyed happiness, she wonders "what remote sense of fair play in heaven had allowed such remission" (*IA*, p. 247).

This impression of the individual powerless in the face of large menacing powers that rule the universe is created not only by the content of the novel—the disasters and misfortunes that beset the characters—but also by its narrative technique. An omniscient narrator ranges over a wide number of characters from an Olympian height, reporting on their tragedies and misfortunes. Indeed, his view encompasses all of Britain: "A huge icy fist, with large cold fingers," he informs us, "was squeezing and chilling the people of Britain, that great and puissant nation, slowing

down their blood, locking them into immobility, fixing them in a solid stasis, like fish in a frozen river" (IA, p. 60). This god-like perspective has the effect of dwarfing human beings, emphasizing their relative powerlessness over the course of events.

Given the dismal nature of Drabble's fictional universe, it is no wonder that many of her characters have difficulty bearing up. In fact, her books contain a large number of people who are psychologically unstable, some of whom eventually commit suicide. Drabble appears fascinated by the psychological response of the person so extremely sensitive to life's ills that he or she cannot function normally. She creates four characters who suffer from this syndrome. In *Jerusalem the Golden* Phillipa Denham finds life so painful that she cries openly in the streets, haunted by an intolerable grief. She claims that "it was injustice that made her weep" (JG, p. 167). She explains to her husband that "she could not bear to have more of anything than anyone in the world and that misery seemed to her to be a duty" (JG, p. 167). So incapacitating is her distress that she can barely perform ordinary daily acts like taking care of her children and her home, going to the store, and chatting with her neighbors. Believing that life is a hopeless, miserable affair, she fatalistically submits to her affliction.

Throughout most of *The Waterfall* Jane Gray is similarly disposed. Her symptoms strongly resemble Phillipa's. The ordinary acts of existence that others perform perfunctorily are for her an immense ordeal. She is amazed that people can "continue to live, as though life were a practical possibility" (W, p. 193), and she wonders "how they all (manage) it, how they (manage) to keep alive, when life (is) so difficult. For herself, she (has) almost given up" (W, pp. 47-48). She can "hardly force herself to walk along a street or ask a grocer for a pound of sprouts" (W, p. 127). Fatalistically acquiescing to her condition, she becomes a near-recluse, doing the minimum to survive and allowing herself and her home to deteriorate physically. As does Phillipa, Jane demonstrates the response of a delicate, sensitive psychological constitution to the spectacle of life's basic injustice and the overwhelming misery of the human lot. She points out, "The principle of natural selection has always haunted me: each day—truly, I am serious, each day—I try to batter out for myself some principle of equality that might apply to the savage and indifferent world. I fail, of course" (W, p. 148).

Beata of *The Realms of Gold* possesses the same psychological make-up as Phillipa and Jane. She is only lightly sketched and kept in the background, but her similarity to the other women is marked. She, too, is neurotic, reticent, and so fatally passive that she does not properly take care of herself, eventually developing anorexia nervosa and having to be spoon-fed throughout her pregnancy. After her baby is born, she turns her back to the world and takes to her bed, where she remains for the rest of

the novel, inert and indifferent. The root cause of her lassitude is similar to Phillipa's and Jane's: she believes that "the conditions of survival (are) so dreadful that it (is) undignified to survive" and that "living is a crime" (*RG*, p. 88).

Beata's husband, Stephen Ollerenshaw, suffers from the same sensibility. He is abnormally conscious of the physical horrors that afflict mankind. Although young, in good health, and from a materially well-off background, he is obsessed with mortality and decay:

> Being alive was sordid, degrading, sickly, unimaginable: to struggle on through another fifty years, tormented by fear and guilt and sorrow, was a fate nobody should embrace. . . . Man had been created sick and dying: for seventy years he feebly struggled to avoid his proper end. There was something overwhelmingly disgusting about man's efforts, against all odds, to stay alive. One spent one's life in inoculating oneself, swallowing medicaments, trying to destroy disease, and all to no end, for the end was death. (*RG*, p. 344)

Concluding that it is better to be dead than alive, he takes his own life and that of his infant daughter, for he cannot bear the thought of her growing up and facing the horrid conditions of existence.

These four characters, then, due to peculiarly sensitive psychological constitutions, battle with despair. There are in addition to this particular form other instances of mental illness scattered throughout Drabble's fiction. In *The Ice Age* Alison Murray, distraught by her personal difficulties and the immense public problems of her nation, suffers a temporary nervous breakdown. In *The Realms of Gold*, in addition to Stephen's suicide, there is reference to the suicide of Frances' older sister, Alice, and to the madness of various relatives and ancestors. Julian of *The Garrick Year* commits suicide, and Jane Gray mentions having "great-uncles in asylums up and down the country, and (her) father's father killed himself" (*W*, p. 136). The protagonist of "Crossing the Alps" once tried to take her own life and that of her retarded child. In *Jerusalem the Golden* the eldest Denham daughter is mad, and while Clara Maugham, the protagonist, is visiting Paris she is disturbed by the spectacle of a madwoman who wanders the city streets mumbling to herself. Finally, in *A Summer Bird-Cage* there is mention of a television program on schizophrenic children who completely cut themselves off from the real world and construct private little worlds of their own. Sarah, recalling the program, reflects, "The psychiatrist kept insisting that the condition was rare and biochemical, but it seemed oddly metaphysical to me" (*SBC*, p. 165).

Drabble's view of mental illness would seem to coincide with Sarah's: it is a reasonable, or at least understandable, response to a harsh universe, and not simply a disease. Although her protagonists all ultimately prove to be resilient and survive life's torments, they are not unaffected by the

dismal perceptions that obsess her mentally ill characters. Indeed, the protagonists must struggle to align themselves with the forces of light and life and sanity, for the forces of darkness and death and insanity loom large in Drabble's universe. Simon Camish, for example, must wrestle with these demons, which occasionally plunge him into despair. At such times he thinks,

> there was no light, or none that man might enter: he could create for himself an ordered darkness, an equality of misery, a justice in the sharing of the darkness, his own hole, by right, in that darkness, and his sense of light, his il-luminations, were an evolutionary freak, an artificial glow that had etiolated him into hopeless pale unnatural underground yellow green deformities, a light misreflected through some unintended chink, too far away for such low creatures ever to reach it and flourish by it. He might as well lose his eyes, man. He might as well grow blind, like a fish in a cave, and maunder on through the centuries in his white plated armoury. (*NE*, p. 172)

Reflections on human insignificance in a universe largely inimical, or at best indifferent, also haunt Frances occasionally. At these times, when "all culture, all process, all human effort" (*RG*, p. 347) strike her as futile, she finds herself posing the same question her despondent nephew Stephen has put to her: how can one possibly imagine that the things one does are worth doing? Stephen and others regard Frances as a super-woman—robust, strong, hopeful—and there is much truth behind this appearance; but it is with an effort that she maintains this attitude. Like the other protagonists, she must force herself to push on against life's pains and injustices. She frequently turns to alcohol to help her endure periods of despair. And at particularly bad times she has even "thought she would like to live her life under an anesthetic. She wasn't up to it; she would fail, yet again." She reflects, "Too much of the world was in-hospitable, intractable" (*RG*, p. 54).

This, then, is the universe of Margaret Drabble, a bleak, dreary, often menacing place, in which an apparent indifference to individual hap-piness invites superstitious speculations about a malicious deity. Given these conditions, she implies, the vast amount of psychological disease in the world is understandable. Yet ultimately, after portraying these miseries, Drabble is affirming life and asserting the possibility of survival in this world. Although her vision is similar to Thomas Hardy's, it is not nearly as dark: her protagonists are not finally tragic figures, as his are. In spite of the disasters and disappointments that come their way, none of the protagonists do themselves in, as do Sue Bridehead and Father Time, or are done in by life, as are Tess of the D'Urbervilles and Jude Fawley. This is because Drabble, "a great believer in surviving," advocates en-during life's difficulties and pushing on.[18] Her protagonists, like herself, "go on relentlessly to the end, trying to make sense of (life), trying to en-dure it or survive it or see something in it."[19] She explains,

I admire endurance and I admire the courage to come back. . . . I know people who have gone through unbelievable torments and have still got up in the morning and got their children to school People often ask me why my characters don't just give up and plunge into the depths and be better for it. Yes, but they can't.[20]

However, endurance in Drabble's world does not mean simply stoical resignation to life's bleakness—although a certain amount of this is involved. Rather, Drabble believes that in spite of the darkness that surrounds human existence, individuals experience occasional moments of profound peace and joy. These are gratuitous, ephemeral moments, but they are a source of spiritual nourishment for her protagonists. These experiences do not take place on a grand scale; on the contrary, they usually occur in ordinary, low-key, often domestic situations. But in these moments the protagonists are flooded with a sudden acute awareness and appreciation of the beauty inherent in ordinary, limited human existence, a beauty which they usually do not perceive. These experiences appear in all Drabble's novels but especially in her last three. In these the protagonists are older and have learned to appreciate more fully such rare good moments, realizing that happiness is not going to come to them on a grand scale, as they had hoped in their youths. Rose and Simon experience such a moment in "the simple pleasure of walking together" (NE, p. 299), and Rose derives profound joy from "such ordinary signals in the world. Cut prices and sunshine and babies in prams and talking in the shops" (NE, p. 99). Frances Wingate has one of these moments when she and her lover, Karel, stop for lunch at a roadside restaurant. This scene warrants quoting at length both because it is prototypical and because Frances' reflections articulate the significance of such moments:

> "I enjoyed deciding to buy this sandwich," said Karel. "And now I'm going to enjoy eating it."
> And hearing him speak, she shivered slightly, as though a moment of intense joy had come to its proper completion, and it occurred to her that she had never been as happy in her life as she was there, sitting at that shabby table gazing through a white net curtain at the road, with two half-eaten sandwiches in front of her, signifying union. To have it was one thing: to know one was having it was something else, more than one could ever have hoped for.
> Of such things did life consist. She enjoyed it all. (RG, p. 66)

Besides such intermittent moments of happiness, humor keeps Drabble's fictional world from becoming finally tragic. In spite of their bleak outlooks, the protagonists are capable of laughing at themselves and their situations.[21] Furthermore, Drabble creates occasional comic scenes that deflate potential tragedy: a character who has been taking himself or his problems very seriously will suddenly revert to an ordinary, mundane concern, and the change creates an anti-climax. The effect of this kind of humor is to make the ordinary and human appear delightful and lovable.

This comic pattern first appears in the final scene of *A Summer Bird-Cage*. Louise, the protagonist's older sister, has maintained the reputation of a glamorous, distant person, conducting her life on an elevated, dramatic level. Sarah's difficult relationship with her underscores the former's sense of alienation and loneliness, which has been the subject of the novel. However, toward the end of the narrative, Louise suddenly reveals to her sister a very human, vulnerable side of herself. Sarah recounts Louise's description of having been caught by her husband in the bathtub with her lover:

> when Stephen went and caught them together in the bath, what upset her most was that she was wearing her bathcap. To keep her hair dry. She said she would have started a scene if she had had her hair loose, but with a plastic hat on like that she felt so ridiculous that she couldn't.
> She must at heart be quite fond of both John (her lover) and me: of John, to have worn it, and of me, to have told it. (*SBC*, p. 224)

Drabble's comments about her comic impulse, exemplified by this scene, are revealing:

> I think what I'm most surprised about is the fact that my books are quite readable and I think, quite amusing. Other people don't agree, but I think they're quite funny. Now this is something that I would never have expected of myself, because I was very keen on tragedy. But when I wrote my first novel and decided that it was going to have a funny ending (the beautiful older sister caught by her husband in the bathtub with her lover) I thought "I'm really going to be a different kind of person:" This is wonderful, I felt. Life is going to be good, not bad[22].

The novels reflect Drabble's dual tendencies toward tragedy and comedy. The tragic vision is always threatening to take over but is warded off by comic moments. Jane Gray echoes Drabble when she remarks at the end of her narrative, which has told the story of her sublime, perilous love affair with her cousin's husband, "it's hardly a tragic ending, to so potentially a tragic tale. In fact, I am rather ashamed of the amount of amusement that my present life affords me, and of how much I seem to have gained by it" (*W*, pp. 281-282). Later she observes that her situation "resolved into comedy, not tragedy" (*W*, p. 283). Earlier, in the midst of her love affair, Jane had imagined a tragic ending: "Perhaps I'll go mad with guilt, like Sue Bridehead, or drown myself in an effort to reclaim lost renunciations, like Maggie Tulliver" (*W*, p. 184). But ultimately her sense of humor and her strong practical streak save her. The latter, though largely suppressed during the height of her affair, occasionally emerges, providing a comic contrast with her usual romantic perspective. For example, when she and her lover have just embarked on their secret vacation and are full of amorous talk, the romantic atmosphere is suddenly undercut by the intrusion of a practical, mundane concern: " 'Oh

44

heavens,' she said, in a voice like any woman anywhere, in a voice so like a real voice that it surprised her, 'Oh heavens, I forgot to cancel the papers and the milk' '' (W, p. 221).

Drabble uses this deflationary technique to lighten temporarily her characters' seriousness and help them put life into a more cheerful and balanced perspective. For example, while traveling in a foreign country, Anthony Keating, in the midst of profound metaphysical speculations which have led him to the revelation that man cannot do without God, suddenly worries that he may have misplaced his passport. "A man without God and without his papers would be truly lost" (IA, p. 265), he dryly muses, subtly making fun of his previous train of thought. Similarly, when her martyr tendencies have led Rose Vassiliou to the tragic brink of giving in to her ex-husband's demands for custody of their children, she suddenly reverts to the role of ordinary, unheroic mother: "'Oh God,' said Rose, munching her salad angrily.' I don't care I'm going to go back now, and soon I can collect Maria and Marcus from school'" (NE, p. 264). Scenes such as these bring to the forefront Drabble's warring impulses toward the tragic and the comic, toward the serious and the light-hearted. It is as though the author becomes impatient when the former begin to take over and chides herself, "It's all well and good to worry about one's soul and one's place in the universe, but after all there are practical matters to attend to." This ability to assert the importance of the practical and to laugh at one's metaphysical worries is a strategy Drabble shares with all her protagonists.

Thus, in spite of the fact that a human being is a tiny, powerless speck in a turbulent, menacing universe, there are redeeming qualities to the position. There is both beauty and humor in the condition of being human. Drabble's fiction holds up for our admiration people who perceive these qualities of life in spite of its prevailing gloom. Although she has deep sympathy for those like Eileen Sharkey who become permanently disillusioned with life, she clearly prefers people like Rose Vassiliou and her friend Emily. These two women have, like Eileen, discovered adulthood to be a disappointment after their girlish hopes; however, they do not lose their taste for joy and humor:

"Christ," they would say to each other, clutching small wailing babies, stewing scrag end, wandering dully round the park. "Christ, if only we'd *known* what we had to *go* through, if only we'd known—" but in the very saying of it, betrayed (in Emily's case) bruised (in Rose's case) and impoverished (in both cases) they had smiled at each other, and laughed, and had experienced happiness. Life had been so much better, and so much worse, than they had expected: what they had not expected was that they were both happy people, incapable of resisting, incapable of failing to discover the gleams of joy. . . . Such things must not be spoken of, they must not be admitted. But why are we alive, at all? (NE, pp. 222-23)

Rose and Emily's outlook is typical of Drabble's protagonists, who, though steeped in a gloomy fatalism nonetheless have a talent for seeking out and relishing the spots of joy life holds. The fictional universe of Margaret Drabble, then, reveals the author's inheritance of two important strains of British philosophy: the dark fatalism of Calvin, the Puritans, and Hardy, and the Romantic belief in the power of the human imagination.

NOTES

[1]See Drabble's comments about sin, guilt, retribution, and grace in Terry Coleman, "Margaret Drabble Talks to Terry Coleman," *Manchester Guardian Daily*, 1 April 1972, p. 8; Nancy S. Hardin, "An Interview with Margaret Drabble," *Contemporary Literature*, 14 (1973), 273-95: and Bolivar Le Franc, "An Interest in Guilt," *Books and Bookmen*, 14 (Sept. 1969), 20-22.

[2]In her interview with Hardin, Drabble remarked that she does not subscribe to any particular religious faith (p. 276) and said, "I'm really not quite sure what my theological position is" (p. 284).

[3]Margaret Drabble, *Arnold Bennett* (London: Weidenfeld and Nicolson, 1974), p. 13.

[4]See Hardin, p. 277; Le Franc, p. 21: and Mel Gussow, rev. of *The Ice Age*, by Margaret Drabble, *New York Times Book Review*, 9 Oct. 1977, p. 7.

[5]Valerie Grosvenor Myer, *Margaret Drabble: Puritanism and Permissiveness*, Vision Critical Studie [London: Vision Press Limited, 1974).

[6]John Marlowe, in *The Puritan Tradition in English Life* (London: The Cresset Press, 1956), explains,

> Puritanism and Methodism were both based on an individual approach to God, without the intermediary of a priest. The Puritans sought to approach God through the Holy Spirit as revealed in Scripture, the Methodists through Jesus Christ as revealed to the human heart. (p. 45)

George M. Stephenson, in *The Puritan Heritage* (New York: MacMillan, 1952), observes, "The vitality of Puritanism was derived from a study of the Bible. It became the sole reading of the household" (p. 15).

[7]In Barbara Milton, "Margaret Drabble: The Art of Fiction LXX," *The Paris Review*, No. 74 (1978), Drabble states:

> What I'm perpetually trying to work out is the relationship between coincidence and plan. And in fact, I have this deep conviction that if you were to get high up enough over the world, you would see things that look like coincidence are, in fact, part of a pattern. This sounds very mystical and ridiculous, but I don't think it is. I think that I, in particular, and maybe certain other people have a need to perceive this pattern in coincidence. It may be that psychologically we're so afraid of the unpredictable, of the idea of chaos and disorder, that we wish to see order. (p. 62)

[8]Hardin, p. 284.

[9]John Updike, "Drabbling in the Mud," rev. of *The Realms of Gold*, by Margaret Drabble, *New Yorker*, 12 Jan. 1976, p. 88.

[10]In her interview with Barbara Milton, Drabble explained this view:

Take the fact that you should bump into somebody after ten years on your birthday after having last seen them at your birthday party. This is a coincidence, but it appears to have a meaning. We know it's superstitious, but so many times in my life I've had coincidences like this that I'm driven to look for another underlying meaning. (p. 62)

[11]Margaret Drabble, *The Millstone* (New York: Morrow, 1966), p. 74. This book has also been published under the title *Thank You All Very Much* (New York: Signet, 1969). Throughout the rest of this essay, references to Drabble's novels will be cited parenthetically in the text, using the following abbreviation scheme:

A Summer Bird-Cage (New York: Morrow, 1964)	(SBC)
The Garrick Year (New York: Morrow, 1965)	(GY)
The Millstone (New York: Morrow, 1966)	(M)
Jerusalem the Golden (New York: Morrow, 1967)	(JG)
The Waterfall (New York: Knopf, 1969)	(W)
The Needle's Eye (New York: Knopf, 1972)	(NE)
The Realms of Gold (New York: Knopf, 1975)	(RG)
The Ice Age (New York: Knopf, 1977)	(IA)

[12]Le Franc, p. 21.

[13]Milton, p. 48.

[14]Margaret Drabble, "Crossing the Alps," *Mademoiselle*, Feb. 1971, pp. 154-55, 193-98.

[15]James Vinson, ed., *Contemporary Novelists* (New York: St. Martin's Press, 1972), p. 373.

[16]Margaret Drabble, *Wordsworth*, Literature in Perspective (London: Evans Brothers Limited, 1966), p. 123.

[17]Margaret Drabble, "The Gifts of War," in *Winter's Tales*, 16, ed. A.D. MacLean (London: MacMillan, 1970), pp. 26-27.

[18]Ralph Tyler, "Margaret Drabble," *Bookviews*, Jan. 1978, p. 7.

[19]Hardin, p. 282.

[20]Hardin, p. 282.

[21]For particular examples of humor in *The Realms of Gold*, see Judy Little, "Humor and the Female Quest: Margaret Drabble's *The Realms of Gold*," *Regionalism and the Female Imagination*, 4 (Fall 1978), 44-52.

[22]Milton, p. 57.

Romantic Revisionism in Margaret Drabble's
The Realms of Gold

Pamela S. Bromberg

The ideas and images of Romantic poetry form the backdrop for the romantic quest which the very modern heroine of *The Realms of Gold* pursues to the novel's ironic twentieth century resolution. A larger, more ambitious work than any of Margaret Drabble's six earlier novels, it leaves behind their issues of feminist social identity in order to search for an answer to broader questions about human fate and purpose. Though it displays the female protagonist characteristic of contemporary feminist literature, the novel is really about Everyman, as well as Everywoman. A woman's hand is perhaps evident in the exaltation of maternal love, and in the insistence upon mankind's earthly roots as limitations upon the imaginative graspings of the Romantic poets for salvation. But Drabble's revisionist adaptation of Romantic concepts to accommodate the depravity of human nature and the palpable horrors of the twentieth century, while yet retaining a reservoir of hope, reaches beyond ideological issues of feminist social identity to the larger question of man's first disobedience. Like the Romantics, she alludes to Milton, whose puritan heritage and religious vocabulary she shares, to pose her questions about the justice of human destiny and the loss of paradise.[1] The problem for Drabble, who rejects belief in either supernatural or imaginative apocalypse, then becomes how to retain the Romantic affirmation of human life without denying the reality of a universe of death: "How can one make a friend of death, how can one accept graciously the wicked deal?"[2]

The novel's argument with Romanticism begins in its title, taken from Keat's early sonnet, "On First Looking into Chapman's Homer," and emblematic of the Romantic belief in the recovery of an inner paradise through the poetic imagination. Though Drabble honors the power of imagination as an agent of discovery, she repudiates the idea that paradise has ever existed except as the overvalued Wordsworthian childhood. Instead she swerves away from all but the late Keats by her final insistence that our necessary accommodation to natural cycle and mortality must lead to the discovery of identity, and whatever salvation exists, within family and community, and the mysterious forces of love that bind them together. Drabble's revaluation of Wordsworth is both more covert and more extensive. She is drawn to his internal conflict about knowledge of

the mortal self because his struggles against doubt reflect her own. The novel's central theme of the memorable moment of joy originates in Wordsworth's theory of "spots of time." But Drabble believes that to be valuable such moments must be shared with others and firmly balanced against knowledge and acceptance of natural process.

Drabble's interest in the Romantics is evident in her earlier fiction and criticism. She published a monograph entitled *Wordsworth* in 1966, and there are specific allusions to Keats and Wordsworth in all but two of the first six novels.[3] More recently, she has used passages from Milton's *Areopagitica* and Wordsworth's poem on Milton, "London, 1802," as mottoes for her eighth novel, *The Ice Age* (1977) and includes a fairly lengthy conversation about Wordsworth's poetry in her latest novel, *The Middle Ground* (1980).[4] One sign of the maturation Emma Evans gains by the moral struggle she undergoes in *The Garrick Year* (1964) is her new found capacity to respond with real tears to the early poems of Wordsworth, poems which Drabble later commends in *Wordsworth* for their compassionate insight into the minds and lives of their homely subjects. Published as part of a popular series called "Literature in Perspective," this deliberately straightforward, occasionally over-simplified, account of Wordsworth's life and poetry is accordingly limited in its critical scope and ambition, yet it does reveal both what attracts and distresses Drabble in her predecessor. She values the *Lyrical Ballads* for their psychological realism and moral sympathy. Her introductory comment on *The Prelude* is particularly revealing: "In some ways . . . it is more like a modern psychological novel than a poem."[5] Clearly, Drabble has found in Wordsworth a literary precursor, despite their disparate genres.

What most fascinates her in the monograph is the problem of Wordsworth's decline. She focusses her study on the question of why Wordsworth lost his faith in the salvation of the poetic imagination and the values of political and social liberalism and became, for the second half of his life, pious, respectable, and mediocre as a poet. She accounts partially for the loss of Wordsworth's moments of vision and poetic genius as the natural waning of exuberance that accompanies middle age. She suspects, too, that the responsibilities of a wife and family, and the example of the tormented, profoundly unhappy Coleridge, may have contributed to Wordsworth's increasing emphasis on the serenity and safety of spiritual resignation. Though Drabble's sympathies clearly lie with Wordsworth's earlier political and social views, she is willing to grant the loss of his poetic inspiration as the price for a happier life. But she believes that inner peace eluded him: ". . . when we read of Wordsworth's later life, we cannot feel that we are reading about a happy man; the picture we get is of a brooding, solitary, disillusioned and often profoundly miserable man." (p. 134). She sees the late Wordsworth as a man bereft of the visionary joy of his youth and, despite protestations to the

contrary, unable to find real consolation, either in a philosophy of social resignation or in his family and friends.

Drabble pursues this question no further in the monograph. But she takes it up again in *The Realms of Gold*, where, by revisionary exploration of the form of Wordsworth's moments of vision and by the development of an ironic counter-myth to the journey toward poetic identity and paradise that he describes in *The Prelude*, Drabble suggests that Wordsworth's youthful faith in the poetic imagination failed him because it was too extravagant. In his attempt to celebrate a secular version of Milton's "paradise within" in the imaginative union of the human mind and its natural home, Wordsworth slighted the conditions that Milton made the starting point for his epic: "Death . . . and all our woe." Drabble, conversely, insists on the natural limitations which circumscribe all human quests for happiness. Frances Wingate's journey of self-discovery is completed in 280 days, the timespan of human gestation. The novel opens with loss, depression, and illness, and closes with two funerals. One of its central themes is hereditary depression; among its main characters are a survivor of the Holocaust and a young parent who commits infanticide along with suicide. Yet, it is a comic, affirmative work. Drabble argues that saving moments of joy may be "salvage (d) . . . from the sentence of death." (p. 350). And such moments are found, not in Wordsworth's solitary confrontations with the imagination in its relationship to the natural world, but in human relationship and community.

II

Though *The Realms of Gold* is structured as a contrapuntal composition of four narrative points of view, the form of the novel as a whole is governed by the plot of the central character, Frances Wingate, who begins her narrative as an archetypal Romantic quest hero.[6] Like Wordsworth in *The Prelude* or Los in Blake's *Jerusalem*, she embarks on an inner voyage of self-discovery in search of paradise.[7] However, Drabble views the Romantic vision ironically; she is particularly wary of the dangers of self-absorption and solipsism which are dramatized in *The Realms of Gold* in two of Frances's relatives, her nephew Stephen Ollerenshaw and her distant cousin David Ollerenshaw. Because Frances is a "lucky woman" whose story is destined for a pointedly "happy ending," she escapes the disillusionment that Drabble sees in the late Wordsworth by abandoning excessive expectation. (pp. 156, 352). Her quest diverges from the Romantic myth when she realizes that paradise cannot be regained; at that decisive point in the novel, after the frustrations of her Wordsworthian attempt to recover the paradisal memories of her childhood, Frances's quest evolves into a more classical, externalized

form. She becomes a Twentieth century female Ulysses, whose voyage home restores the community as well as her divided self. Her search for self-discovery culminates not in apocalypse or "revelation," but in acceptance of the natural cycle which bounds the novel. (p. 350).

While *The Realms of Gold* dramatizes only these two stages in Frances's quest, there is, in fact, an earlier stage that predates the novel's narrative time and is told briefly through flashback. This first stage corresponds to the early stage in the life cycle of the Romantic poet when he discovers and celebrates his poetic identity and the power of the imagination to create new worlds, either through the prophetic unveiling of a natural paradise proclaimed by Blake in *The Marriage of Heaven and Hell* and Wordsworth in the Prospectus to *The Recluse* ("Home at Grasmere," 754-860), or through the more strictly aesthetic epiphany that Keats describes in "On First Looking Into Chapman's Homer." Comparing the experience of reading Homer in Chapman's English translation to the astronomer's discovery of a new planet, the explorer's discovery of a new ocean, Keats enacts a journey toward discovery by the power of imagination, which reveals new worlds, or "realms of gold," just as the telescope and explorer's ships do. Frances has embarked on an analogous journey of discovery in her professional role as an archaeologist in search of "a utopia in the past." (p. 121). Frances's lover Karel Schmidt, a historian, and her cousin David Ollerenshaw, a geologist, are also Romantic voyagers into the past. Karel, a lucky survivor of the Holocaust, specializes in the history of agriculture in the late eighteenth century and explains his attachment to the rural past as a way of trying to reclaim "the lost land of the Jew." (p. 120). David digs into the earth's past in search of mineral riches. Each hopes to find some answer to the failures of the present in their ever-lengthening views into the processes of its formation.

Frances succeeds in making an important discovery, the lost Saharan trade city of Tizouk. Like Keats, Drabble sees the imagination as the universal faculty of discovery, for poets, historians, geologists alike. As Frances recalls the process that led her to Tizouk, she remembers the sudden moment of "revelation" when she knew that "the city of her imagination" existed under the sands of the desert. "I must be mad, she thought to herself. I imagine a city and it exists. If I hadn't imagined it, it wouldn't have existed." (p. 29). In the delusive flush of self-satisfaction she experiences after finding Tizouk Frances leaves Karel, choosing the individual, self-controlled fulfillment of work and imaginative activity over the messier, more threatening, more complicated satisfaction of sexual love. Yet, though Frances loves her city as the poet loves his creation, that love for the created or found object does not sustain her. After leaving Karel, Frances experiences the pain of unexpected loss. The novel opens as Frances begins to realize both that she misses Karel and that the

imagination is dangerous. The mind can "conceive of desolation" and depravity as well as buried cities of gold. (p. 29). Her desert people in Tizouk were "men of peace, not war," but the Phoenicians they traded with practiced infanticide. Drabble here poses the problem of evil, both in terms of culture and morality and in terms of the individual's experience of loss and mutability.

This crisis of disillusionment and loss initiates the second stage, or internalization, of Frances's quest for paradise. Alone in a hotel room in Naples, where the next day she will deliver a lecture on her triumphant discovery of Tizouk, Frances feels not joy but undirected despair and anxiety.[8] She locates the source of her depression within her own confused, divided self and begins a painful process of self-examination comparable to the purgatory that Wordsworth enters after his loss of faith in the French Revolution. Frances recognizes that her unhappiness is linked to her rejection of Karel but not until she has achieved a full understanding of herself will she be ready for a reunion with him. Thus the postcard she mails telling Karel she loves and misses him remains at the bottom of the letter box for nine months because of a postal strike, and Frances, who mistakenly believes he has forsaken her, must continue to search for the origins of her despair.

Frances's journey of self-discovery follows the classic form of descent and ascent.[9] She must undergo the mental and physical agony of the death of her old self in preparation for renewal and rebirth. The day following the nameless depression she awakes with a toothache so excruciating it prompts consideration of suicide. Teeth serve in *The Realms of Gold* as recurrent symbols of mortality, the visible, vulnerable reminders of our skeletal selves. When codeine fails to dull her pain, Frances repeats sonnets by Milton and Wordsworth, "On His Blindness" and "Westminster Bridge," as an anodyne, recalling that this poetic cure had, in the past, worked equally well for the pains of childbirth and undesired sexual intercourse with the husband she later divorced. (This may be the ultimate female put-down of male literary precursors.) But Milton and Wordsworth are ineffectual in Frances's present crisis; their poems of resignation and calm do not console her, spiritually or physically.[10] Instead, the toothache becomes emblematic of the ultimate pointlessness of all human effort.

> The effort of comprehension was beyond her, she felt like despairing; love and understanding were beyond her . . . The world was drying out, and everything she touched would die. (p. 54).

The extraction of her "wicked" tooth cannot cure her loss of faith. Physical torture is followed by mental when she returns to England to await Karel's reply to the card and is greeted by silence. She abandons

hope, contracts flu, suffers yet another tooth extraction, and is finally hospitalized for removal of a lump in her breast. Drabble's emphasis on the physical, as well as mental, deterioration of Frances Wingate is revisionary, in keeping with her central thematic insistence that we cannot escape the natural cycle and the undignified frailties of the flesh. Frances's fall is correspondingly arrested both by biological good fortune— the lump is benign—and by the saving power of memory that Wordsworth celebrates in his poetry.

A substantial portion of Frances's narrative consists of flashbacks to the past, appropriate for an internalized quest to see what combination of "heredity and environment" and luck has made her, and to recover the loss of her love. In fact, there is a double strand in the narrative: the present time of her travels, which take her in a series of three progressive cycles from overseas back to Tockley, her ancestral home; and a wide range of remembered moments from her past, recovered by the mental activities of self-examination and association. Memory, therefore, is the faculty used to search for self-understanding. What Drabble takes from Wordsworth is his theory of memory's operation and power. Frances recalls experiences of heightened awareness that work like Wordsworth's "spots of time." By a "conscious effort . . . to remember moments" Frances gradually works herself out of her depression, and begins the movement of ascent in her inner journey. She recollects at length a "moment of intense joy" when she and Karel had shared a cheese and tomato sandwich, fully conscious of their bliss.

> . . . it occurred to her that she had never been as happy in her life as she was there, sitting at that shabby table gazing through a white net curtain at the road, with two half-eaten sandwiches in front of her, signifying union. To have it was one thing; to know one was having it was something else, more than one could ever have hoped for. (p. 66).

Drabble's moments of joy resemble Wordsworth's spots of time as paradisal experiences which furnish memories that "retain/A renovating virtue." (*The Prelude*, XII, 209-210) The content of Frances's memory, however, makes an ironic commentary on Wordsworth's central concept of the solitary mind in communion with nature. As in Wordsworth's poetry, visual perception often acts for Frances as the initial focal point for recollection, but then her memories depart from the landscape to the human relationships which originally invested the particular spot with its importance. For Wordsworth the spot itself is important, for the thoughts it once inspired.

After the redemptive memory of the shared sandwich comes a succession of others that advance Frances's quest by illuminating her conflicts about Karel, her family, work, and love.[11] She now recognized the choice

of the individual achievement of work over the vulnerability and risk of love as a destructive victory of fear and anxiety, what Blake would call selfhood, over Frances's healthier, more integrated, capacity for intimacy and commitment. This insight does not conclude her quest, however. Though Karel, in truth, remembers Frances even as she remembers him, he has yet to receive the delayed postcard and return. Thus Frances still feels the weight of her solitude.

She seeks release from the burden of her self-division by making a pilgrimage into her personal past. She returns to Tockley and Eel Cottage, her paternal and childhood summer home. There she expects either to recapture the paradise of her childhood or to confirm the fear that her depression is genetic, too deeply rooted and organic to yield to self-discovery. She worries that she has inherited "some incurable and ratlike family disease" from her father's family, the Ollerenshaws: "the same illness that had killed her sister, driven Hugh her brother manic to the bottle, and driven her father into a world of silent brooding." (p. 97). She needs to discover whether madness is genetically programmed and inevitable, or may be conquered by spiritual struggle and self-knowledge.

Frances remembers Eel Cottage as a "paradise, like the original garden,": which she lost, not through original sin, but through the inevitable natural processes of her maturation and her grandparent's illnesses and deaths. (p. 102). She recalls with particular fondness a drainage ditch at the end of her grandfather's potato field, "a whole unnecessary and teeming world of creation." (p. 103). This ditch, a self-contained miniature cosmos, was a natural paradise, comparable to Wordsworth's Grasmere. Frances finds, however, that her paradise cannot be regained. In the years since her childhood the landscape has changed; suburban sprawl has metastasized in Tockley; the beloved drainage ditch has become a polluted putrescence; bubbles made by diving newts, particular signs of divine blessing and natural innocence, have been replaced by the bubbles of decay. Memory can only help discover, not reclaim, the past.

At this moment of crisis Wordsworth comes dramatically to the surface of the novel. On the way back to her hotel in Tockley Frances visits an exhibit of English agricultural instruments at the local museum, where the display of an eel stang reminds her of the leech gatherer in "Resolution and Independence," Wordsworth's great crisis poem. Drabble's reading of stanzas iv-vii in *Wordsworth* is instructive.

> . . . he seems to imply that it is the very intensity of joy itself, the violent gladness of the young poet, which wears him out and plunges him later into sorrow and misery. He fears that the moods of exaltation described in *The Prelude* may be paid for in the end . . . He seems in this part of the poem to be foreseeing the loss of his own powers, and to be dreading the fate of unseeing mediocrity in store for him. (p. 119).

54

The failure of her effort to regain paradise has brought Frances to a comparable point of crisis. Yet she responds not with the depression and anxiety Drabble sees in Wordsworth. Rather, at this critical point in the novel Frances avoids Wordsworth's despair by recognizing that the real problem is the delusive Romantic dream itself, the quest for a permanent state of bliss.

The realization that her personal paradise has been irretrievably lost prompts the understanding that her professional quest cannot yield that salvation either.

> The pursuit of archaeology, she said to herself, like the pursuit of history, is for such as myself and Karel a fruitless attempt to prove the possibility of the future through the past. We seek a utopia in the past, a possible if not an ideal society. We seek golden worlds from which we are banished, they recede infinitely, for there never was a golden world, there was never anything but toil and subsistence, cruelty and dullness. (pp. 120-121).

In this central passage in the novel Drabble repudiates the exuberant faith in the apocalyptic power of the imagination to create golden worlds that Keats expresses in his sonnet. The need to believe in the illusion of paradise lost and to justify the existence of evil has resulted in self-deception and professional casuistry. Frances thinks of her own field: ''. . . we unearth horrors, and justify them. Child sacrifice we label benevolent birth control, a dull and endless struggle against nature we label communion with the earth.'' (p. 121). But at the same time that Frances relinquishes the dream of finding paradise and accepts the reality of evil and suffering, she also begins to lose her fear of psychological determinism, a twentieth century form of original sin. And conversely, she sees her own professional success not as the badge of spiritual election but as the inheritance of generations of upward mobility in the Ollerenshaw family. At this point in the novel, when she abandons the quest for paradise and begins to find freedom as well as limitation in her genetic inheritance, Frances's quest moves into its third, more classical stage, an ironic commentary on the Romantic hope of the earlier phases.

In the final stage of Frances's odyssey the romantic concept of an inner journey toward self-discovery is undercut by the elegant ironies of the novel's plot. The action of her individual voyage toward identity is subsumed in the larger structure of the plot, which uncovers an undreamt-of network of kinship among the central characters. Frances completes her quest not in Tockley, where her search for a personal past was frustrated by the loss of the rural Wordsworthian landscape, but in the fictional African country of Adra. There, at an interdisciplinary conference on Saharan resources, she resolves her identity crisis with the emphatically fortuitous discovery of a hitherto unknown relative, her distant cousin, David Ollerenshaw.

55

Just as she is about to revert to her old self-destructive modes of behavior, to succumb to the temptation of idle sexual competition and conquest, Frances forestalls the seemingly inevitable betrayal of her love for Karel with "one last conversational gambit," a remark about the flatness of the Saharan landscape that reveals her kinship with David through his answering mention of Tockley. Heredity, environment, and luck converge equally to effect this climax. The discovery of her cousin makes Frances realize that what she really desires is her love for Karel: "There was no point . . . in being alone." (p. 263). She chooses kinship, family, and sexual love—identity in community—rather than solitude and the endless quest for individual transcendence and salvation. When she makes that choice the stone of anxiety and self-division that has ached in her chest since the novel's beginning finally dissolves.

The climax of Frances's quest takes place ten days into the conference, thus coinciding exactly with the arrival of the postcard she had mailed to Karel at the beginning of the year. Furthermore, that postcard is lifted from its nine-month resting place in the letterbox at the precise moment that Karel achieves a comparable illumination about himself, his past, and his love for Frances. Drabble draws attention to this second coincidence by defending its plausibility in a disarmingly naive address to the reader. (p. 218). The naivete is, of course, an ironic dramatic pose. The postcard is merely a signal for a far more extensive web of coincidence, which is in turn tied into the web of kinship that it helps to uncover. The novel's revelation of the enormously complicated, partly accidental process by which character and fate are formed constitutes perhaps its fundamental argument against the illusion of romantic self-determination. It also frees Drabble from her inversely related fear of Calvinist and Freudian predestination.[12]

Frances's individual quest is eclipsed still further by the cosmic power of luck and kinship as more of her unknown family past surfaces and makes its claim on her. Just as Karel sets off to Adra in response to the postcard, Frances is called back to Tockley by the scandalous discovery of the starved corpse of her great aunt Constance Ollerenshaw. As Frances arranges for the funeral of this mysterious, reclusive relative, she makes yet another unexpected discovery, her own atavistic relationship to Constance, a woman who two generations earlier, "might have been one of the lucky ones," but was not quite lucky enough to be born at the right time and place. At the end of the novel Frances purchases Constance's cottage, moves in with Karel and their two sets of children, and tells people: "it may not be paradise, but it suits me." (p. 352). In *Fables of Identity* Northrop Frye writes of the ironic epics of the twentieth century that, although "creative time is the hero . . . it is subordinate to clock time, and the only paradise it can reach is a lost paradise."[13] Frances's personal and professional quests lead not to apocalypse, but to nature and cycle.

She finds identity within family and community, perceiving that the only possible continuity or immortality belongs to the species, not the individual.

Contance's death and funeral complete the novel's major action of the discovery of kinship by providing the occasion for the culminating assembly of the four main characters. Frances discovers yet a third unknown relative, her cousin Janet Bird, and then Karel and David join them from Africa. In this ironic epic Aunt Constance's funeral acts as the counterpart to marriage, the celebratory ritual of the traditional comic aspect. The loss of an individual, and in this case an unknown and unmissed individual, reveals the immortality of familial generations.

III

Frances Wingate's quest for self-discovery and salvation furnishes the chief structure for Drabble's reconsideration of the Romantic tradition in *The Realms of Gold*. Within this narrative framework Drabble also focusses more specifically on Wordsworth's theory of memorable moments or "spots of time." We have seen how Frances's memories of "the good times" shared with Karel enable her to reverse her fall into self-absorbed despair. Each of the novel's other three main characters also experiences or recalls at least one such moment of intense awareness and insight.[14] Viewed as a group these moments form a clear set of variations on their Wordsworthian prototypes. David Ollerenshaw's recollection of a mountain landscape in the Hebrides verges on parody of its originals, the climatic epiphanies of the Simplon Pass and Mount Snowdown in Books IC and XIV of *The Prelude*. Janet Bird's unexpected, awestruck vision of a sunset is strongly evocative of Wordsworth's late poem, "Composed Upon an Evening of Extraordinary Splendour and Beauty," but with critical differences. Frances Wingate's moments of joy are the least Wordsworthian in form, content, and spirit; they are comic, they originate in love, and they celebrate the fecundity of all organic life rather than the creative power of the solitary imagination. Karel recalls, with a difference of perspective but equal joy, the same moments as Frances. The essential point in this series is that only the good moments experienced together by Frances and Karel function as a declaration of faith. The more Wordsworthian visions of David and Janet do not afford any lasting hope or redemption.

David's recollection of the moment in the Hebrides takes place, ironically, as he defends the potential destruction of his remembered landscape for the sake of oil in the North Sea. Twentieth century technology, especially nuclear physics, radically undercuts the Wordsworthian premise that nature is bigger than man. Like Wordsworth's cen-

tral mountain visions in *The Prelude*, David's epiphany begins with a state of expectation and heightened awareness as he ascends a hill and beholds a natural vision that almost, but not quite, undergoes a supernatural transformation. Imagination then takes over, creating an inner vision of paradise from the landscape.

> He walked through the flowers as though it were the first morning, and through a little gate and up a hill . . . he climbed on, upward, to see the sea, . . . and there at the top lay a view more splendid, more wild, more various than anything he could have imagined in the darkness of the night, for there before him lay a sea full of small islands, rising gray seals, raising their backs like dolphins from the water, heaving and burgeoning, as far as the eye could see . . . The landscape seemed alive, as though seething in the act of its own creation . . . The Isles of the Blest, he said to himself. Uninhabited, ancient. Out they stretched forever, to the north and the west, to the ultimate reaches of man's desiring, where man was lost, and nothing, at the edges of the world. (p. 50).

David's vision concludes, characteristically for him, with the dream of an infinitude of perspective in which man ultimately vanishes.

David's vision in the Hebrides provides a key to his enigmatic role in the novel, as well as a central element in Drabble's reassessment of Wordsworth. Exactly midway throught the novel Drabble intrudes into the narrative to reflect on the fates of her two antithetically balanced female characters and then to confess that David Ollerenshaw "was intended to play a much larger role in this narrative, but the more I looked at him, the more incomprehensible he became, and I simply have not the nerve to present what I saw in the detail that I intended." (p. 176). Could it be that Drabble here masks her concern, not about David, but about her great literary precursor? She would be understandably reluctant to engage in revisionist criticism of Wordsworth if the insight which she lacked the "nerve" to articulate were that the great poet lost his vision because after the admirable realism of the *Lyrical Ballads* it became too remote from the human life that he purported to write about.[15] Yet this intrusive comment from the author can have little other purpose. And David Ollerenshaw, with his geologist's perspective down the ages, his attraction to sublime landscapes and his solitary existence, fills the bill as an updated cartoon of Wordsworth.

David resists comprehension because he resists intimacy. Though perfectly sociable he is a solitary, a geologist who prefers the silent company of the inanimate world. David has made a career of the solipsism that Frances renounces and their other cousin, Janet Bird, longs to escape. Rocks offer him an escape from the flesh, with its guilt and vulnerability. While Frances carries Karel's false teeth in her brassiere to guard her virtue and real teeth and bones in her pockets as "lucky charms," David keeps a piece of stream topaz, preferring the purity of the

58

inorganic. (p. 335). Love for the object world compensates for his emotional isolation. We may see David, then, as a version of the earlier poetic self, "the heart that lives alone, /Housed in a dream, at distance from the kind!'', whom Wordsworth bids farewell in the penultimate stanza of "Elegiac Stanzas.''

Geology gives David the safety of the "long view of time,'' which diminishes the individual human life, even the life of all mankind, and offers the consolation of "order in the Universe.'' (p. 170). The psychological conflicts of his youth shrink in the enormity of geological perspective. David has formulated a personal religion of geological eschatology, his particular form of "the faith of scientific determination.'' (p. 179).

> . . . it would be his idea of heaven to sit on an observation platform somewhere and watch the earth change . . . Man's life span was too short to be interesting: he wanted to see all the slow great events, right down to the final cinder, the black hole. (pp. 178-179).

It is here, in his reliance on the serene consolation of the dwarfing perspective of geological sublimity as an answer to the anxieties of organic experience and consciousness of mortal limits, that David most resembles Wordsworth. At least one critic has detected a similar strain of escapism in Wordsworth, who gains "detached composure'' about "the unsettling tug of immediate human concerns'' from "the contrast of human life with the immensity of nature.''[16] In *Wordsworth*, intended to enhance his status with "ordinary'' readers, Drabble stops short of this conclusion, though she emphasizes the eventual failure of Wordsworth's relationship with nature. However, she does make clear in *The Realms of Gold* that David Ollerenshaw's love for the natural world is a sublimation of his repressed sexual energy and related fear of death.

Most importantly, David's solution to his family's legacy of depression does not work very well. His rationalist effort to safely distance himself from human life succeeds only by a denial of his own flesh and feelings that occasionally breaks down. Of the group that attends Constance's funeral David alone is depressed by it, as he realizes that his chosen solitude is lonely and vulnerable.

> . . . he alone of all of them was likely to die, like Constance, quite alone, and quite unmissed, and the prospect had very slightly alarmed him. It was all very well, to take the long view. He had a large drink. There would be bad moments, before the long view paid off. (p. 339).

Though the "long view'' fosters a healthy appreciation for the enormity of the past and the complexity of all origins, it ignores the dilemma of the individual, self-conscious human organism. Thus, while David's epiphany of "the Isles of the Blest'' is memorable through its link with

the landscape in the Hebrides, he cannot recall it for comfort at Aunt Constance's funeral because it delusively transcends the natural boundaries of birth and death.

At the same time that Drabble employs David Ollerenshaw to dramatize the limitations of Wordsworth's vision, she also uses this character more generously to acknowledge her debt to Wordsworth as her precursor. David stands in the same relation to Frances Wingate as Wordsworth does to Margaret Drabble. Harold Bloom says of poetic influence that it is a "family romance."[17] So is *The Realms of Gold*. We must recall the pivotal role that David plays in the completion of Frances's quest. His "romantic arrival" from the isolation of the Sahara desert makes possible Frances's salvation through the discovery of their kinship. Drabble, likewise, must recognize her kinship with the Romantic vision of Wordsworth, and his descendant Keats, before she can define her own identity as a post Romantic ironist who sees salvation not in imaginative communion with nature, but in the natural, procreative immortality of the human generations, fueled by the same biological life-force that programs the octopus that Frances marvels over in the novel's first paragraph.

Janet Bird's moment of heightened perception is intermediary between the visionary transcendence of David's and the comic sexuality of those shared by Frances and Karel. Her vision of the sunset, though Wordsworthian in its solitary apprehension of natural splendor, includes at its center a quiet reminder of death as natural process, instead of the typical Wordsworthian evocation of death in terms of the imagination's alienation from the natural objects of its desire.

Janet is one of the most extreme and fully realized versions of a whole line of female characters in Drabble's novels who suffer painfully from their failure to heal the puritanical rift between body and mind and to emerge from their aridly self-protective emotional solitude to experience the salvation of sexual love. Janet lives in a joyless limbo of passive negation, trapped in a marriage of mutual fear and hatred, depressed and lonely in her isolation. She seems as victimized by herself, her world, her luck, as self-effacing and repressed in her outward life, as Frances is, antithetically, triumphant, energetic and exuberant in hers. Janet has only one companion in her solitude, her infant son Hugh. Maternal love is, throughout Drabble, an agent of salvation both because she sees it as "an image of unselfish love" and because it represents the fulfilment of biological destiny.[18] Drabble understands and enjoys, as perhaps few other late twentieth century women writers do, the profound experience of rightness that many women find in their generativity.

Hugh is not, however, the only grace which Janet's stingy fate has allowed her. Even Janet is granted the joy of an unexpected moment. Because she so thoroughly detests her life but can imagine no other, her

fantasies of salvation typically take the form of various scenarios of apocalyptic destruction that spare only Janet and Hugh for a new and blank future, "free—but free for what? She could not imagine." (p. 129). She expects no joy or change in her life. Thus when Janet reads a church poster quoting Psalm 131, "I will lift up mine eyes unto the hills: from whence cometh my help?", she reflects that in her life "there was no Lord, and there were no hills." (p. 127). Yet the psalm's words of promise continue to resonate in her mind, and later when Janet furtively steps into her backyard, she suddenly experiences a visionary moment as she beholds the sunset which moves her to a surprised acknowledgement of hope.

> As she straightened herself up, she caught sight of the huge sky, which was an amazing color, dark blue, with a foreground of dark pink and purple clouds, a whole heaven of them, spread like flowing hair or weed over the growing darkness. It arrested her. She stood there, and stared upward. It was beautiful, beyond anything. The two colors were charged and heavy, and against them stood the black boughs of the tree at the end of the small garden, where black leaves, left desolate, struggled to fall in their throes. The day before she has watched from the bedroom window a single leaf on that tree, twisting and turning and tugging at its stalk, in a frenzy of death, rattling dry with death, pulling for its final release. So must the soul leave the body, when its time comes. The amazing splendor of the shapes and colors held her there, the tea pot in her hand. I will lift up mine eyes, she thought to herself. I should lift them up more often. (pp. 149-150)

This vision of celestial glory echoes the astonishing, unexpected sunset that momentarily restores Wordsworth's lost "gleam" in his late poem "Composed Upon an Evening of Extraordinary Splendour and Beauty." (1817) In *Wordsworth* Drabble cites the poem for its passionate expression of "regret for lost power." (p. 134). Janet, who expects so little from her life, finds an unbidden joy in "the amazing splendor," notwithstanding the image of death at its center.[19] Wordsworth, who has perhaps expected too much in his youth, greets the equally unexpected and belated version of his middle age with reluctance, since it reminds him of his own "frail Mortality" and the loss of his capacity to see "the gleam." Though Janet's vision awakens her deeply repressed hope, the momentary loss of oppressive self-consciousness before natural beauty is not adequate as inspiration for any epic quest. In Drabble's novels only human relationship acts as the catalyst for self-discovery and salvation. At the end of the novel Drabble does suggest that Janet's fortunate discovery of her cousin Frances, who provides at least one flesh and blood answer to Janet's uncertainty about the uses of freedom, may help her to escape her life of negation.

Though the moments recalled by Frances diverge from the Wordsworthian model of solitary imaginative insight, they resemble Words-

worth's in their regenerative power. Her recollection of the bliss of a shared sandwich is typical in its homeliness and emphasis on the pleasures of the flesh. Still earlier in the novel another moment of joy, recalled by its Wordsworthian association with a specific place, awakens Frances's desire to return to Karel. On her preceding trip to Naples she and Karel had gone for a drive in the country which led not to the scenic landscape they hope for but to a flat, muddy swamp. There, in what seemed at first to be a sterile silence they became aware of "a kind of honking and squawking and bubbling, a comic and sinister sound" coming from a large piece of drainage pipe. (p. 19).

> . . . there they saw a most amazing sight. Hundreds and hundreds of frogs were sitting down that pipe, and they were all honking . . . Huge big ones, tiny little ones, fat ones, skinny ones, they all sat and honked. Down the pipe they sat, as happy as can be, croaking for joy. Karel and Frances stared, awestruck, amused: the sight was repulsive and at the same time profoundly comic, they loved the little frogs and the big ones. (p. 19).

The memory of the frogs and the muddy lovemaking that followed that epiphany moves Frances to send the postcard to Karel, for it affirms the comic miracle of love and procreation that binds the human and natural worlds, the salvation of the flesh. Throughout Drabble's novels moisture and dirt symbolize the cycle of birth and death to which all life must submit. After Constance's funeral Frances and Karel recall their love for the frogs and then recapitulate their baptism in mud as they both slip and fall into the stinking slime of the decaying drainage ditch in Tockley. The site of Frances's former quest for paradise has been transformed into the locus of a comic immersion in the impurity of the organic. This ritual pratfall acts as an admonitory reminder of the limitations of the flesh; afterward Frances and Karel may finally enjoy their long-delayed sexual reunion.[20]

IV

But Drabble does not conclude the novel here with the comic assembly of its four main characters and the restoration of Frances's lost love. Constance's funeral, with its eighteenth century pastoral setting and festive gathering, is more an occasion for decorous rejoicing than grief. Drabble needs a darker version of life's unfairness, a more wrenching and deeply felt experience of loss, against which to project the limited and realistic optimism of Frances's lucky "happy ending." Therefore, she appends the twelve page coda of the nightmarish suicide and infanticide committed by Frances's nephew, Stephen Ollerenshaw. A secondary character in the novel, Stephen fulfills two primary thematic needs. As the worst case of the Ollerenshaw family disease, a depressive who suffers from the lack of

a "will to live," Stephen's terrible bad luck confirms the reality of its opposite in Frances; the irony of his tragedy makes realistic her equally ironic romance.

Stephen is also the ultimate failed Romantic. His need for self-determination is so absolute that it cannot be fulfilled. Stephen falls from a confused, drug-induced and dangerously delusive dream of paradise and immortality all the way into the demented abyss of the Romantic Spectre. He can see nothing beyond a universe of death. He is so obsessed by the frailty of the human organism and the inevitability of death that he sees only sordid futility in man's struggle to stay alive. He cannot bear the knowledge that he is subject to any order or power beyond his own will. So, like Empedocles—he admires the painting by Salvator Rosa—he seizes his own fate and kills himself to cheat death.

NOTES

[1]Drabble discusses her puritan upbringing in interviews with Nancy Hardin (*Critique*, 15 (1973), 286-288), Bolivar Le Franc ("An Interest in Guilt," *Books and Bookmen* 14, Sept. 1969, 20-21), and Dee Preussner ("Talking with Margaret Drabble," *Modern Fiction Studies*, 25 (1979-80), 575). Valerie Grosvenor Myer discusses Drabble's conflict about nonconformist theology in her first six novels in *Margaret Drabble: Puritanism and Permissiveness* (New York: Barnes and Noble, 1974), the only full-length study of Drabble.

[2]Margaret Drabble, *The Realms of Gold* (New York: Knopf, 1975), p. 346. Further references to this work will appear in the text.

[3]Except for Colin Butler's article, "Margaret Drabble: the Millstone and Wordsworth" (*English Studies* 59 (1978), 353-360), critics have ignored Drabble's relationship with the English Romantic poets. Butler attacks that novel's realism and what he sees as Drabble's related impulse in the monograph to make Wordsworth into more of a realist than he was.

[4]Margaret Drabble, *The Middle Ground* (New York: Knopf, 1980) pp. 211-215.

[5]Margaret Drabble, *Wordsworth* (London: Evan Brothers, 1966), p. 80. Further references to this work will appear in the text.

[6]In "Humor and the Female Quest: Margaret Drabble's *The Realms of Gold*" (*Regionalism and the Female Imagination*, 4, No. 2 (1978), 44-52. Judy Little sees Frances not as a female "hero" but in terms of the "Female Quest" of Demeter for Persephone. In her reading Little ignores the novel's male characters, and her interpretation of Frances as an already ascendRd Demeter disregards the facts of Frances's descent and quest for identity.

[7]In *Wordsworth* Drabble characterizes *The Prelude* as "a voyage of self-discovery, not a journey to a fixed destination." (p. 85).

[8]Drabble never names the city where Frances gives her lecture. She does identify it as a "steep naval city" with "one of the most famous views in Europe." (p. 36). A number of other details also support my guess that it's Naples. Certainly, Mary Lay is mistaken in her confusion of this city with Tizouk, the ancient trading city which Frances has unearthed from the Sahara. ("Temporal Ordering in the Fiction of Margaret Drabble," *Critique*, 21, No. 3 (1980), pp. 79, 80.)

[9]Northrop Frye, *Anatomy of Criticism* (1957; rpt. New York: Atheneum, 1968), pp. 318-319.

[10]I presume that "On His Blindness" is Drabble's short title for Milton's Sonnet XXII, "To Mr. Cyriack Skinner Upon His Blindness." Wordsworth was on his way (with Dorothy) to visit Annette Vallon and their daughter Caroline when he saw the vision of London at dawn that he recounts in "Composed Upon Westminster Bridge, September 3, 1802." (Dorothy Wordsworth's *Journals*, ed. E. de Selincourt. (London, 1941; rpt. Hamden, Conn.: Archon, 1970), pp. 172-173). It belongs to the same troubled period as "Resolution and Independence," and is noteworthy for the tranquillity that a long vista and quiet hour confer upon the usual London "hubbub" that so disturbed Wordsworth.

[11]The past that Frances here recalls, and comes to understand and forgive, is paradigmatic of the destructive struggles toward identity that the heroines of Drabble's earlier novels undergo.

[12]Drabble discusses predetermination and accident in her interview with Preussner (p. 567) and earlier, in "The Author Comments," says "Happiness can only be found in an accidental way." (*Dutch Quarterly Review of Anglo-American Letters*, 5, No. 1 (1975), pp. 35-38).

[13]Northrop Frye, "Quest and Cycle in *Finnegan's Wake,*" *Fables of Identity* (New York: Harcourt, 1963), p. 263.

[14]The idea of a blessed moment is widespread in Romantic and post-Romantic literature; Blake's "moment in each day that Satan's Watch Fiends cannot find," Browning's "good moment," Joyce's epiphany, and Woolf's moments of "ecstasy" comprise only a partial list.

[15]David Ferry makes this case persuasively, arguing that Wordsworth was always distant from humanity because of his intense need to escape consciousness of the human limits of mortality. See *The Limits of Mortality* (Middletown, Conn.: Wesleyan Univ. Press, 1959).

[16]David Perkins, *The Quest for Permanence* (Cambridge, Mass.,: Harvard Univ. Press, 1954), pp. 44-46.

[17]*The Anxiety of Influence* (New York: Oxford, 1973), p. 8.

[18]Interview with Preussner, p. 569.

[19]The inclusion of this image recalls Matthew Arnold's judgment that "Wordsworth's eyes avert their ken/From half of human fate." ("Stanzas in Memory of the Author of 'Obermann'," 53-54). However, Drabble explicitly rejects Arnold's interpretation in *Wordsworth* (pp. 145-147), citing the *Ballads* in particular for their "determination to look poverty and old age in the face."

[20]The delay is itself another ironic reminder of the paradoxical vulnerability of the flesh, a comic rendering of Keats' trope, "Beauty that must die." Karel arrives back from his unnecessary trip to Africa with a fever from an equally unnecessary cholera innoculation that makes him too sick to have sex with Frances.

[21]Joan Korenman argues that Drabble sees Frances's survival negatively, as the denial of Stephen's revelation of life's meaninglessness. Accordingly, then, Korenman regards Frances's happy ending as a last-minute disavowal of the novel's predominant pessimism. See "The Liberation of Margaret Drabble," *Critique*, 21, No. 3 (1980), pp. 66-70. But Drabble uses the term "revelation" ironically, in keeping with the novel's thematic rejection of religious and romantic ideas of apocalypse. Moreover, the happy ending is anticipated throughout the novel by Drabble's insistence on the possibility and potency of good luck.

Parables of Grace in Drabble's
The Needle's Eye

Arnold E. Davidson

Despite the dissolution of Empire, the near collapse of the country's economy, the bleak prospects for peace that have persisted since the end of World War II, the imminent approach of 1984, and other rather obvious hints of impending apocalypse, England has still managed to produce a number of contemporary writers who have concerned themselves with an ancient and apolitical problem: the problem of grace. What is it? Who has it? How is it apportioned, apprehended, measured, weighed? Such questions, by their very nature, cannot be conclusively answered, so various possible views have been advanced. These range from straightforward fictional expositions of traditional Christianity such as Evelyn Waugh's *Brideshead Revisited* (1945) through Graham Greene's studies of the human sinner as religious saint to the dark fictions of William Golding, who, in novels like *Free Fall* (1959) and *Pincher Martin* (1965), shows evil everywhere and the existence of good—and God—definitely in doubt.

Even in this fiction, however, "the age (has) demanded an image/Of its accelerated grimace." The positive religious affirmation that Waugh attempts in *Brideshead Revisited* rings less true than his more negative social satire. Waugh and the reader can both believe in the savagely sardonic vision that informs, say, *A Handful of Dust* (1937) or the later *The Loved One (1948)*, for the characters in these novels get pretty much what they deserve. But man's view of man's just deserts is not necessarily God's view, and therein lies the crux of the problem. Furthermore, in an increasingly complex world it becomes increasingly difficult to decide just what literary characters (not to mention real people) even on the social level deserve. Nevertheless, a number of contemporary British writers have employed modern society as mostly the backdrop for a much more problematic matter, the nature of God and the manner in which the incomprehensibility of His workings and judgments might be partly apprehended by fallible men. Man in society becomes the starting point for a leap of faith.

It is against this background that Margaret Drabble's *The Needle's Eye* can best be appreciated. To reduce a complex and multifaceted novel to a single, simple formulation, the book is, as its title implies, a parable—or, more accurately, a series of parables. As I will subsequently demonstrate,

66

these parables have an obvious social and psychological significance. What is not so clear is their religious significance. Thus *The Needle's Eye* can be seen as both an advance and a retreat from the prevailing mode of modern British religious fiction. To start with, the step from obvious paradox to suggestive parable is a step timely taken. Paradox presented too often declines into cliché. The saintly sinner and the believing doubter are by now both tired characters. And with respect to the latter figure, a Samson Agonistes really does require a wrestling opponent more imposing than his own lack of faith. Furthermore, Drabble is willing to suggest that her central character—Rose Verture Vassiliou, heroically determined to shape her life to fit the values in which Rose herself does not fully believe—may be mostly a neurotic woman who uses religion to hide her own shortcomings from herself. As another character in *The Needle's Eye* observes of Rose: "You've no idea . . . how absolutely wicked and selfish people are when they get hold of this idea of being good."[2] In short, the religious issues are, by their very diffuseness, more complicated in this novel than they are in the straightforward religious work of writers like Greene or Charles Williams.

If there is perhaps less to Drabble's heaven than is dreamt of in the philosophies of these other authors, there is certainly more to her earth. The religious implications of the book arise in a definite and believable context. Drabble obviously knows her England. Contemporary British society is so closely observed that, from one perspective, *The Needle's Eye* is a throwback to the great English social novels of the nineteenth century. There is a suggestion of Dickens in the scope of the novel, not to mention the law case that cannot resolve the issue that the law addresses; a touch of Trollope in the intricate twists and turns of the unfolding action. The novel, however, particularly calls to mind the later works of George Eliot, who also knew how intricately noble spiritual promptings and the necessarily imperfect reality of partly achieved vision intertwined. The imperfection of the achieving, Eliot and Drabble both show, reflects the dreamer and the dream—and the world in which dream and dreamer operate. More to the point, these various reflections illuminate one another. The religious and moral questions with which Drabble is concerned require a realistically rendered social setting. They arise in modern London, not in Lewis's Narnia or Tolkien's Middle Earth.

How then do humans exist physically and metaphysically in the modern city? The novel opens with an episode from London life, a dinner party, that suggests the equivocal answer, "well and badly." The meal is everything that it should be. The setting is a tribute to the taste and affluence of the host and the hostess; "the room . . . glowed diffusely, elegantly inhabitable, fashionably quaint, modern with a modernity that had no hard edges, no offence, no bravura in it" (p. 12). It would seem the

67

best of both worlds, the old and the new. Yet past and present conjoin in a slightly different fashion in the marriage of the host and the hostess, apparently so fortunate in their marriage. As one of the guests muses:

> For who could have guessed, watching the pair of them as they circle attentively with drinks and olives, so blending and agreeably harmonising with their choice in colours, their framed pictures by their own three rather talented small children, that this time a year ago they had parted for ever, with the great and customary acrimony that attends such separations? There had been much speculation both about their parting and their reunion: he himself had always had faith that a genuine affection had brought them back together, an affection supported not too ignobly by a reluctance to abandon so much comfortable bourgeois texture. (p. 12)

There are other sides to the social graces presented here, the shining surface of the successful party. Indeed, the party ends with the hostess anxious to be rid of her guests and then, as they prepare to depart, anxious to have them stay. "She could not bear to think of them all going away, their separate ways, and discussing with one another as they went her cooking, her house, her dress, her marital problems" (p. 36). After they are gone, "as she stood there, gazing into the debris of the sink, a wave of panic filled her: so pointless it was, such an evening, such a stupid life she led, such stupid frivolous aspirations" (p. 37). Yet it was a successful party, and at that party one of the guests, whose life seemed to him far more a dead end proposition than the dark musings of the hostess, meets a woman with whom he can fall spiritually in love. Much of the novel charts this process, the way Simon Camish begins to live again.

Simon, one of the main characters in the novel, early considers another matter central to the novel's social and religious focus, the divisions of wealth and class that reflect, on a larger level, the personal disjunctions that we see in the lives of most of the characters. Simon, on his way to the party, had forgotten to equip himself with an appropriate gift. But at a small store conveniently near his hosts' home he can purchase a bottle of wine. The situation is mundane enough but the meaning immediately expands. In front of Simon is another customer, a customer who lives just around the corner but not at all in the same world that Simon's friends inhabit:

> The woman was short and broad and she was wearing bedroom slippers. What raffish districts of London his friends inhabited: NW 1, this was, with all its smart contrasts. They depressed him unbearably, the well-arranged gulfs and divisions of life, the frivolity with which his friends took in these contrasts, the pleasure they took in such abrasions. It appalled him, the complacency with which such friends would describe the advantages of living in a mixed area. As though they licensed seedy old ladies and black men to walk their streets, teaching their children of poverty and despair, as their pet hamsters and guinea pigs taught them of sex and death. He thought of these things, sadly. (p. 9)

The matter of manners (and in many ways *The Needle's Eye* is a novel of manners) extends considerably beyond the bottle of wine that propriety requires. At issue here are other customs of the relatively rich—their proclivities for seeking "atmosphere" and economical housing in run-down areas that will soon be "in" precisely because the "in" people are beginning to move in; their convenient blindness to the human dimension of the "gulfs and divisions" that underlie their "well arranged" lives. Obviously, the "seedy old ladies" and "black men" have taught them nothing of poverty and despair or they could not see these same humans as "guinea pigs" who will impart the lessons the parents missed (without even knowing they have missed them) to their children. Simon knows whereof he speaks. He grew up in the world of the seedy old lady. But so did his host who has now, materially, left that world so far behind him that he cannot really "see" it at all even though, physically, he has returned to it. Calculated ironies abound in Drabble's fiction.

The conjunction of these two disparate worlds and Simon's continuing meditation on the difference between them (which, appropriately, occupies him throughout the party that he attends after completing his purchase) brings us back to the title of the novel. *The Needle's Eye* must call to mind the Biblical parable, the injunction that it is as difficult for a rich man to enter the kingdom of heaven as it is for a camel to pass through the eye of a needle. The eye of the needle does not allow room for the dodges that the well-to-do require: to acquire their wealth; to keep it; to protect their self-esteem in the face of their self-evident selfishness. That same point is made more clearly at another strained party when Simon and Rose unexpectedly find themselves guests in her parents' dwelling. Here Simon sees the very rich at home. And hears one too:

> Some men, even self-made men like Rose's father, had so picked up the tones of reason that it was hard to believe that it was not the national interest alone that they had at heart. But Mr. Bryanston gave himself away. He spoke of the workers as though he were a mill-owner in a nineteenth-century novel, even delivering himself of the classic view that the fact that he himself had started work collecting scrap metal in a handcart was a perfectly adequate reason why workers deserved no sympathy at all—a view which showed a mental leap so precarious, so ibex-like, from crest of unreason to crest of unreason, that one could not but sit back and admire his magnificent, gravity-defying arrival. (p.326)

Self-concern has been dedicatedly pursued, "and that perhaps was why he was perched up there on his solitary eminence, his Alpine peak of national interest, on a nasty snowy little rock of illogic" (p. 327).

But again a characteristic irony intrudes. Simon, too, is preoccupied with self; with the meaning of the life he has achieved partly through his mother's sacrifice; partly through his own efforts; and partly through marrying another woman who, like Rose, is the only child of wealthy

69

parents. Yet Simon is not completely lost, and he is not lost precisely because he can recognize that he might be. It is this recognition that draws him to Rose. It is Rose who draws him out of himself and thereby allows him to participate again in his own life as well as in hers. The grace and gracelessness of the opening gathering is a parable that sets forth most of the main issues that are central to the rest of the book. Simon and Rose, like the host and hostess of the ''on again, off again'' party, must also try to come to terms with their ''on again, off again'' marriages; they must try to find grace in their public and private lives.

Since the central question is the problem of grace, Margaret Drabble's literary antecedents go back considerably beyond the nineteenth-century novelists. Her earliest English ancestor, theologically speaking, is John Bunyan, whose name is prominently evoked in the latter portions of the novel. *The Needle's Eye*, however, is written by Drabble, not Bunyan, and that is a crucial difference. Christian never asked himself the probing questions that Drabble's characters, almost obsessively, pose to themselves, nor is his journey along the straight and narrow path encumbered by the conflicting and often contradictory claims of spouses, parents, children, friends, employers, society. The allegorical Vanity could be dealt with when encountered; so could Temptation or Despair. Each danger came conveniently labelled and each represented an obvious and monolithic threat. How, though, can one seek grace when to do so will injure the very persons and principles for whom one is sacrificing? ''Oh yes, she knew it had been narrow, her conception of grace, it had been solitary, it had admitted no others, it had been without community'' (p. 378). Ends and means. There are no longer self-evident ends, manifestly just means, right answers. Thus the structure of the book, the series of contemporary parables that illuminate the questions that Drabble poses but wisely does not seek conclusively to answer.

Even the parable that gives the book its title is partly countered in this complex work. If wealth is a burden that precludes the hope of heaven, then can the wealthy, in good conscience, subject others to that danger? It is not entirely a specious question. ''Shake down the superfluity'' suggests that all will finally have enough. But what of the middlemen through whose too human hands the superfluity must pass? The novel shows us one such middleman. Rose was determined to give away in a good cause the part of her father's fortune that had already been irrevocably passed onto her. The single largest gift is a check for £20,000 that she contributes to an African in England trying to raise funds for a school to be built for native children in a particularly poor and backward African country. The school was built, but only a month or so after it was completed it was destroyed in a senseless war of attempted secession. The school was built, but the fund-raiser could not entirely resist the temptation of twenty thousand pounds. ''He also bought himself a huge

great white Mercedes. Out of my money." Telling the story to Simon, Rose must admit that Christopher may have been correct. "Christopher said I should have expected it, I should have known better, I shouldn't have trusted that man—and maybe he was right. I didn't stop to think. I couldn't have thrown the money away more ineffectively, could I?" (p. 111). The final question is well taken. All Rose can know for certain is that her action did not particularly help any of the Africans in Africa; that it corrupted the African in England trying to help his fellow countrymen. The way to grace is not clearly marked.

Rose, returned to the misery of being married to Chrisopher, tries to justify the sacrifice of her own previous hard-won happiness: "And now she lived in dispute and squalor, for the sake of charity and of love. She had ruined her own nature against her own judgment, for Christopher's sake, for the children's sake" (p. 378). The rationale rings false. "Dispute and squalor" along with "charity and love" comprise rather strange bedfellows. Furthermore, although she suspects that "she had sold...her own soul," and feels herself "lapsing, surely, slowly from grace" simply because she has done her "duty" for Christopher and "the children" (p. 378), Rose must also admit that she does not care for Christopher. The children, she further acknowledges, do not profit from what can finally be defended only in their name. She is now irritable, querulous, and well aware of the natural consequences of her natural resentment. "To yell at the children, angrily, I'm doing this for you, you fools, could hardly be good for them" (p. 379). She is even denied the one solace that she would especially appreciate; simply to talk about her present unhappiness to Simon as she had freely talked about her past problems: "But how could she commit such an indiscretion, how could she betray one man to another?" (p.379). She must be faithful to Christopher, in her fashion, as Simon, in his, was previously faithful to Julie.

There is, in short, a distinct possibility that the actions of the past will continue, in the same parallel fashion, into the future. The hints that the visions and revisions worked out in the novel will be subsequently reversed, I would argue, are quite clear at the end of The Needle's Eye. Simon, for example, congratulates himself on the fact that Julie "had managed to become smart, and generous, and worldly" (p. 367). Other words for the very qualities—vain, indulgent, insensitive—that formerly displeased him most. What has clearly and obviously changed is Simon's emotional perspective: "Julie seemed to be becoming what he had once taken her to be"; perhaps "he alone, guiltily, had misinterpreted" her when he formerly weighed her limitations as a human being (p. 367, emphasis added). Or perhaps he misinterprets now. Perhaps—a sad thought, but one Drabble definitely suggests—Julie remains Julie and Simon, Simon. Certainly Rose and Christopher are, at the end, essentially the same characters that they previously were and are as unhappy in their

reestablished marriage as they were in the original one.

For Rose the only immediate prospect of any happiness at the end of the novel lies in Christopher's absence. Going about his father-in-law's business occasionally takes him abroad, which is the one gleam of hope in his wife's life: "The relief at the thought of two weeks without him had been overwhelming, shaming, vindicating, triumphant" (p. 378). The odd conjunction of shame and vindication shadows forth the contradiction in which Rose is still caught. She can use, as she does, her brief respite to "prove" that "she had been right to take him" back (p. 378). In best bad Christian style, she is suffering—sacrificing herself, and doing so, as she also recognizes, to no particular point or purpose. Neither her children's life nor the state of her soul is improved by what she does. She is acting according to (Rose's terms again) "faith-demented ideologies" (p. 379). It is shameful. So if the enduring happiness of Simon is not assured, neither is the continuing sorrow of Rose. The brief remission from suffering looks back to a longer period of relative happiness while legally divorced from Christopher; it might also look forward to a bigger break in the future. Drabble, in another context, has suggested as much: "Probably (Rose) and Christopher would part again in five years because she couldn't take it."[3] Drabble makes the same suggestion in the novel too. Consider the way in which the narrator sums up Rose's juggling attempts at self-justification for self-sacrifice: "At times she tried to persuade herself that her decision to live with Christopher was not only right but also, beneath all her resistance, satisfactory to her: at times she came near to persuading herself that this was so" (p. 378).

Rose here comes dangerously close to violating the first religious illumination of her life. To justify that claim it is necessary to go back in the novel again, back to the episode that gives the book it title. Rose, at one point, tells Simon of a crucial childhood experience that occurred with Noreen, the religious fanatic who was her childhood nurse. They had heard a sermon on the eye of the needle that explained "how Christ hadn't really meant it, and the eye of a needle not being really an eye of a needle but a Hebrew phrase meaning a gate in the walls of Jerusalem, and of course camels could get through it, or small ones anyway, though it was a bit of a squeeze" (pp. 81-82). Noreen sarcastically dismisses such "casuistry" as "soft soap." For the eight-year-old child, however, it is much more: "But to me it was like the Road to Damascus, a horribly heavenly light shone upon me and I knew what life was like, endless prevarication and shuffling and squeezing and self-excusing and trying to cram oneself into grace without losing anything on the way" (p. 82). But can one cram oneself into grace with self-excusing suffering any better than through similarly rationalized riches? "How can one say, excuse me, excuse me, I'm only a small child, if one recognizes the truth in one's bones?" (p. 82), Rose responds to Simon's claim that a woman like

72

Noreen should never have been allowed near a child. A similar question hangs in the air at the end of the novel. How can one say excuse me, I'm only a confused adult (with a taste for suffering), if one recognizes the truth in one's bones? Rose still recognizes the truth. Ironically, she is not completely lost at the end of the novel only because she cannot convince herself that she is not completely saved.

From one perspective, the conclusion of the novel is dark indeed. Simon has achieved a dubiously based domestic happiness that will not likely long endure. Similar in opposition to the very end, Rose has gained just the same variety of sorrow. The two main characters have not, it would seem, traveled far. But pilgrims without progress, they are pilgrims still. And therein lies their hope for the future. Yet Drabble is, throughout the novel, deliberately equivocal about the conventional import of the religious themes so regularly sounded. Thus Rose, as a child, discovered that Noreen was right. She had once tested the servant's dubious claim that a razor "would cut you as soon as look at you" (p. 339). She was cut. "So, it had all seemed true. Razors cut, Christ was crucified, man was wicked, Hell was open" (p. 341). Occam's razor would cut away three of those conclusions. The simpler proposition is "razors cut," and of course they do. That is what they are made for.

The same dubious affirmations of doubtful faith also continue through to the end of the novel. Simon and Rose make the two trips, the two journeys (model pilgrimages?) that they had promised themselves, and neither turns out as intended. They visit her childhood home to get back the children Christopher had abducted. The outcome of the visit is that, although Simon proposes, he loses Rose to Christopher. And Rose, it should be added, loses Rose too. The second journey provides the book with its brief closing episode. Simon and Rose finally make another long-promised excursion. It is, however, only a trip to a dog show and "a very second-rate dog show" at that (p. 375).

Out of that dog show come the two contrasting visions with which the book ends. Simon and Emily look first at what the dogs have done. Reykjavik (where dogs are illegal) is, for Emily, "the only civilized capital city in the world. 'All dogs should be shot,'" she adds, to make the point even clearer. They then pass to what humans have done, with predictable results:

> They stood there, the three adults, on the parapet, and looked at the view, and looked back at the Palace, with its odd shabby Corinthian pillar, its peeling plaster caryatid, its yellow bricks, its ugly Italian parodies, its bathos, its demotic despair, and then looked back at the view, where houses stretched, and tower blocks, and lakes of sewage gleaming to the sky, and gas works, and railways lines, effluence and influence, in every direction, all around, as far as the eye could see. It seemed that Emily was right. They felt the cold chill of her reading, and she said, leaning on the stone by the eroded perfunctory sphinx, "It's not the dogs that should be shot, it's the people. Look at it. Just look." (p. 381)

This "talk of shooting" brings Rose to her first final vision: "They were probably right, she was almost certainly wrong. There was no knowing. I will leap off the ladder blindfolded into eternity, sink or swim, come heaven come hell. Like a rat, swimming through the dirty lake to a distant unknown shore" (p. 381). The savagely ironic reference is made clear in the novel. Rose had previously quoted the appropriate passage from Bunyan's *Grace Abounding*. But Bunyan, in his leap, could invoke God: "...sink or swim, come heaven come hell, Lord Jesus, if thou will catch me, do, if not, I will venture for thy name" (p. 343). Rose can anticipate only the graceless world about which Emily and Simon were "probably right." One falls a "rat" into a "dirty lake," the only hope "a distant unknown shore." Or the lake itself. Part of the shoddy ugliness of the scene are the lions that decorate the exposition hall. They are "crudely cast in a cheap mould" (p. 381). One of them is even broken, a fact which especially pleases Rose. On this note the novel ends: "She liked the lion. She lay her hand on it. It was gritty and cold, a beast of the people. Mass-produced it had been, but it had weathered into identity. And this, she hoped, for every human soul" (p. 382).

This second charitable vision, a hope "for every human soul," is as problematic as the riddle Samson set the Philistines. Does this broken British lion of the people presage an end to other divisive political structures besides the former British Empire, a more egalitarian future? Has "sweetness" of any temporal or eternal variety come forth? Is it significant that the lion achieves "identity" after it is broken ("half of its head was missing") and contains such unlikely yet suggestive items as "a Coca Cola bottle, a beer can, and a few odd straws"? (p. 381) After it is one with the "terrible mess" around it? Is this comic and grotesque setting another version of what Simon earlier termed, in a far more natural and beautiful setting, "some delusive allegory of the soul" (p. 313)? Such questions are not answered. There is no evidence to answer them. Nevertheless, the novel can still end with an affirmation of hope and a parable of grace abounding in a seemingly graceless world. In this sense *The Needle's Eye* is darker and brighter, and far more paradoxical, than the more traditionally religious British fiction of the twentieth century.

NOTES

[1] William Golding, *The Spire* (London: Faber and Faber, 1964), p. 222

[2] Margaret Drabble, *The Needle's Eye* (1972; rpt. New York: Popular Library, 1977), p. 244. Subsequent references to this readily available paperback edition of the novel will be made parenthetically in the text.

[3] "An Interview with Margaret Drabble," *Contemporary Literature*, 14, (1973), 285.

Margaret Drabble's Short Stories: Worksheets for her Novels

Suzanne H. Mayer

In his discussion of Henry James's shorter fiction, Morton Dauwen Zabel concludes that, although the master's greatest strength lies in his novels, the scope and diversity of his powers are apparent in his tales: "They give us not only the ground and reach of his imagination; they serve equally as matrix or seedbed for the novels themselves."[1] Zabel is thinking both of James's themes and of his developing resources as a craftsman. After reading Margaret Drabble's little-known short stories, one concludes that the same is true for her. Although her productivity of short stories has been meager compared with the prodigious output of a James, it seems clear that the subjects and themes and even the narrative techniques treated in her nine novels are almost invariably found, often in embryonic form, in short stories written earlier.

Drabble's novels are not simple affairs, for she "is not writing to preach or teach. She is asking questions."[2] Readers identify readily with her characters and their problems, and they seek answers to the questions asked. Few writers have been interviewed so often about their own work as Drabble has. Even though she seems to be extremely generous with her time and energies, the discussions usually center on a few basic subjects: novels just finished, themes explored, her reactions to other writers. Her position in the literary world assures interviewers that their efforts will be rewarded by readers; however, often Drabble's revelations only stimulate more questions, not answers. If the shorter fiction fails to supply the answers, perhaps it helps to bring the questions into sharper focus.

American readers have access to seven of Drabble's stories published in the United States between 1966 and 1973. They are uncollected at present, but once assembled provide an outline of the themes found in her novels and knowledge of her creative process. For this discussion it will be most helpful to see the stories chronologically, as best as can be determined by copyright dates,[3] and as they fit into Drabble's total fiction canon.

	Novels	Stories
1963	*A Summer Bird-Cage*	
1964	*The Garrick Year*	
1965	*The Millstone*	
1966		"Hassan's Tower"
1967	*Jerusalem the Golden*	"A Voyage to Cythera"
1968		"The Reunion"
1969	*The Waterfall*	"Crossing the Alps"
1970		"The Gifts of War"
1971		
1972	*The Needle's Eye*	"A Success Story"
1973		"A Day in the Life of a Smiling Woman"
1974		
1975	*The Realms of Gold*	
1976		
1977	*The Ice Age*	
1978		
1979		
1980	*The Middle Ground*	

The seven stories are not of equal literary merit. My purpose is not to evaluate them, but briefly to familiarize readers with them and then to relate their themes and techniques to Drabble's longer fiction published about the same time. These stories, like Henry James's, provide insights into her artistic preoccupations and creative processes. In a sense, they are highly polished work sheets for her novels.

Anyone who has read Drabble's novels can make two generalizations. First, she is the novelist of maternity in her first six novels but has gradually shifted the focus from children to much wider concerns, including the state of the nation, in her last three novels. Her main characters, mostly women, have learned to function, or at least try to function, outside the nursery. As the main characters changed, the point of view in the novels shifted from a feminine first person singular to a gradually more detached omniscient authorial voice. It is interesting that a reader would come to these same truths about her content and form after reading only Drabble's short stories, for an identical progression appears in them.

Her fiction begins with three novels published within a three-year span that explore the role of young women beginning adult, after-university life. All are narrated from a feminine first person, very personal, quasi-autobiographical point of view. Sarah in *A Summer Bird-Cage* examines marriage and questions her possible acceptance of it for herself. Emma Evans in *The Garrick Year* introduces motherhood as a dominant theme

76

and establishes children as the reasons for a mother's existence. Rosamund Stacey in *The Millstone* portrays the "mother with illegitimate child: who needs anyone else, at least for now" theme.

After writing three versions of a woman confronting adulthood, Drabble shifted to the male point of view. For this experiment, she used the short story form. This story is "Hassan's Tower" (1966),[4] which seems far removed from her earlier writing. The setting is outside England; the protagonist is male; the conflict begins over money: too much of it.

"Hassan's Tower" is told by a man on his honeymoon in Morocco. He and his wife Chloe are uncomfortable with one another and look for tourist activities to make the trip less disillusioning. Every excursion outside their hotel is frightening because they are both intimidated by foreigners; however, they go to Rabat because "it was necessary to go somewhere" (p. 49). Once there, Chloe wants to visit the local Tower of Hassan, and when they finally find it she insists they climb to the top for the view. As they are resting at the top, Kenneth turns his view inward and comes to terms with his future life with a woman whom, he is beginning to see, he neither loves nor appreciates.

Kenneth and Chloe are traveling in Morocco because it is expected of them. In their world people with money are supposed to use it. Part of their discomfort in the foreign country results from the contrast between their wealth and the natives' poverty. But money also separates them. Kenneth earns a great deal with little effort, "writing idle articles for a paper" (p. 45), and is inexperienced and awkward about spending it. For Chloe, who has inherited a small fortune, money is a part of her background. This difference becomes a major theme in Drabble's fiction.

Interviewer Dee Preussner has said about the author: "money is a structuring principle in her novels. Her characters are often shaped by money or a lack of it, and attitudes toward money form the basis for social ties between family members and friends, or play a part in tearing these social units apart."[5] Drabble herself admits to this obsession: "I find the idea of generosity and not knowing what position you're in because you're wealthy, therefore you don't know what you are in human terms, very interesting."[6] She is talking here about writing *The Needle's Eye*, but the subject appears in most of her work in various forms: women who marry for money, Rosamund Stacey *(The Millstone)* who knows she has education enough to support herself and so can keep her baby, Rose Vassiliou *(The Needle Eye)* who signs away her legacy, Kate Armstrong *(The Middle Ground)* who lives an expense account life many men would envy.

In "Hassan's Tower" the fretting and frustration over money is meant to enhance the central focus on the harsh realities of married life. Although the point of view is the husband's, we are given enough details about the wife to recognize her emotions: "her face was plain in repose, a

little blank and grim" (p. 47); "she leant back in her chair, letting her headsquare fall to the ground, and not even acknowledging it when a hovering uniformed boy handed it back to her" (p. 48). As she stands atop Hassan's Tower looking at the scenery, spellbound by it, the husband tells himself: "She is younger than me, and she enjoys things I no longer enjoy. I have finished with love, just as I have finished with scenery" (pp. 55-56). This young woman is trying to retain her enthusiasm for life, but it is difficult. We do not know how she feels about adulthood; her questions are yet unanswered. We don't know if she fits Lee Edwards' description of Drabble heroines; "What women learn is that their hopes have played them false and that their visions are unrealizable, childish, or both.. To be an adult, then, is to be forced to give up one's illusions and to make do with whatever smaller, duller possibilities the world provides."[7]

Finally, this story is a treatment of a young man's acceptance of limitations:

> He breathed, he lived. And he would continue to do so. He had married the wrong woman . . . but he would not therefore cease to live. He could not have said that he was happy, but he could concede that at some distant time the pleasure of successful labor . . . might be transformed into something like happiness: not the happiness of innocence, of passion, or of violence, but a kind of happiness nevertheless . . . in future he would expect less from life, and suffer it more. (pp. 55-56)

But Kenneth's answers are more than mere accommodation. He is given a vision which brings him strength. It comes as he looks around at the Arabs resting at the top of the tower:

> and as he gazed he felt growing within him a sense of extraordinary familiarity that was in its own way a kind of illumination, for he saw all these foreign people keenly lit with a visionary gleam of meaning . . . as though the terms of common humanity . . . had become facts before his eyes And the vision before him now was of a promise and a hope far fuller than any of the passions of his youth, because it was no longer a lonely knowledge: it has a hundred different faces. (pp. 57-58)

This finding compensation for the loss of youth's passions in a vision of the interrelatedness of all men was certainly on Drabble's mind while she was writing in 1966, for that was the year she published a monograph on Wordsworth that is focused on precisely the same questions. Ellen Cronan Rose[8] traces this theme through Drabble's early fiction, and points out she is still reworking it as late as The Needle's Eye (1972). "Hassan's Tower" is an early version.

After using a male as the central focus in this short story and doing a study of Wordsworth and his poetry, Drabble finally did part of a novel from the male point of view. In the novel Jerusalem the Golden, Chapter

7 is a study of the workings of Gabriel's mind as he tries to justify his love affair with Clara, in whose consciousness the remainder of the novel is centered.

After these ventures into the male mind, Drabble turned again to the female point of view, to problems of women who are trying to function in a working and social world. Obviously there were more questions for her women to ask. The second short story treats the theme of illusion from a female point of view. The ending is not as optimistic nor as conclusive as "Hassan's Tower." Published in 1967, "A Voyage to Cythera" is the psychological study of a Romantic young woman who anticipates adventure whenever she travels. She finally has one on a train to London. A fellow traveler asks her to address a letter to his lover and then to mail it from her section of the city. The romance of the situation builds in her mind until a month later, she cannot resist seeking out the lady's home. At the end of this journey she sees, through a basement window, a domestic scene of two women and their several children putting up a Christmas tree and preparing tea. After Helen has surfeited herself on the vision of domestic intimacy and warmth, she begins to walk away. The man from the train has been sitting in his car watching her. Finally, he speaks: "I don't know what to say to you, you look so fragile that a word might hurt you."[9] He then goes into the house to join the women, and Helen walks away into the snowy night.

This woman believes she has had her great adventure, and probably she has, but it has not brought her intimacy. She has only "recollections" of the intimate scene. Wordsworth had his own recollections to sustain him; she will have to exist on visions of others' lives. And there will be no handsome prince to awaken her from her dreams.

In this story Drabble has given pictures of two aspects of the feminine experience. One is of women who cannot establish relationships with men and whose illusions gradually become delusions. The other view is of women and their children sharing life, excluding outsiders. Sometimes the outsiders are other women, but more often they are men. Merging these two pictures of womanhood results in a return to the typical heroine of Drabble's early writings: the woman who lives for her children rather than for their father. This woman appears again in her later novels and short stories.

Although the reader is not told the thoughts of the women in the basement flat, the description of the scene is filled with details that reveal the view we are to have of them: "the children chewed at the buns while she scooped up the torn pieces of bread and bestowed them all, with a smile of such lovely passing affection, upon the baby, a smile so tender and amused and solicitous that Helen, overseeing it, felt her heart stand still" (p. 150). There is a raw contrast between the women indoors who are capable of spontaneous, natural relationships and Helen standing out-

doors in the cold, unable to form even an unnatural relationship.

The mythological Cythera is a place, a mountainous island noted for the worship of Venus. It is also a name for Venus, who with Mars formed an illicit affection and for this was exposed to the ridicule of the court of Olympus. In "A Voyage to Cythera," Helen has a strange, powerful feeling for the man from the train, but it remains one-sided. At the end of the story it is written: "She walked carefully, because her ankles were so brittle from the cold that she feared that if she stumbled, they would snap" (p. 150). Drabble does not subject her character to ridicule, that would be judgmental, but the irony of fragile illusions is obvious.

Jerusalem the Golden, the novel written the same year as "A Voyage to Cythera" has a protagonist, Clara Maugham, who can and does enter into illicit sexual relationships. Her primary motivation is not emotional gratification but social ambition. Most critics are dissatisfied with this character and her future. The novel is not totally deserving of Bernard Bergonzi's captious judgment: "*Jerusalem the Golden* . . . represent(s) that aspect of Margaret Drabble's art which is closer to women's magazine fiction than to George Eliot or Henry James";[10] but it does give readers a woman who is more intent on escaping—her past, her body—than on molding a future for herself.

Six years after she wrote this novel, Margaret Drabble was still worrying about this view of feminine experience. "Clara Maugham is certainly looking for another pattern of life that she can go into, and in the book I have ambivalent feelings myself about whether she's found a good one. Clearly not. She's found something that suits her. She's going to turn into something fearsome, I think. I rather dread her future."[11] Clearly, Drabble did not consider Clara the woman who had found answers.

With *Jerusalem the Golden*, the scope of the novels expands somewhat. A woman is presented with no children who might be buffers against the uncertainties of the outside world. The novel instead focuses on the man/woman relationship with emphasis on the physical. Clara is committed more to repudiating her past than to settling her future. This obsession with one's past, having to grow beyond it in order to function, is another of Drabble's primary themes. Its presence in the novel signals artistic growth.

At the end of *Jerusalem the Golden*, Gabriel calls Clara and asks why she walked out on him in Paris. After a lengthy discussion about who left whom, they admit they are finished with one another but agree to "have one last glorious ride together" (p. 250). Drabble's very next published work has a similar plot. Short story number three, "The Reunion,"[12] (1968) pictures former lovers who happen to meet in a restaurant while eating lunch. The part played by accident/chance/fate in their meeting runs through the story but is secondary to the picture of the relationship.

Viola and Kenneth meet again three years after their separation. Their

affair ended on a prearranged, mutually agreed upon date, which neither expected the other to respect. After the initial shock and embarrassment of coming across one another in their old haunt, Kenneth sets the tone for their conversation when he says, "You forgot me quicker than I forgot you, didn't you?" (p. 158) They trade admissions about resisted attempts to reestablish communication and eventually decide they have been "alarmingly faithful" (p. 161) after all. From here, it is a short step to a full resumption of their affair. Readers are left with no doubt that in this new stage of the affair they will be alarmingly faithful to the same rituals of delivering ultimatums, kissing and endlessly discussing "the impossibility of kissing," (p. 151), kissing "above the Moussaka and chips, because they believed in such things" (p. 168).

Although we are meant to feel that Viola and Kenneth will be happy playing the role of unhappy lovers, just like Paolo and Francesca in hell with whom they are compared, it is difficult to accept this as the vision of the future Drabble would seek for all women. It is closer to women's magazine fiction than her other stories. It is easier to accept the story as an experimental exercise on the theme of consistency, done in preparation for (or in recollection of) writing *Jerusalem the Golden* that same year.

Drabble's next work was her novel *The Waterfall* (1969). Like "The Reunion," it explores the theme of chance vs. fate, and constructs, in part, a "very forceful image of romantic, almost thirteenth-century love" (Hardin, p. 293). But it goes beyond the limits of the short story to become a complex study of a woman who tries to free herself from her Puritan conscience by flinging herself into an affair which is the most physical Drabble has ever portrayed.

The point of view of this novel is a radical step in the author's artistic development, for the narration alternates between the first and third person. Chapter by chapter we shift from Jane Gray participating in her life to Jane objectively describing her life. These shifts allow the author to ask one of her typical questions:

> (Developing the shifts in narrative style) wasn't deliberate, you know. It just happened that way. I'd been wanting to write the first section of that book for a long time and I wrote it and I was intending to turn it into a novel. When I'd written it, I couldn't go on because it seemed to me that I'd set up the very forceful image of romantic, almost thirteenth-century love. Having had the experience or describing the experience, one had to say what is this about? I thought the only way to do it was to make Jane say it. (Hardin, p. 293)

This shifting point of view marks a change from the exclusive use of first person; in fact, "since *The Waterfall*, Drabble has avoided the first person singular. And 'I' of the subsequent novels belongs to the author *qua* author."[13] It puts distance between her and her characters, her

answers and theirs. From this point on, the conscious craft of developing narrative perspectives becomes a superstructure for the plots until, in her eighth and ninth novels, the narrative technique is at least as interesting to follow as the plot.

The Waterfall also marks a new direction in the author's portrayal of motherhood. No longer are children the means to salvation for the mother. In this work a relationship between adults is fulfilling. Jane says of her love affair: "What I deserved was what I had made: solitude, or a repetition of pain. What I received was grace."[14] Author Drabble says she meant to give a picture of a woman "saved from fairly pathological conditions by loving a man," but agrees with critics that it is "a wicked book . . . that's not how I can approach my life. There's no guidance in that for me" (Hardin, p. 293). She doesn't consider this answer valid for all women.

Joan Korenman says of *The Waterfall:* "With Jane, Drabble's examination of the problems and possibilities confronting women in contemporary society reaches an impasse. As if in acknowledgement of the difficulties she faced, Drabble took three years to publish her next novel, *The Needle's Eye* (1972)."[15] Actually, there is another way to look at her fiction writing of the next few years. It appears to be a phase during which she turned to the short story form more than the longer novel. Following *The Waterfall* until 1975, Drabble published one novel, *The Needle's Eye* and four short stories. It may be no coincidence that these years coincide with a period of several nonfiction and editing projects done by the author. Two of the four short stories published during this time period are especially valuable as indicators of her preoccupation with her old themes. They are the final work sheets of the novelist of maternity. And, in the last two of these, we find the shift to the novelist of maturity who seeks to place women in the world outside the home to see if they can survive.

Published the same year as *The Waterfall* is a short story which mirrors the novel's portrayal of motherhood, but presents a relationship between adults that is not so physical. "Crossing the Alps" has a simple plot. A man and woman travel to Yugoslavia for a vacation, far away from his wife, her retarded child, their jobs. He gets the flu and must be mothered. On this bare frame is hung almost every theme Drabble has explored in her previous writing, and many plot devices used before. Echoing her first story "Hassan's Tower," this story has a couple traveling outside England; it is told from the man's point of view; and it has him finding solace and comfort by means of a vision of the "unity of all sorrow."[16] As before, the vision has a Wordsworthian flavor, (a quotation from Wordsworth's *Prelude* heads the story) and is triggered again years later in London by the recollection of a view from an Alpine mountain with its peaks and pine trees.

Unlike the narrator in "Hassan's Tower" who says, "I have finished with scenery" (p. 55), and whose vision helps him accept lowered expectations of life, the narrator of "Crossing the Alps" draws strength or healing from the scene:" 'I'm better,' he said, and indeed he felt so very strange that it was hard to tell if he were better or worse. Certainly, whatever he had was less locally painful" (p. 196). He is comforted by the insight that people don't bring one another sorrow; they share it. It is more positive to share love that brings sorrow than to be "finished with love." Drabble has moved beyond the absolutes of youth in this story.

The woman in "Crossing the Alps" is able to leave her child, one who needs special care just to exist. Being able to take over driving the heavy car when her lover is too ill, and being able to deal with border officials and hotel porters while he sleeps, gives her a sense of achievement which is carefully pictured. She is shown mothering/nursing the man and accepting a truth she speaks for both of them: "There'll never be any reason to know we couldn't . . . be happy" (p. 198). She does not arrive at the comforting answers he had with his vision, but she had had partial success in a world without children. Drabble has thus made a major break in her portrayal of motherhood using the short story form. It is a break heroines in her novels have made since Clara in *Jerusalem the Golden*, but in her short stories she went on experimenting with variations of the motherhood theme long after her novels had moved on to other, perhaps larger, concerns.

"The Gifts of War" (1970) may be the finest statement of the author's feelings about the mother-child relationship, even though its view of children bringing salvation had been rejected in her previous two novels. She seems to be trying again, wanting it to work. But, it is not really a return as much as a variation on a theme. In this version there are two women. One is, unlike previous Drabble heroines, poor and uneducated.

"The Gifts of War" opens the morning the unnamed protagonist is planning a trip to town to spend her carefully saved thirty shillings on a birthday gift for her seven-year-old son Kevin. The relationship between mother and son is carefully crafted to show their mutual understanding and love. It is this love, this feeling that enables her to accept a bitter life with a husband who mistreats her: "The visiting prince, whom need and desire had once truly transfigured in her eyes, now lay there at home in bed, stubbly, disgusting, ill, malingering, unkind."[17] She no longer has any illusions about loving him or dreaming of happiness through marriage. "In the child, she found a way of accepting the man; she found a way of accepting, without too much submission, her lot" (p. 21).

This view of the role of children appears in most of Drabble's early fiction and is reaffirmed often in her interviews. As she recently told Dee Preussner, "I certainly feel the mother-child relationship is a great salvation and is an image of unselfish love, which is very hard to get in an

adult relationship, I think, if not impossible."[18] For the mother in "The Gifts of War," it was *the* salvation, her reason for existing. And salvation is used here in more than a secular sense; it is mystical. This son redeemed his mother. The imagery used to describe the relationship makes this clear. She had "a sense of her own salvation . . . she had been saved . . . redeemed . . . one of the elected few . . . almost visionary" (pp. 27-28).

During the bus ride to the shop the mother sees a landscape of bombed sites and feels affinity with the willowherb growing "so tall in tenacious aspiration out of such shallow infertile ground" (p. 28). She knows what it is to survive, to make something out of little. This pathetic comment on her life and her child's is the last we get from her, because the story abruptly shifts location, heroine, and point of view. Frances Janet Ashton Hall takes over. She is everything her name implies.

In the fall Frances begins her studies at a university, but presently puts in time affirming her pacifism by standing "outside the biggest department store in town, carrying a banner and wearing (no less) a sandwichboard, proclaiming the necessity for Peace in Vietnam" (p. 30). While on public display she conducts a private examination of her motives, asking if she is doing this to profess faith, to demonstrate love for Michael, her new friend, or to annoy her parents. No rational answer presents itself, so she goes in the store to see how Michael is doing in his mission to persuade the toy department manager not to sell war toys. She finds him creating a scene, using a toy called The Desperado Destruction Machine as a symbol of the ultimate harm a war toy can bring to a child's mind. The disagreement between the manager and Michael escalates, and at its climax Kevin's mother arrives to buy that very toy.

Quickly she is at the center of the battle, besieged by the manager and by Michael, who wants her to buy something "less dangerous and destructive" (p. 34). Frances enters during a lull in the action and talks "in what she thought was a very friendly and reasonable tone (saying) with all the violence in the world today it was silly to add to it by encouraging children to play at killing and exterminating and things like that" (p. 35). After being forced to listen to the intellectual arguments, the mother replies emotionally in "one word, and it was a word that Frances had never heard before, though she had seen it in print in a once-banned book" (p. 35). The customer reacts with despair, anger, and defeat for the first time in her existence, then puts (perhaps throws) down the clockwork toy and walks away crying. The war language used to describe her exit underscores the horror: "They did not know how to follow her, nor what appeasement to offer for her unknown wound" (p. 36). The mother is not equiped to defend herself against the rest of the world. Once she leaves home, she is no longer capable of saving herself and, by extension, her son. The gift she wanted to give is destroyed.

This story is a last attempt by Drabble to portray a mother-child relationship which sustains the adult, but to the picture she has added a new truth: the relationship is only temporary. The child grows up; the mother wants more; the outside world intrudes. From this point in her fiction, the mothers are able to separate themselves from their children, although they don't seem to find anything as fulfilling to take their place. "The Gifts of War" may contain the last portrait of a positive relationship in Drabble's fiction.

Using sharply contrasting points of view for the two halves of the story, the author forces the readers to make some abrupt shifts. For some, it may be too radical a break with the traditional unities generally observed in short stories. Drabble apparently liked the effect, for all her subsequent novels contain such shifts. In 1972 *The Needle's Eye* was published. It is the author's last novel, to date, that focuses primarily on parenthood. That the topic is parenthood rather than motherhood is underscored by the dual viewpoint used, Simon Camish's and Rose Vassiliou's. From this novel on, all her books have male characters as the central consciousness for at least part of the story, and, in each there is a shifting focus, with an omniscient narrator/author gradually becoming more central in later works. This demonstrates how enlarged Drabble's focus has become since *A Summer Bird-Cage, The Garrick Year*, and *The Millstone*. This split point of view begins a new phase in her writing technique.

Her treatment of the parenthood theme in *The Needle's Eye* is very interesting because the woman gains by allowing herself to be drawn back to family life. At the end of the novel, Rose Vassiliou returns to live with her husband, taking their three children along, "because she cannot morally keep the children away from him."[19] Rose is portrayed as a strong survivor who gains grace by doing "Her duty, that was what she had done. For others. For him, for the children."[20]

The book ends on a positive note; the heroine will survive, we are assured. But by October of the year the book was published, Margaret Drabble was saying of Rose:

> I think that probably she and Christopher would part again after another five years because she couldn't take it. That's why I wrote so as to make the position completely intolerable for her . . . A person like Rose might have found a deep spiritual experience in quitting and going off, but Rose has to reject that, too, and what she accepts finally is no less painful . . . how difficult it is to be righteous, particularly when you've got small children . . . There are simply no answers. (Hardin, p. 285)

After this novel, her fiction portrays women and men acting for themselves, not using children as anchors. The novelist of maternity is done.

Before the novels with the new focus were published there was a lapse of three years. In this span Drabble wrote her fine Arnold Bennett

biography, but her fiction writing was not dormant. She wrote two short stories which presage the coming novels. Both feature the new women in Drabble literature, career women trying to enter society defined by men.

"A Success Story" was published in 1973 in *Spare Rib Magazine*, a feminist journal in London. It was reprinted in December, 1974, in *Ms.* for American readers. It is no accident that this story, a treatise on career women, appeared in two leading publications devoted to raising women's consciousness.

The plot involves a very successful playwright, Kathie Jones, who goes to a party given by the "grandest (socially speaking) theatrical entrepreneurs in London."[21] She goes alone because the journalist she lives with, and loves, is on assignment in Hungary. At the party she meets an American writer named Howard Jago, who was "the hero of her childhood dreams" (p. 54). They leave together, go to his place, drink and talk "a lot of nonsense" (p. 94), and he admires her legs. Later in the evening Kathie turns aside his womanizing and leaves.

Framing this conventional plot are the comments of an omniscient author who examines Kathie's motives. "The point is: what did she (Kathie) think about this episode?" (p. 94). We are given the answer. Kathie admits to herself that "she had received more of a thrill through being picked up by Howard Jago at a party . . . than she would have got from any discussion, however profound, of his work and hers . . . it gave her permanent satisfaction . . . that she'd been able to make a man like him look at her in that way . . . that's how some women are" (p. 94).

Both at the beginning and end of the story the narrator stresses the times, the feminist political climate, during which this story is being told. Women, the same as men, "like admiration more than any thing" (p. 94), and now it's all right to say this about them. And it's all right for women to admit it to themselves. "But Kathie Jones is all right now. The situation is different, the case is made. We can say what we like about her now, because she's all right" (p. 94). But the story and the message don't end here. The narrator adds these two words: "I think." The chill these words leave may be a symbol for a lessening of the warmth Drabble feels for this heroine and her prospects. Are women so trapped by narcissism? Is this what motivates the career women? Will it be enough?

The final lines of all[22] of Drabble's works offer clues to her view of her own characters and can often be used as a gauge of their future prospects. She does not seem to be certain of a satisfying future for her career women. Kathie Jones is all right "I think." Of the heroine in her next short story the narrator says, "Looking back, she was to think of this day as both a joke and a victory, but at whose expense, and over whom, she could not have said."[23] And her career-woman novels which follow continue this trend, an example being the ending of *The Ice Age*, which has been called "a simple and total condemnation of female experience."[24]

> For Alison there is no leaving. Alison can neither live nor die. Alison (mother) has Molly (daughter). Her life is beyond imagining. It will not be imagined. Britain will recover, but not Alison Murray.[25]

Leaving the nursery behind did not solve all problems for women. Having a career, becoming a success story, didn't seem to solve all problems either; this just focused on new questions. It is not only a need for enlarging her artistic scope that makes Drabble broaden the social milieu of her novels. It may also be the lack of satisfying answers for women.

In the early 1970's her writing interests had become focused on career women, and our last short story is another portrait, "A Day in the Life of a Smiling Woman" (1973), which incidentally covers more than one day in the life of Jenny Jamieson. Again there is a narrator. Distance from the subject is achieved by a tone which is slightly condescending as well as ironic.

Jenny Jamieson has her own television talk-show and is famous. Her husband, who had gotten her the job to keep her from being bored, does not like her success. One evening, after months of being psychologically and physically mistreated by him, Jenny finally rages at him. "She would never be the same again . . . this time it had happened, and the difference between its nearly happening and its happening was enormous . . . she went to bed a different woman" (p. 146).

How different we see the next day in her new perceptions of her routine activities. She defines life in new terms. Suddenly, she realizes "she disliked fairly intensely" (p. 150) the committee members she serves with. And the clergyman she had a working lunch with no longer seems as promising a guest for her television program. Then she visits a gynecologist and hears, "You'd better come in for a little operation" (p. 154). This shock, coming so soon after the scene with her husband, forces her to examine her very existence, but her thoughts get interrupted by yet another duty, an awards day speech to a girls' school audience who hear her say that it is important "to think in terms of having careers as well as husbands . . . for the two these days, can be so easily combined. We are so fortunate these days, and we must take every advantage of our opportunities" (p. 164).

Her spoken words are the smiling side of her. She excuses her speech by saying to herself, "That is one way of looking at it. There are other ways" (p. 164). One other way is her realization that she could be betrayed by her own body, which is bleeding even as she speaks, and that she could die before she finishes raising her children. This side is fear and anger.

Jenny has what she calls a revelation when she realizes that her love for these children might help her: "those who do not love, die, and they are forgotten, and it is of no account. But those who love as I have loved cannot perish. The body may perish, but my love could not cease to exist . . . my love is stronger than the grave" (p. 163).

87

This is not the same feeling for motherhood Drabble wrote about in earlier works. While realizing the salvation children bring, Jenny also must acknowledge the temporary nature of the children's need for her and, maybe even harder to accept, the lack of fulfillment offered by a successful career. Earlier Drabble characters, mainly men, had moments of insight which caused them to lose some of their illusions and to see life more realistically, but which also gave them something to sustain them as they grew older. Jenny has lost her smiling view of her existence and wonders if any thoughts of a future might be a joke on her.

The disillusioned feeling experienced by Kathie Jones and Jenny Jamison when they review their success outside the home becomes a recurring motif in the rest of Drabble's fiction. These final two short stories may have been artistic work sheets for the coming novels. Just after the stories were published, Drabble told Iris Rozencwajg:

> In the book I'm writing at the moment (*The Realms of Gold*),—the children are older, the woman is very independent—she's a real career woman, and she's asking herself what it is that she's now struggling on for when there doesn't seem to be any justification at all from the outside world. She's simply doing it for herself. She's beginning to get rather anxious about her own motives, you know, her driving force, which seemed to be "natural" to begin with becomes problematic. Interesting point I think. (p. 338-39)

The characters are asking questions, and are provided a larger part of society in each novel as grounds for further questions. Maybe this enlarged scope is to divert attention from the lack of answers women find, or from the author's faith in providing them. She has shown her characters moving away from family life toward a less personal future. Her narrators shift from first to third person and eventually become distant and detached.

In the past American readers could anticipate shifts in Drabble's themes, main characters, questions by reading her short stories as they were published. What appeared in them often was present in enlarged form in her next novel. Since the 1973 publication of "A Day in the Life of a Smiling Woman," our magazines have been printing excerpts from her forthcoming novels rather than new short stories. It could be she isn't writing them these days because her interests and energies are focused on non-fiction books. It could be she approaches her novel writing differently now. If either theory is true, Margaret Drabble scholars and all short story readers have lost something of value and interest.

NOTES

[1]*In the Cage & Other Tales*, ed. Morton Dauwen Zabel (New York: Norton, 1969) pp. 3-4.

[2]Nancy Poland, "There Must Be A Lot of People Like Me," *The Midwest Quarterly*, 16 (1975), 264.

[3]Although care with the copyright dates has been attempted, perhaps their real value comes when charting a history of publication more than a history of creation. All those familiar with the publishing world recognize the possibility of works not appearing immediately after they are written. The emphasis of this discussion is on the stages of thematic and artistic growth and change in Drabble's writing more than on precise dating.

[4]Margaret Drabble, "Hassan's Tower," in *Winter's Tales 12*, ed. A. D. Maclean (New York: St. Martin's Press, 1966), pp. 41-59. Subsequent references to this story will appear in the text.

[5]Dee Preussner, "Talking with Margaret Drabble," *Modern Fiction Studies*, 25 (1978-79), 564.

[6]Iris Rozencwajg, "Interview with Margaret Drabble," *Women's Studies*, 6 (1979), 336.

[7]Lee Edwards, "*Jerusalem the Golden:* A Fable for Our Times," *Women's Studies*, 6 (1979), 325.

[8]Ellen Cronan Rose, "Margaret Drabble: Surviving the Future," *Critique*, 15, No. 1 (1973), 17-20.

[9]Margaret Drabble, "A Voyage to Cythera," *Mademoiselle*, Dec. 1967, p. 150. Subsequent references to this story will appear in the text.

[10]Bernard Bergonzi, "Margaret Drabble," in *Contemporary Novelists*, ed. James Vinson (New York: St. Martin's Press, 1976), p. 374.

[11]Nancy S. Hardin, "An Interview with Margaret Drabble," *Contemporary Literature*, 14 (1973), 278.

[12]Margaret Drabble, "The Reunion," in *Winter's Tales 14*, ed. A. D. Maclean (New York: St. Martin's Press, 1968), pp. 149-68. This story also appeared under the title "Faithful Lovers," in *The Saturday Evening Post*, 6 April 1968, pp. 62-65. The *Post* version, which is less than half of the original, did not benefit by editing. Subsequent references to the short story will refer to the "Reunion" version and will be noted in the text.

[13]Elizabeth Fox-Genovese, "The Ambiguities of Female Identity: A Reading of the Novels of Margaret Drabble," *Partisan Review/2*, 46 (1979), 244.

[14]Margaret Drabble, *The Waterfall* (New York: Knopf, 1969), p. 56.

[15]Joan S. Korenman, "The 'Liberation' of Margaret Drabble," *Critique*, 21, No. 3 (1980), 63-4.

[16]Margaret Drabble, "Crossing the Alps," in *Penguin Modern Stories, 3*, ed. Judith Burnley (Harmondsworth, Middlesex: Penguin, 1969), rpt. in *Mademoiselle*, Feb. 1971, p. 198. All subsequent textual reference to this story will be to the *Mademoiselle* edition.

[17]Margaret Drabble, "The Gifts of War," in *Winter's Tales 16*, ed. A. D. Maclean (New York: St. Martin's Press, 1970), p. 27. Subsequent references to this story will be noted in the text.

[18]Preussner, p. 569.

[19]J. O'Brien Schaefer, "Reconsideration: The Novels of Margaret Drabble," *New Republic*, 26 April 1975, p. 22.

[20]Margaret Drabble, *The Needle's Eye* (New York: Knopf, 1972), p. 365.

[21]Margaret Drabble, "A Success Story," *Ms.*, Dec. 1974, p. 54. The original copyright date is 1972. Subsequent references to this story will be given in the text.

[22]With the exception of the ending of *The Middle Ground* which consciously echoes Virginia Woolf's *Mrs. Dalloway* and which Drabble herself refers to as a "literary joke."

[23]Margaret Drabble, "A Day in the Life of a Smiling Woman," in *The Looking Glass: Twenty-One Modern Short Stories by Women*, ed. Nancy Dean and Myra Stark (New York: G. P. Putnam's Sons, 1977), p. 165. This story is also printed as "A Day in the Life of a Public Woman," *Cosmopolitan*, 1973. Subsequent references will refer to the "Smiling" edition and will be noted in the text.

[24]Fox-Genovese, p. 234.

[25]Margaret Drabble, *The Ice Age* (New York: Knopf, 1977), p. 295.

Arnold Bennett and Margaret Drabble

Charles Burkhardt

Early in her biography of Arnold Bennett, Margaret Drabble describes her indebtedness to him:

> I should acknowledge at this point my own debt to Bennett, in my novel *Jerusalem the Golden*, which was profoundly affected by his attitudes, though as they are of course also a part of my own background I can't quite distinguish what came from where. The girl in *Jerusalem the Golden*, like Bennett's first hero (Richard Larch in *A Man from the North*), is obsessed with escape, and she too is enraptured by trains and hotels and travelling: she feels she has 'a rightful place upon the departure platform' of her home town. There is a good deal of Hilda Lessways in her too, for like Hilda she relished adventure and irregularity, and like Hilda she is summoned to her mother's death bed by telegram and does not respond in quite the right spirit. Perhaps it is irrelevant to mention these matters, but to me they are so much bound up together that my novel is almost as much an appreciation of Bennett as this book is meant to be.[1]

"Trains and hotels and travelling": how they figure in both Bennett's and Drabble's novels! —springing, perhaps, from that original all-productive journey characteristic of so many writers: "The yearning of the provincial for the capital is a quite exceptional passion." (p. 47)

The degree of her identification with Bennett, along with her objectivity, compassion, and extraordinary research, makes her biography, I think, the most satisfactory book she has done, and for its sympathy and shrewdness it deserves comparison with Mrs. Gaskell's life of Charlotte Brontë, surely the greatest of nineteenth-century literary biographies. People quarrel about Drabble's novels; they attack or defend them; novels like hers or like Bennett's are relatively open in form and thus vulnerable in a variety of ways. But the only repeated objection to her life of Bennett has been to laxities of style (from Frank Kermode, John Wain, and others).[2] Yet Bennett himself used the contractions Drabble is criticized for, and I don't see how anyone could not admire, if only for their rhythm, passage after passage like the following, which concludes her book:

> So I, too, feel depressed, unreasonably enough, by his death. He was a great writer from a stony land, and he was also one of the kindest and most unselfish of men. Many a time, rereading a novel or a piece of his journal, I have wanted to shake his hand, or to thank him, or to say well done. I have written this instead.[3]

She too is from a stony land, and this may have been the origin of the attraction:

> My maternal great-grandmother was a Bennett, and the family were potters from Hanley . . . It is widely believed in the family that there is a close family connection with Arnold Bennett . . . I never lived in the Potteries myself; we were brought up in Yorkshire, as were both of my parents. Most of the family has now moved away. Like Bennett himself, they didn't like it much. But many of the things he described—the meat teas, the winding of the grandfather clocks, the kitchen dressers, the stone steps, even the pots on the mantelpiece—are part of my own memories. My mother struggled through the same disdain for conventional Sunday School religion. His need to escape was felt throughout our family. (p. 24).

It is particularly through her mother, brought up in a chapel-going district in South Yorkshire similar to the Potteries, that Drabble feels her affinities with Bennett:

> My own attitudes to life and work were coloured by many of the same beliefs and rituals, though they were further in the past for me, but as Bennett knew all too well they are attitudes that die hard. He might have been surprised to find how closely I identify with them, after two or three generations of startling change. So, like all books, this has been partly an act of self-exploration. (p. xii).

Just as Bennett established control over his provincial background and could use it as raw material and was no longer "afraid of being sucked back into the smoke" (p. 145), so she too has come to terms with it. When Bennett returned to the Potteries at the age of thirty, he could no longer see them as ugly; "I had a startlingly similar experience," says Drabble, "when writing *Jerusalem the Golden*, which I had based on my childhood memories of Sheffield . . .": on her own return she found it "all bright and sparkling and beautiful." (p. 5) She has commented on an interesting and very unusual physical parallel: "I used to have a terrible stammer, which I indeed still have at times."[4]

In contrast to many twentieth-century writers whose work is hermetic or arcane they are public writers who aim at a wide audience. When Drabble was asked in an interview whether an artist is obligated to write for the masses, she said that she feels a "continuous sense of obligation . . . an obligation to those who haven't had it very easy, and who could communicate—who could be communicated with . . ." Speaking of Henry James she says that "extremely attractive to any kind of artist" as he is, "if you look at him in one light—he's simply a colossal snobbish bore, missing out most of the human race."[5] They are public-spirited and responsible citizens (vid. Bennett's services to Britain in World War I) whose writings, like those of their nineteenth-century predecessors, are open, honest, and rhetorical.

And like their predecessors they have in common great fluency and facility. Perhaps too great. Bascially both of them are prose writers, in that their style never takes off, as does Lawrence's or Woolf's, into more thrilling areas. They are not phrase-polishers; they are not Flaubert. "Guided by an instinct which I cannot explain and on which I rely without knowing why, I seek to write down a story which I have imagined with only fitfully clear vision. Why I select certain scenes, why I make a point of beginning a chapter at this point, and end a chapter at the other point, why I go into minute detail here and slur over whole months there—God only knows." This is Bennett, in a letter to his friend George Sturt (p. 61); it could be Drabble, at least in her earlier novels (she once said, "I actually compose very easily. I don't sweat over the sentences at all; they just pour out.")[6] A page of the manuscript of *The Old Wives' Tale* which Drabble reproduces shows how little, and how effectively, Bennett revised; compare it to the jungle of a page from the hand of Proust.

The tradition of Bennett and Drabble is the tradition of realism and its offshoot, naturalism. Drabble considers herself to be a realist;[7] of Bennett she writes,

> One might think that the more heavily a novelist leans on research, the less deeply felt and original his work will be. With Bennett, precisely the reverse seems to be true, and in this he is very much part of the tradition he admired— Zola's novels have the same quality. Documentary reinforced by indignant emotion is his forte, and I at times find his protests about social conditions more moving than Dickens's, and his irony more delicately judged. (p. 278)

Drabble herself relies increasingly on documentation. In her last three novels she gets up ("swots up," as the English say) subjects like archaeology (*The Realms of Gold*) or real estate high finance (*The Ice Age*) or epidemiology and Middle Eastern politics (*The Middle Ground*). At its best, this amassing of supportive detail contributes a sociological and historical dimension to Bennett's and Drabble's fiction in the great tradition of George Eliot or Trollope. The data convinces us, whether it concerns money, class, politics, the contrast between provincial and metropolitan culture, or simply the details of day-to-day life. As Drabble says of Bennett, ". . . Quotidian is, interestingly, one of his favourite words . . ." (p. 104) and she refers to the "hunks of sociology and documentation" (p. 181) of *Clayhanger*. One's sense of felt life in Drabble's own novels deeply depends on her command of the drift and flux of the everyday, whether her heroine is going to a launderette or buying sweets for her children (gobstoppers, sherbet dabs, humbugs). At its most ordinary, the sociology is journalistic. Drabble remarks that "Bennett was good at making a little knowledge go a long way." (p. 167) So is she. Like him she has extraordinary powers of observation, whether for the

look of a street in Chelsea or for a human-interest vignette (e.g. a dazed old woman who has escaped from a hospital) such as the daily newspapers are full of. Drabble has commented on Iris Murdoch's distinction between the "journalistic" novel and the "crystaline" novel: "Like her I'm all in favor of the journalistic . . ."[8]

The nineteenth century was preoccupied with the past because it believed in causality, whatever form it took—whether the determinism of George Eliot, the fatalism of Hardy, the genetic preoccupations of Zola, or the complex expository information that Ibsen supplies. Although the roles of accident and arbitrary coincidence seem to be enlarging in Drabble's later novels,[9] her own belief in the past will make it difficult for her ever to escape the determinist mode. Her recall of the details of her childhood is almost uncanny, as she suggests in her remark that ". . . Bennett, like most writers, has remembered his childhood with startling clarity." (p. 148) The past is useful: ". . . I can't deny that I've used an awful lot of incidents out of my own life. I think all novelists do."[10] Bennett in the middle of his career had escaped from the past more than Drabble in the middle of hers has done. Her heroines revisit their childhood, like Frances Wingate in *The Realms of Gold;* in that novel the three main characters are professionally as well as personally occupied with the past—Frances is an archaeologist, her distant cousin, David Ollerenshaw, is a geologist, her lover, Karel, is an historian. Drabble's method of creating characters is to offer us their life histories and their relationships, most of all relationships with their families, but also with lovers, friends, colleagues, strangers, each of whom is given her own case history. The power of childhood (and the oddities of her late adjectival style) are summarized in this generalization from *The Middle Ground:* "The dirty, tangled roots of childhood twisted back forever and ever, beyond all knowing. Impacted, interwoven, scrubby, interlocked, fibrous, cankerous, tuberous, ancient, matted."[11] Lee R. Edwards has written of Clara in *Jerusalem the Golden* that the efforts of such a protagonist to shape her future "must be accompanied by an equal motion back into the character's own past. This past, this network of parental expectations and social customs, cannot simply be annihilated, but must instead be re-perceived in order that, through understanding, it may lose its power to strangle."[12] But its power is also to enrich, define, and clarify; I do not think it loses its power, anymore than it does in Bennett.

Bennett and Drabble do not differ in their belief about the power of the past. One might expect divergences, as one would between most male and female writers, in their ideas about "the role of woman." Drabble is often thought of as a feminist, Bennett as a member of the male establishment in an era when the "new woman" was being born in plays and novels. It took a long while for her to be born; Bennett helped. When Drabble says, "Bennett was no great feminist, but he always liked

women who did things—writers, actresses, singers, journalists, secretaries," (p. 82) one wonders if he wasn't as much a feminist as any man can be, remarkably so for his age. Everything Drabble writes on this subject—Bennett as feminist— is fascinating. She tells us that, in his first journalism job as assistant editor of *Woman*, his "weekly stint . . . appeared under the name of Barbara." (p. 58) ". . . Bennett is one of the few novelists who can write with sympathy and detail about the domestic preoccupations of women . . . It must have been at this time . . . that Bennett (who did not become a father until he was in his fifties) acquired his unusual knowledge of the behaviour of babies . . ." (p. 56) She points out that "Jane Austen never left two men alone together in her novels; Bennett deals quite confidently with a whole table full of women." (p. 113) Beginning with *Jerusalem the Golden*, Drabble has more and more frequently adopted a male point of view. Bennett's novel of 1916, *The Lion's Share*, deals with feminists and suffragettes.

However, though "feminists ought to have been grateful for the reasonable, encouraging, practical tone which Bennett adopts, and for his repudiation of the outworn concepts of femininity: he always defends the right of women to work, to earn, to achieve economic independence and fair pay, and attacks the 'economic slavery' of the married woman,"— still, Drabble is alert to the complexities of Bennett's attitude. "Despite his solid creation of characters like Anna Tellwright, or even of Leonora (heroine of his novel of that name, 1903), who is certainly real enough, there is, and particularly in his lighter fiction, an implication that women are utterly mysterious, unreasonable, strange creatures, interesting largely because they are so remote and unfamiliar." (p. 120) Elsewhere she says of this dichotomy in Bennett that he is "haunted by the idea of a wife at once docile and beautiful, well-dressed and gracious, intelligent yet servile, a kind of secretary-mannequin-housekeeper-companion all rolled into one." (p. 164) Her own notions flaunt forth like a banner when she writes, "Half of him wanted to see women as delicate, innocent, luxury-loving, foolish creatures; the other half was attracted to women as they really were, tough, adventurous, spirited, independent." (p. 132) This is too prescriptive: can't women be both, as well as a great deal else? But Drabble herself finally escapes categorization; as one of her interviewers, Nancy Hardin, has written of her, she is "not a feminist writer; she is too private a person and is not one who fits well into organizations or women's liberation groups."[13] One is tempted to call the nineteenth-century English novel, the tradition from which Drabble comes, a female form, because, of, among other concerns, its strong social values centered on marriage, children, and the home, yet is it not true that one often, even in Eliot, has the impression that a woman is writing to conform to imposed male standards rather than to an independent female outlook? With Rhys and Lessing and Drabble a woman's

world has become a woman's world, not a man's idea of a woman's world. I do not believe anyone has written as intensely and movingly of pregnancy, childbirth, and young motherhood as Drabble, in her early novels, has.

Her novels have reached a large audience, as did his. Drabble makes very clear which novels Bennett wrote primarily for money and those in which his creative investment was deeper, not that he didn't sometimes overrate his "pop" novels, nor was he unconcerned with the profits from one of his "lit" novels.[14] He knew from the beginning, for example, that *The Old Wives' Tale* was a serious statement, while *The Grand Babylon Hotel (1902)* was a deliberate extravaganza of the type he eventually ceased to attempt— "though, as some would say," Drabble comments, "his serious work unfortunately took on the qualities of his popular work until the one has subsumed the other." (p. 85)

Public novelists of the type of Bennett and Drabble tread a dangerous borderline between pop and lit. To reach their audience they must be accessible; nowadays, since the modernists, we have come to expect that the literary novel, in style, in prose readability, should be a little more difficult. One spends a summer on *Gravity's Rainbow* (or a lifetime on Joyce). One is hard put at times to distinguish between Drabble and the classier soap opera or women's magazine. James Gindin describes the latter part of *The Ice Age*, where the hero Anthony Keating is shipped off to Wallacia, an imaginary Eastern European country, as a sudden switch "into the genre of television adventure series."[15] Her journalistic qualities, along with her facility and her occasional trendiness, blur the distinction between pop and lit. One does not know if there needs to be one, simply that with Bennett one is on surer ground; one knows where one stands.

"As the day for Louise's party drew near, I realized I hadn't got anything to wear." This is the first sentence in the eighth chapter of *A Summer Bird-Cage*. If one is eager to read the next sentence, one will be immune to certain aspects of her early technique, certain weaknesses to which Bennett was never prone. (He had others—his own kind of barebones flatness of style, his frequently flat characters, his glibness or thinness of texture.) Like Bennett, she wrote so much so young, but unlike him, or unlike Charlotte Brontë, elements of personal fantasy and wish-fulfillment sometimes remain untransformed. In her early novels there are moments when she is far too full of herself, as Bennett never quite so intimately was. On the one hand this helps to guarantee authenticity (*The Millstone*),[16] but it can also trigger a kind of romanticism that, at its most balatant, echoes Gerty MacDowell. In Bennett the heroes and heroines often settle for what they were born to, but in *Jerusalem the Golden*, Clara the provincial heroine seeks in London "a truly terrestrial paradise, where beautiful people in beautiful houses

spoke of beautiful things." It's unfortunate that she finds it; Jerusalem the Golden turns out to be the Denham family, intended no doubt to be a bunch of Mrs. Ramsays full of love and perceptions, but which strike me as a group of glamorized fakes. Gabriel Denham, a son, becomes Clara's lover; he is "successful, worldly, intelligent, supremely handsome, safely married" and "satisfies her desire for life, for adventure, for excitement . . ."[17] In this 253-page novel the point of view switches with a disastrous wrench on page 170 from Clara to Gabriel. *Jerusalem the Golden* would be her worst novel if it were not for the long flashback to Clara's adolescence, secondary school, and rites of passage—the longest comedy scenes in her novels, as hilarious in their way as *The Prime of Miss Jean Brodie*.

In *Jerusalem the Golden* the fantasizing portions, when the Denhams conquer Clara, betray themselves in a blather of sentimental stylistics. The word "and" takes over:

> He turned at her approach, as though he had seen her, and when he saw her, he held out his hand to her, and took it, and he shook it, as though they were acquaintances but he held it tightly, and then he kissed her cheek, lightly, as though they were friends, and she inclined lightly towards him, to receive, on a bare exposed cheek, his lips.[18]

It's hard to say which is more striking, the Jamesian commas at the close or the Wordsworthian bathos of "and took it, and he shook it." Other repetitions abound:

> "Look," he said, hearing her soften, "let me come up, let me come up and see you. We can't leave it, we can't leave it like this."
> "Oh no," she said, "you can't, you can't do that. What will they think, if you go away again so soon?"
> "Let me come," he said. "Let me come and fetch you back. You can't stay up there, all by yourself. I'll come up and drive you back." (p. 249)

This is the "Look, Jane, look. See Spot run" school of romance, and it is very fraudulent syntax. Worst of all is the sort of quivery apocalypse which ends the novel:

> Her mother was dying, but she herself would survive it, she would survive because she did not have it in her to die. Even the mercy and kindness of destiny she would survive; they would not get her that way, they would not get her at all. (p. 253)

This, from a student of Leavis's and a double first.

This style does not survive into the later novels, and it is my belief that her study of Bennett—his example, his practice, his authority—has had its effects on them. The Bennett biography would seem to mark a watershed in her career, not that the land on both sides isn't Drabble's easily

recognizable world. It is what I would call a broadening out or an enlargement, beginning with *The Needle's Eye*, published in 1972 when she was researching the Bennett biography (1974), and more obviously to be seen in *The Realms of Gold* (1975), *The Ice Age* (1977), and *The Middle Ground* (1980). Her novels have become longer. As she points out, Bennett himself believed that "he could not write serious short novels," (p. 333) and his last novel, *Imperial Palace*, is very long indeed. There is a tendency in the careers of nineteenth-century novelists for their books to become longer; Dickens was always long, and *Vanity Fair* was Thackeray's first considerable success, but George Eliot became vast, and Trollope's masterwork may well be his magnificent huge panorama of 1875, *The Way We Live Now*. A writer's vision matures, he has seen more and has more to say. In Drabble's case this broadening out—so imaginatively defended by Cynthia Davis and so sharply attacked by Elizabeth Fox-Genovese[19]—takes the form, as it did in Trollope, of a consideration of "the question of England." The interest has of course been present in Drabble from the beginning, but in the early first-person novels psychology won out over sociology. Perhaps her more mature creative intentions can best be seen in this passage about Bennett from *A Writer's Britain* (1979):

> The opening chapters of his two greatest novels, *The Old Wives's Tale* and *Clayhanger*, both give panoramic views of the whole region, using a technique not dissimilar to that employed by Dickens at the beginning of *Bleak House*— the wider setting narrows to the perceptions of one or two largely imperceptive people living within it, unaware of the forces that created their world. Yet Bennett is much more interested than Dickens in causes. Dickens evokes the fog, but does not add a lecture on air pollution. Bennett tells us everything—the influence of canals and railways, the quarrels that preceded their construction, the nature of the trade that made the Potteries wealthy, the dependence of the rest of the country on this trade.[20]

She has always been ahead of Bennett as a rural writer (". . . his novels are remarkable for their lack of rural landscape" (p. 63), her knowledge of birds, flowers, trees rivaling that of Eliot or Hardy or Lawrence; [21] but now she had added a far-more-than-regional range of comment on "the way we live now," on everything from air pollution to railways. When it doesn't work it has the weakness of late Angus Wilson, the unfleshed sociological focus, too abstract, too paradigmatic. When it does work it has the authority of the following passage from *The Ice Age* which, just because of its wider perspective, must be quoted at length:

> Anthony stirred, restlessly. Surely, even as a boy, he and his clever friends had mocked the notion of empire? Surely they had all known the past was dead, that it was time for a new age? But nothing had arisen to fill the gap. He and his clever friends had been reared as surely, conditioned as firmly, as those like

Humphrey Clegg, who had entered the old progression, learned the old rules, played the old games. Oh yes, they had dabbled and trifled and cracked irreverent jokes; they had thrown out the mahogany and bought cheap stripped pine, they had slept with one another's wives and divorced their own, they had sent their children to state schools, they had acquired indeterminate accents, they had made friends from unthinkable quarters, they had encouraged upstarts like Mike Morgan, they had worn themselves out and contorted themselves trying to understand a new system, a new egalitarian culture, the new illiterate visual television age. They had tried: they had made efforts. They had learned to help their working wives to cook and care for the children; they had learned to live without servants, to give elaborate dinner parties without the white cloths and cut glass and silver cutlery of their grandparents, they had learned to survive broken nights with screaming babies, broken nights with weeping, angry,emancipated,emaciated wives. They had learned— academics, teachers, and parents alike—to condemn the examination system that had elevated them and brought them security: they had tried to learn new tricks. But where were the new tricks? They had produced no new images, no new style, merely a cheap strained exhausted imitation of the old one. Nothing had changed. Where was the new bright classless enterprising future of Great Britain? In jail with Len Wincobank, mortgaged to the hilt with North Sea Oil.[22]

The vivid generalizations just quoted are in sharp contrast with the immediacies of her early first-person novels. Her efforts to liberate herself from the solipsistic constitute in fact the direction she's taken. There are hesitant switches in point of view, as we have seen in *Jerusalem the Golden;* in *The Waterfall* there is an interesting but at times rather dizzying alternation between two viewpoints, one, the first person of the heroine, the other, the same heroine viewed ("limited omniscience") in the third person. In *The Realms of Gold* (1975) authorial omniscient comment appears, sometimes jarringly, in discrete paragraphs surrounded by parentheses, e.g.

(The greatest stroke of luck in the family, though Frances was never to know it, lost as it was beyond the possibility of research, had been the marriage of an Ollerenshaw daughter to a shoemaker from Kettering in 1854. . .)[23]

Finally in *The Middle Ground* point of view has attained total omniscience:

While Kate and Evelyn were indulging in recollections of fairy stories and luminous lambs, and inspecting the surface of the pavements of Finsbury Park and the sewage banks of Romley, Hugh Mainwaring sat at his table in front of the typewriter and the pile of books and papers that he was attempting to process into his own Middle East book. (pp. 162-63)

This has a little the sound of "Meanwhile back at the ranch." The shifts from one recording personality to another that one finds throughout Bennett, so supple as to seem an innate rather than a conscious craft—as in-

deed they probably were—she is still not quite easy with.[24]

She has further called attention to what might be called the mechanics of panorama by resorting to the reflexive; abrupt addresses from the author as author to the reader as reader. First, from *The Realms of Gold:*

> As for Sir Frank Ollerenshaw and Harold Barnard, who knows what they were thinking? Omniscience has its limits. (p. 232).
> So there you are. Invent a more suitable ending if you can (p. 346).

In *The Ice Age* there is a passage that recalls the brief chapter "The Author Reviews his Characters" in Gide's *The Counterfeiters:*

> It ought now to be necessary to imagine a future for Anthony Keating. There is no need to worry about the other characters, for the present. Len Wincobank is safe in prison: when he emerges, he will assess the situation, which will by then have changed, and he will begin again . . . (p. 205)

By the time of *The Middle Ground* the omniscience can sound know-it-all, flippant, or cynical; Henry James would have shuddered:

> Evelyn's parents, fortunately for the balance of the narrative, are fine, both still active and in good health, though Mrs. Morton, now retired, is not quite as optimistic about comprehensive schooling as she once was, though she is still as committed to the principle. Ted's parents—but one could go on endlessly, and why not, for there seems little point in allowing space to one set of characters rather than another. (p. 185)

It is difficult to tell whether this is a nod to literary fashion or a sign of ever-increasing creative distance.

Most aspects of her stylistic career have been so well analyzed by Elizabeth Fox-Genovese[25] that one wishes only to summarize one or two others. In her first novels (*A Summer Bird-Cage* and *The Garrick Year*), where the tone can be too jaunty and knowing but which are lit by shafts of dazzling intelligence, the sentences are simple, and easily read:

> "My first novels are much more ingratiating and made far more concessions to the reader. That was because I didn't know how to write a good long sentence and it seems to me if you're trying to express what seemed to me some very complicated concepts, you're bound to get involved in your prose while you're doing it."[26]

Contrast "As the day for Louise's party drew near, I realized I hadn't got anything to wear" with these riotously adjectival passages from *The Ice Age:*

> England, sliding, sinking, shabby, dirty, lazy, inefficient, dangerous, in its death-throes, worn out, clapped out, occasionally lashing out. (p. 77)
> Their supper that night has been tinned soup, hamburger, mash and swede,

and rhubarb and custard. The thin green-pink strands of rhubarb had floated like weed, like scum, acidic, sinister, in the watery juice, nudging uneasily, like a jellyfish against a rock, against the great solid dob of custard. (p. 70)

Perhaps she has gone too far from her laid-back style in the Sixties. Her latest novels are richer in texture but also denser, more portentous and more fraught with conscious symbolism, metaphor, and other referential paraphernalia. In his analysis of *The Ice Age*, which he calls "a metaphor for the economic and social 'freeze' of 1974-75," James Gindin, despite his admiration for it, finds that there is "a blunting of sensibility, a heaviness of reference" and that certain "imagistic connections . . . seem too heavy, too obvious." Elsewhere he comments, "Some of the extreme metaphors of the 'ice age' seem only gesture, something pasted on, not earned through the development of the characters and events in the novel . . ."[27]

Whatever her future course, her debt to Bennett, and through him to Zola, is clear. One sees it most of all in the metaphors, however "pasted on," that organize the last three novels, which so specifically concern the condition of England. With a title like *The Realms of Gold* the picture of England could be ironic or optimistic, and is in fact both: the beautiful church of Tockley, native town of Frances Wingate, is "densely surrounded by building societies and Wimpy Bars"; yet "How beautiful England was, how lovely a place is an English town." (pp. 288-289) Referring to archaelogical or geological sites in Africa, Frances exclaims that England is "Oh, so different, so beautifully different from the parched red mud of Adra, from the glaring altitudes of rocky, weathered Tizouk. England." (p. 293) Then the tone darkens to *The Ice Age*, where architecture, a favorite symbol with both Bennett and Drabble, predominates:

By their monuments ye shall know them. By the Pyramids, the Parthenon, by Chartres and the Hancock Building, by St. Pancras Station and the Eiffel Tower, by the Post Office Tower and the World Trade Center. (p. 168)

But inconceivable to Bennett, too graphic even for Zola, is the image of excrement that most bizarrely pervades *The Middle Ground*. Where can Drabble go beyond, or beneath, the bowels? She believes that Bennett was too hung up or too old to deal with sex as openly as Lawrence and Joyce, but she out-épaters both the latter (and is she trying to?) not with sex but with sewage. The father of the heroine, Kate Fletcher, worked in a pumping station, as his father and grandfather had before him, and had "developed a lively interest in the science of drainage, sewage, and pollution. . ." (p. 15) If in the preceding novel it's an age of ice, in this one it's an age of shit. Kate Fletcher had read a "best-selling angry feminist novel" which describes "the hardships of the woman's lot with the phrase 'shit and string beans.'" She is offended with the phrase: "perhaps it was because her own father had indeed spent his life dealing with shit,

101

real shit, whereas women only have to deal with nice clean yellow milky baby shit, which is perfectly inoffensive, in fact in its own way rather nice." (p. 58) She takes a tour of the London sewage system; returning to her childhood home she sits on a sewage bank and muses on the past (the least heroic evocation of the past in all Drabble's nine novels):

> Oh, God, Kate sighed. She'd never read Proust, but she'd heard of Proust's *madeleine*. How typical of her to have chosen a sewage bank for such stirrings, instead of a nice little cake and a nice cup of tea. (p. 118)

The use of the word "nice" is perhaps coarser than the insistence on excrement. But Drabble goes further:

> Take Sally Jackson, for example. Sally had been a classic case, one of those women who revert to eating their own shit in middle age in complete collapse. A trendy psychiatrist, an acquaintance of Kate's, had cured her by trendy loving means. (p. 133)

All one can say of such a passage or of such a metaphor is that, if not complete collapse, it is, at the best, trendy.

The lesson she could still learn from Bennett, an instinct which she has come close to losing since her first novels, is to write from the inside out. She has been writing from the outside in: instead of "I will say how it was, to me," it's become "I will write a panorama of England, and my image will be ice." Where she once wrote so powerfully out of herself she had come to write backwards, so to speak, out of externals, out of contrivance and heavy stratagem. That her books remain so compellingly readable may mean that she may rescue herself. Perhaps she might return to the best of her books, her life of Bennett, and learn in a practical way how a career can be sustained.

NOTES

[1] Margaret Drabble, *Arnold Bennett* (New York: Knopf, 1974), pp. 47-48. All references in the text are to this edition.

[2] "The Drabble Biography," *Arnold Bennett Newsletter*, 1 (Jan. 1975), 2-11. Roger Sale admires the biography but finds it too long: "Huxley and Bennett, Bedford and Drabble," *Hudson Review*, 28 (Summer 1975), 285-293.

[3] Or see the comparison between Bennett and Virginia Woolf, p. 294, para. 2.

[4] Nancy S. Hardin, "Interview with Margaret Drabble," *Contemporary Literature*, 14 (Summer 1973), 290.

[5] Iris Rozencwajg, "Interview with Margaret Drabble," *Women's Studies*, 6 (1979), 337.

[6]Hardin, p. 275. The interview took place in 1972; perhaps, for her later novels with their more complex prose, Drabble's speed of composition has slowed.

[7]*Ibid.*, p. 290.

[8]Rozencwajg, p. 341.

[9]Cynthia A. Davis, "Unfolding Form: Narrative Approach and Theme in *The Realms of Gold*," *Modern Language Quarterly*, 40 (Dec. 1979), 390-402.

[10]Hardin, p. 259.

[11]Margaret Drabble, *The Middle Ground* (New York: Knopf, 1980), p. 132. All references in the text are to this edition.

[12]Lee R. Edwards, "*Jerusalem the Golden:* A Fable for Our Times," *Women's Studies*, 6 (1979), 323.

[13]Hardin, p. 274.

[14]The pop/lit terminology is mine, not Drabble's.

[15]James Gindin, "Three Recent British Novels and an American Response," *Michigan Quarterly Review*, 17 (Spring 1978), 234.

[16]The American title of *The Millstone* is *Thank You All Very Much.*

[17]The quotations are from Lee R. Edwards, not Drabble; Edwards clearly does not intend them ironically.

[18]Margaret Drabble, *Jerusalem the Golden* (New York: Popular Library, 1977) p. 182. (Originally published in 1967.) All references in the text are to this edition.

[19]Elizabeth Fox-Genovese, "The Ambiguities of Female Identity: A Reading of the Novels of Margaret Drabble," *Partisan Review*, 46 (1979), 234-48.

[20]Margaret Drabble, *A Writer's Britain* (New York: Knopf, 1979), p. 218.

[21]See her evocative essay "Hardy and the Natural World" in Margaret Drabble, ed., *The Genius of Thomas Hardy* (New York: Knopf, 1976), pp. 162-69.

[22]Margaret Drabble, *The Ice Age* (New York: Knopf, 1977), pp. 218-19. All references in the text are to this edition.

[23]Margaret Drabble, *The Realms of Gold* (New York: Popular Library, 1977), p. 296. All references in the text are to this edition.

[24]See Fox-Genovese for an authoritative account of point of view in Drabble.

[25]See Fox-Genovese, *op. cit.*; see especially p. 241.

[26]Hardin, pp. 293-94.

[27]Gindin, pp. 230, 229, 231.

An Invitation to a Dinner Party: Margaret Drabble on Women and Food

Judith Ruderman

Margaret Drabble has recently surmised, perhaps facetiously, that her next novel "will be about food and the crushing effect on the psyche of having to worry about food so much of the time when one half of the world is starving and the other is wondering what to have for its next dinner party."[1] Actually, all of Drabble's novels have to some degree been "about food('s) . . . crushing effect on the psyche," frequently using the dinner party image to express in a condensed and heightened form the complex relationship between women and food. Given the attitude toward dinner parties implied in the above remark, Drabble's use of this image has evolved in a surprising way. As her novels have moved from the private and domestic realms into the public and societal, and as her perspectives on food have become more sociological, even metaphysical, Drabble has placed an increasingly positive value on a woman's preparation and serving of meals—especially those special meals called dinner parties.

In the early novels, those prior to *The Needle's Eye* (1972), the marriage between women and food is as unhappy as that between the various female protagonists and their husbands. *The Garrick Year* (1964), Drabble's second novel, provides a good starting point for an analysis of Margaret Drabble's changing views on the dinner party, because here the focus on food is the most intense of all the early novels and the issues are most precisely defined.

The Garrick Year begins with a dinner party in miniature; Emma Evans sits breastfeeding her infant before putting him down for the night and conversing with her husband about his plans for a "Garrick year"—a year in the provinces doing repertory theatre. Emma wishes to protest these plans, since she has secured a part-time job in London that will afford her a respite from domestic responsibilities; yet she is unable to put up an effective opposition, for if she does not keep calm the child will sense her tension and feed poorly. As Emma puts it, "(O)ne is at a hopeless disadvantage with baby on one's knee, with milk dripping all over and the prospect of a sleepless night if one loses one's temper."[2] The necessity for calmly and regularly providing food always puts some Drabble characters at "a hopeless disadvantage," since, like Emma, they themselves are consumed in the process. Emma's willingness to prepare an impromptu

supper for the theatre people whom her husband, David, has invited to the house is perceived by the actress Sophy Brent as a clear signal that Emma is only an adjunct to David and hence a non-person. Thus, Sophy— who is not a very good actress, and knows it—leaves the dinner party, with its shop talk, and seeks Emma out in the kitchen for some non-threatening conversation. Stuck in her kitchen, Emma is quick to point out that she was once a model and might be so again, at which news Sophy beats a hasty retreat, carrying out two plates of spaghetti but failing to return for more (*she* is no cook, no drudge). This kitchen pas-de-deux, the kind of scene at which Drabble excels, discloses the resentments and insecurities of both housewife and "professional woman."

Told from the housewife's point of view, *The Garrick Year* expresses a woman's frustrations at being a slave to and in her own domain, the kitchen. The unmarried protagonist of Drabble's first novel, *A Summer Bird-Cage* (1962), has to be informed by a married friend of "the difference it makes not to have meals provided. To know that if you don't start peeling the potatoes there won't be the potatoes" (*SB-C*, pp. 35-36). Emma Evans, being married, knows this difference intimately and dwells on it continually. She tells how, when she lies ill in bed, an understanding physician prescribes freedom from her family's demands: "I know what families are like You can drop dead and they still expect you to come to life again in time to get their breakfast" (*GY*, p. 233). Emma notes with disgust that even Sophy Brent has come to rely on her for food and chat in the kitchen and never thinks of putting on the kettle herself. In another man's house, at a tryst with her husband's director, Emma finds that she is expected to cook supper here as well, before they hop into bed; and the expectation (with which she complies) spoils their attempt at lovemaking. Later, a car accident puts Emma in bed once again and elicits her poignant comment that "(e)veryone came to visit me, and brought me presents, and I did not have to do the cooking" (*GY*, p. 250).

Yet others' needs for sustenance confer power on the sustainer, who gloats with pride even as she sighs with frustration, "If I didn't put the food in front of you, you'd all starve to death" (*GY*, p. 175). Emma's space may be proscribed, but it is her space and in it she is commandant: her cooking utensils are the tools of war, her cooking ingredients her ammunition. Emma can prepare meals but begrudge the doing, thereby winning perverse points for her martyrdom; so David interprets her preparation of that impromptu supper for his friends. On another occasion, David's innocuous question, "What are we going to have for supper, then?" becomes a battle cry, and Emma, who would rather be watching television, cannot allow David to prepare the meal lest she relinquish her power over him:

> And so we continued, in cold and weary rage, until I made my way into the kit-
> chen to the chops, for that was the only way I could maintain my arguing
> position about that other, more profound affair (the "Garrick year"); to add to
> my position, to creep another half inch higher up that muddy hill of domina-
> tion, I actually peeled and boiled a pound of potatoes (GY, p. 19).

For the potato peelers of life, even those with other outlets for their creativity, the kitchen is a place where one's mettle is constantly tested and food can be used as a weapon against oneself if the wrong kind is provided or the quantities are insufficient. Whenever someone from outside the family steps into this kitchen, one's reputation is on the line. An unexpected visit to Emma Evans by an old school chum is cause for anxiety: "I was already beginning to worry because there was nothing for tea, and for what occasions but this should one always have a cake in the oven?" (GY, pp. 108-109). When Sophy Brent calls as well, the threesome becomes, in Emma's mind, a party, which she, as hostess, must make a success. Because the kitchen tests the woman's adequacy as a provider of nourishment and hence as a woman, every offer to make a special or difficult or uncalled-for meal is a kind of heroic gesture. As Emma says (apropos her "helping" two-year-old Flora to load the washing machine without the child's being aware of it). "Such disciplines on another's behalf are perhaps some kind of salvation" (p. 218). Emma interprets her impromptu supper for her husband's colleagues as a sign not of her martyrdom, as David believes, nor of her nothingness, as Sophy sees it, but rather of her love. In Drabble's novels the selfish characters, like Clara Maugham in her fourth book, *Jerusalem the Golden* (1967), prepare no dinner parties. Clara does not like to put herself to the bother of entertaining, though she is happy to be entertained in the homes of others; a taker rather than a giver, she cannot love. Another Drabble protagonist, Jane Gray in *The Waterfall* (1969), recognizes that her own feelings of aversion toward cooking are a sign of a deep psychological problem: a distaste for the impurities and imperfections of real life (W, pp. 135-36).

Jane Gray retreats from life into art, into the security of rhymed poetry: she says, "I could see myself living out that maxim of literary criticism which claims that rhyme and meter are merely ways of regularizing and making tolerable despair" (W. p. 114). Other Drabble heroines, more domestic than Gray, cope with their despair by cooking and serving, but their gestures, in these early novels, are only stopgap measures. Even Emma Evans must admit, ultimately, that her offer to prepare supper for the actor friends was not really an offer of love but a substitution of food for sex: her dinner party is a temporizer as well as a coverup for the fact that all is not well at home. When she discovers David's affair with Sophy she drops a bottle of milk, admitting, "I fight so hard against domestic chaos, my efficiency is nothing but a reflection of terror" (GY, p. 217). After consummating her own affair with David's director she goes off into the

kitchen to make tea (always ᴜne good hostess) and to tidy up; to get him to leave she begins to clear away the tea things, an act which evokes her later response, "It is striking and frightening . . . to see how clearly, how childishly, how woman-like I take refuge in triviality and try to order chaos by sweeping up a few crumbs" (p. 241).

Emma's depressing view of domesticity is voiced especially loudly by the unmarried women in the Drabble canon. These women reserve their greatest scorn for the dinner party, which they see as a meaningless, empty activity helping to fill meaningless, empty lives. The narrator of *A Summer Bird-Cage* discusses the sad state of her sister's marriage with a cousin: "I think she spends her time giving boring dinner parties . . . I suppose she could go on giving dinner parties all her life." The cousin proposes what is to him another horrid alternative: "Perhaps she'll have a baby" (*SB-C*, p. 144). Rosamund Stacey in *The Millstone* (1965) takes the second route, without benefit of husband, and finds it extremely fulfilling and exciting. But dinner parties are another matter. At the food market she meets up with her detested sister-in-law, who is shopping for her next admittedly boring dinner party, and the happily pregnant Rosamund feels quite superior to her. Putting dinner parties on a par with "endless visits to the dry cleaners and sessions under the hairdryer" (*M*, p. 71), Rosamund obviously considers her own endless visits to the obstetrician—as she will later consider those to the pediatrician and the pharmacy—to be of a higher order. So admirably self-sufficient, Rosamund Stacey is also rather exclusionary and somewhat shortsighted in her view of the dinner party. Certainly she would have no admiration for Emma Evans' creation of excitement in her boring life in the provinces by the separation of "endless eggs" for a mousse, nor any sympathy for Emma's dejection when the party is unavoidably cancelled (*GY*, p. 101).

It is in *The Needle's Eye*, Drabble's sixth novel, that the positive aspects of dinner parties receive their first emphasis. As we have seen, the issues involved in woman's relationship with food are presented in the earlier fiction, particularly in *The Garrick Year*; but dinner parties occupy critical positions in three of the four latest Drabble novels: the beginning of *The Needle's Eye* (1972), the middle of *The Realms of Gold* (1975), and the end of *The Middle Ground* (1980).

At first *The Needle's Eye* dwells only on the infelicities and anxieties of dinner parties; the hostess' anger at one guest's lateness, which delays dinner and threatens a culinary disaster; the guests' obligatory remarks of appreciation for each course; their feelings of entrapment by uncongenial seatmates; their sense of liberation at getting up from the table and seeking new possibilities for conversation. As the party nears to a close, Diana, the hostess, experiences contradictory emotions of relief and panic. She alternately wants and does not want her guests to leave. She is overcome with dread that the event itself has been a meaningless frivoli-

ty, and yet she also fears the opposite, that the dinner party has conferred on her a great power to change the course of life:

> She went into the kitchen to pour herself a glass of water, as she was dying of thirst—perhaps everyone has been dying of thirst, perhaps that was why they had all gone home, to get themselves from their own taps the drinks of water which she had not thought of offering. And as she stood there, gazing into the debris in the sink, a wave of panic filled her; so pointless it was, such an evening, such a stupid life she led, such stupid frivolous aspirations, and they had all gone away and left her, her part was finished, she would drop from their minds as casually as a leaf from a tree, as naturally unregretted, having played her part, having fulfilled her role, she would drop from their minds as from this story, having accomplished nothing, set nothing in motion—or if something had been set in motion, how terrifying, how alarming, she was not able to cope with the consequences, she did not like to think that anything would happen, nor that nothing would happen. What was it for, she asked herself, as she rinsed out the clean watery glass, what was it for, and why would she do it again the week after next? *(NE*, pp. 36-37).

In fact, as the rest of the novel will show, Diana *has* accomplished something, set something in motion. She has served up people to other people along with the chicken cassoulet and the chocolate mousse, and at least one of these conjunctions is fruitful; the meeting of Simon and Rose at this dinner party results in a deep and long-lasting relationship between them. Here Drabble intertwines the motif of the dinner party with the theme of accident versus design that—judging from its prominent place in all her novels—is of such importance to her. Simon and Rose seem to have been thrown together by chance, but actually the host and hostess have brought the two together to be a match of sorts, as Simon recognizes when he counts the guests: "There would be another woman expected; another woman for him" (*NE*, p. 16). After this party, Diana drops out of the story, her work completed. But Simon's wife, Julie, gives her own dinner party halfway through the novel, which the reader cannot help comparing with the earlier one. At Julie's dinner party Simon meets no one he likes and sees that the guests are as bored as he. His wife expresses her resentment and anger at Simon in the subtle ways she serves his chicken or positions her chair. Unlike Diana, Julie creates no magic through food and conversation. Simon neatly encapsulates her shortcomings: "She was not built for dinner parties" (p. 179).

After Diana's party the focus shifts to Rose Vassiliou as the female who metaphorically *is* built for dinner parties. Rose's feelings about the shabby street on which she lives apply equally well to the phenomenon of the dinner party as Drabble increasingly views it: "All this, you see, I created it for myself . . . I carved it out, I created it by faith, I believed in it, and then very slowly, it began to exist. And now it exists. It's like God. It requires faith" (*NE*, p. 42). In these later Drabble novels, chaos and ugliness threaten on all fronts, not only the domestic, and the search for

order and beauty is a creditable undertaking, no matter what seemingly trivial form it takes. Rose Vassiliou is impractical, otherworldly, and laughable, but hers is the life exemplifying the virtues (Vertue *is* her middle name) and hers is the last word in this novel.

In Drabble's next novel, *The Realms of Gold* (1975), the dinner party is literally the central image, occupying fifty pages in the middle of the book. The matter of food—cooking it, eating it—has become in Drabble's fiction a matter of survival, survival not only of the childrearing years or of a bad marriage but of life itself over death. The book begins with Frances Wingate alone at dinner in a restaurant, reading Virginia Woolf. Frances muses on Woolf's suicide, deciding that she herself, with her "amazing powers of survival and adaptation" (*RG*, p. 17), will no doubt live on into her dotage. Virginia Woolf is never mentioned again, but she appears for all intents and purposes in the character of Beata, wife of Frances' nephew—a woman who suffers, as Woolf probably suffered, from anorexia nervosa, the mental disorder which causes the patient, ninety percent of the time a young female, to starve herself. Beata, who never appears in person in the novel, is a strange, ghostly, and disturbing counterpart to the "incredibly greedy" (p. 116). Frances, with her insatiable appetite for food and for life (just as the sick Virginia Woolf, refusing to eat, is a disturbing counterpart to the well Virginia Woolf, enjoying food and drink, and to Woolf's fictional heroines like Mrs. Ramsay in *To The Lighthouse*, revelling in her boeuf en daube[3]). Critic and poet Sandra Gilbert, calling anorexia "the disease of the decade," explores the complex connections between this illness and femaleness in a 1978 essay entitled "Hunger Pains." She says, in part, that

> while anorexia nervosa is a disorder to which only outwardly compliant and stereotypically feminine personalities are subject, it is paradoxically associated with a fierce denial of femaleness, even though that denial is expressed, again, through a stereotypically feminine form of selfabnegation—dieting. The central paradox of anorexia, then . . . may be precisely its parodic use of femininity to deny or subvert femaleness, and in a larger sense its strategic use of self-denial as an ironic form of self-assertion . . . It may be that as a parodic strategy anorexia dramatically tells us that to be female is to be hungry, even starving. Significantly, women—like a number of other oppressed and subordinated peoples—have consciously used literal hunger as a means of protesting the metaphorical starvation in their lives. Together with the grotesque force feeding (through nasal tubes) inflicted on them by prison authorities, these events constituted a particularly 'striking' demonstration that the only right available to the powerless is the right of refusal.[4]

Gilbert's remarks help to explain the behavior not only of Beata Ollerenshaw in *The Realms of Gold* but also of Phillipa Denham in the earlier novel *Jerusalem the Golden*; since the birth of her third child, a girl, Phillipa eats little and cries often, overcome by the futility of adding yet

another vulnerable female to the world. A mark of the bleakness of Drabble's eighth novel, appropriately named *The Ice Age* (1977), is that "most people's children," so its protagonist reflects, seem to suffer from venereal disease, schizophrenia, drug addiction, or anorexia (*LA*, p. 50). Indeed, Anthony Keating's own unhappy and rebellious teenage "stepdaughter," who has gone from one bizarre diet to another, eventually chooses starvation in a foreign prison (and is force fed) as a gesture of self-assertion.

But the bleak and anorexic vision of *The Ice Age* is not the vision of *The Realms of Gold*, in spite of Beata's refusal to eat, in spite of the suicides of Beata's husband and Frances's sister, in spite of the death by starvation of old Aunt Connie Ollerenshaw (whose stomach is found to contain bits of a cardboard box). Because of the alternatives presented by these characters, the dinner party stands out in great relief and carries a burden of significance not seen in the earlier fiction. Drabble devotes fully one seventh of the book to the party given by Frances' cousin Janet, apologizing afterwards for the length: "And that is enough, for the moment, of Janet Bird. More than enough, you might reasonably think, for her life is slow, even slower than its description, and her dinner party seemed to go on too long to her, as it did to you" (*RG*, p. 174). In fact, Janet's party does not go on too long, merely long enough to present in a striking manner the many issues involving women and food.

Janet Bird's party begins inauspiciously, with Janet's gloomy thoughts as she exercises the baby before settling down to her cooking; passing the shop windows, full of household items, she thinks of marriage as a temporary lapse of sanity to which girls are lured by "Pyrex dishes and silver teaspoons as bribes, as bargains, as anesthesia against self-sacrifice" (*RG*, p. 124). The prospect of her party depresses her further, even fills her with dread; for she lacks confidence in her cooking—"Every meal that she prepared seemed to contain in it the charred or bleeding ghosts of her first disasters" (p. 128)—and knows that her husband will shame her in front of their guests (whom she doesn't like) if he finds so much as one lump in the sauce. Once in her kitchen, Janet enjoys slicing mushrooms for the soup, but the chicken arouses fears that she may have given these guests chicken the last time they came for dinner, and what if they've already tried the same recipe from *Femina!* An unexpected visit from her mother further complicates matters. Janet feels her mother's stern disapproval of her every deviation from maternal culinary norms: of her peach sauce for the chicken, of rice as a side dish rather than potatoes, of the soft crackers offered to her mother with tea. It is with relief that Janet sees her mother to the door, her feeling of power and control returning as she steps back into her own kitchen. This lack of communication between mother and daughter is typical of Drabble's novels, but here its pathos is increased by the equal time given to the thoughts of Janet's

110

mother, and by the fact that the failure to make contact occurs in the kitchen, the traditional site of female communication in the passing on of nutritional lore from mother to daughter.

Janet enjoys setting up for the dinner party, choosing the dishes and placemats and goblets and placing them in a pleasing arrangement on the table—creating what Jane Gray would call "feminine endings" *(W.* pp. 211, 248) and T.S. Eliot "fragments shored against ruin." She has no sense of pleasant expectancy before her guests arrive; "Maybe it would be all right" is the best sentiment she can muster, and then only fleetingly *(RG,* p. 154). For with the arrival of the guests, things go wrong: the baby cries, her husband makes an issue of the noise, everyone orates pompously. The absurdity of the entire situation strikes Janet hard as she thinks of "(w)hat a funny business it was, dressing up in one's best clothes to go out to one another's house to stare at one another's husband" (p. 157). But when the electricity goes off in the house—and with it the lights and heat—everything changes, seen in a new (candle) light. Drabble encourages the reader to take the long view of the dinner party as a custom or ritual by having one of the guests remark that they all might freeze there and "be put in a museum as a diorama, they could call it 'Dinner Party in the Provinces in the Nineteen Seventies'" (p. 162). For a moment the guests are knit together, finding their roots in a common humanity, just as Janet, Frances, and yet another Ollerenshaw cousin will soon discover their kinship and bind together as a family. Janet's getting water to boil on a little cooking stove unites the group in the creation of coffee:

> They all watched, spellbound, for the water to bubble, as though watching the process of boiling for the first time . . . It was not the coffee they wanted, it was the magic of the process, it was not the triumph of the process but the magic of it, not the will and the domination but the secret invocation (p. 163).

The coffee itself, produced in this manner, becomes "more an offering than a drink" (p. 164). For these few moments the dinner party has created its magic, transforming familiar people and softening ugly realities. The magic is brief. Jokes coarsen, dishes lie dirtily about, and, ultimately, an unloved husband demands sex. But the moment of communion achieved through Janet's dinner party is not to be scoffed at.

The possibilities of a new relationship with Anthea David, who at this party has shown sides of her personality never before seen, lie open before Janet, who desperately needs a close woman friend and will soon gain an approximation of one in her cousin Frances. With Frances, Janet will learn what Sandra Gilbert says women must learn: "to feast together (as Judy Chicago's new Dinner Party project suggests they should) rather than to fast in isolated declines." Indeed, Gilbert's discussion of anorexia nervosa—contained in her review of Hilde Bruch's book on the subject,

111

The Golden Cage—points us in the right direction for seeing a major emphasis in Margaret Drabble's later novels:

> Can a feminist theorist of anorexia nervosa foresee a finish to female hunger? I myself do see a few signs that help me, at least vaguely, to sense an ending to all this. Minnie Muenscher's wonderful and representative *Herb Cookbook* gives me one idea to which, although some readers may think it trivial, I would like to cling. For in this volume—part herbarium, part recipe book—a cook-botanist who works in the half-forgotten tradition of 'wise women' exuberantly classifies and codifies both plants and recipes, reviving and revitalizing the ancient healing powers of the female kitchen. Maybe if women themselves could mythologize the transformative energies of domesticity (as, indeed, such great modernists as Mansfield, H. D., and Woolf did in their happiest moments) female hunger-and-emptiness would turn to female fullness-and-fulfillment. I am not suggesting, you understand, that Hilde Bruch should crave (cram?) Minnie Muenscher's Lavendar Salad or Lima Beans with Tarragon down the throats of anorexic adolescents. But I am hinting that there may be hints for us to follow in forgotten matriarchal huts, at the edge of the forest that surrounds our culture.[5]

As evidenced by *The Realms of Gold* and especially by *The Middle Ground*, Margaret Drabble is one of the women who are helping "to mythologize the transformative energies of domesticity." The dinner party that is the culminating activity of Drabble's latest novel is fraught with none of the doubts and disasters that mar the parties given by a long line of Drabble females stretching back to Louise Halifax in *A Summer Bird-Cage*. But to understand this party fully—to see what Drabble means to do with it—we must place it in the context of the novel, which in turn is placed in the context of the 1970s.

"The sourness of the seventies" (*MG*, p. 121) pervades *The Middle Ground*, and the fragmentation of society that the novel mirrors continually threatens to tear the book itself into pieces. People are so separated into groups and factions, proclaiming their opinions on a wide variety of subjects, that the reader has trouble in seeing them as part of a unified whole. The heroine, Kate Armstrong, also feels assaulted by opinions from all sides; even worse, since she is a journalist, opinions are her own stock in trade. The single issue on which Kate has established her reputation is women's rights, and, as might be expected, the dinner party figures in this novel as a fashionably feminist issue: an acquaintance who has had her consciousness raised complains to Kate of being expected by her chauvinist husband to give dinner parties for his colleagues (pp. 99-100). Yet in this issue-oriented novel, filled with haranguing about the third World, Israel, the National Front, Marxism, and so on, and set in "the global decade" that has seen the destruction of possibilities for cultural absolutism and ethnocentricity (p. 173), the dinner party provides one small but very real moment of unity. Drabble is rather apologetic about this fact. Her above mentioned prescription for her next

novel indicates that the question of dinner parties is, to her mind, at the opposite end of the spectrum in importance from the matter of world hunger. And in *The Middle Ground,* Kate Armstrong notices that her rabidly pro-Arab house guest, Mujid, has become "as interested as anybody in the trivia of existence" such as whether Kate will include him for dinner; she thinks that Mujid has "sunk to their own level" (p. 110), since he used to be interested in larger issues (We notice that Sandra Gilbert also semi-apologizes, with the word *trivial,* for her ideas on mythologizing domesticity). Yet clearly Drabble believes that wondering what to have for one's next dinner party is not necessarily the pastime of the shallow, unliberated woman, indifferent to the fate of the hungry. At its best the dinner party is a celebration of community, no matter how fragile and temporary, and a testimony to strength and survival.

The compatibility between deep regard for humankind and the giving of dinner parties is shown in *The Middle Ground* by Evelyn Stennett, who is surely Drabble's most saintly female character, saintlier even than Rose Vassiliou. Kate Armstrong envies and admires her, for after working all day with the poor of London (she is a social worker) Evelyn manages at night to give "proper dinner parties with proper food" (*MG,* p. 115). Kate's own children, who get meals slapped down on the table in haphazard fashion in their mother's home (as Drabble's do in theirs[6]), think of Evelyn's house as a refuge, where one can "actually get a proper meal sitting down at table" (p. 56). At one of Evelyn's dinner parties early on in the novel, the wife of a World Health Organization official is so horrified and depressed at what she has seen of poverty and death in Africa that she can hardly eat and eventually locks herself in the bathroom; after she leaves, the others help "themselves hungrily to more cheese, to great slices of brown bread, pouring themselves more wine . . . They ate and drank, the survivors, excited, exhilarated, their lease on life renewed by the precarious tenure of others" (p. 48). Greedy for life, like Frances Wingate, the main characters in *The Middle Ground* survive an astonishing variety of disasters, both personal and global. Evelyn herself, whose husband begins an affair with her best friend, Kate, at this very dinner party, knows the worst about everything but chooses to survive. She does so by keeping her womanly "ancient places" (p. 180): in the domestic realm, catering unselfishly to her husband; in the outside world, serving others through social work. Though the woman's movement has called these places in question, though Drabble herself has called-ed them in question, *The Middle Ground* calls in question the calling in question.

Thus, at the end of the novel Kate Armstrong sets aside the onerous burden of dealing with Woman in the abstract and decides simply to be:

A wonderful if temporary relief flowed through Kate, at this release from the

grip of the representative. Henceforth she would represent nothing but herself. And if she liked to sit here with three teenagers not even her own, and happy, yes, she could not deny it, happy to have been called in, to be of use, to be able to do something for Evelyn and for them, if only to make cups of tea, well, that meant nothing at all but that *she liked it* (MG, p. 229).

The prospect of dinner party to mark various friends' "passages" fills Kate's entire household with excitement. Indeed, at the preparations for this party, which occupy the final twenty-five pages of the book, the novel for the first time picks up tempo and spirit. Cleaning up is a monumental task. The grocery list is exotic and chaotic. The guest list unites all the ex-spouses and ex-lovers. Even characters from other Drabble novels will come to this party: Phillipa Denham from *Jerusalem the Golden*, no longer married to Gabriel and presumably no longer fasting and crying; Rosamund Stacey from *The Millstone*, still unmarried and perhaps ripe for an affair with Ted Stennett. Margaret Drabble cannot bear to keep her characters, her friends, separate—they must know each other, be drawn together and connected, as she connects them in this novel, as Kate connects them at her dinner party.

A reference to *Mrs. Dalloway*, which Kate's daughter is reading at school, reminds us again of Virginia Woolf's importance to Margaret Drabble, and of the dinner party as a central image in the fiction of both writers. Virginia Woolf also makes connections in her novel: not only does Clarissa Dalloway invite her friends from all parts of town, but Woolf invites a favorite character from another book—Mrs. Hilbery, from *Night and Day* (this is tit for tat, since the hostess Clarissa was herself once a guest in another book, *The Voyage Out*). *The Middle Ground*, like *Mrs. Dalloway*, was written when its author was about forty years of age and painfully aware that the time for enjoying life and creating beauty is not unlimited. Both novels culminate in a dinner party, and both point to one means that women have traditionally possessed of creating unity and beauty in defiance of dissension and ugliness. Kate's choice between boeuf bourguignon and quiches seems frivolous when elsewhere old women are eating cat food to survive; still, the alternatives to making this choice are themselves unpalatable. *Mrs. Dalloway* has helped the Armstrongs to structure their dinner party correctly, and hence to structure their lives; but if they wish to add a tree to the prescribed flowers, that is their prerogative. Within the parameters of the dinner party form lies a multitude of choices. Indeed, the novel ends with Kate's indecision about what to wear to her party—"Not, of course, a very serious choice, unless you wish to read it symbolically; but not, you will agree, an uncommon one. A lot of time is spent in such attitudes, by many of us who would not care to admit it" (p. 276). In the setting of her house in order, Kate feels herself to be the center of her family "in the most old-fashioned of ways oh (Drabble sighs), there is no language left to

114

describe such things, we have called it all so much in question" (p. 275). But Kate, unlike Woolf's hostesses and Drabble's earlier heroines, is not limited to a domestic realm. Her party, like her life, lies before her, filling her with expectancy, for "(a)nything is possible, it is all undecided. Everything or nothing" (p. 277).

Artist Judy Chicago has said of her own *Dinner Party*, "cooked up" by both women and men over a five-year period, "As the project grew and expanded, my isolation as an artist slowly gave way to a studio environment in which many people worked together The struggle to bring this piece into fruition has given birth to a community."[7] So too the dinner party as Margaret Drabble interprets it in *The Middle Ground* is a paradigm—yes, some will "wish to read it symbolically"—for human activity of the best kind, as well as a testimony to one woman's feelings of integration into society. In the course of Drabble's fiction, dinner parties have become significant rather than trivial only by the same "conspiracy of faith" that Evelyn recommends for keeping cities safe (p. 244), and Rose Vassiliou for seeing streets comfortable. Drabble's choice to believe may gain her criticism, since the feminists who chastised her for choosing a male protagonist for the business world of *The Ice Age*[8] may now protest her placing her heroine back in the kitchen—men's places, women's places. But Drabble's kitchen is filled with men as well as women, together preparing refreshment in the largest sense.

NOTES

[1]Quoted in "Waylaid by Novels," by Catherine Stott, the London *Sunday Telegraph*, July 6, 1980.

[2]*The Garrick Year* (New York: Popular Library, 1977), p. 9. Further parenthetic page references to this edition will be preceded by *GY* in the text. Other works by Drabble cited in this essay, with their abbreviations, are as follows: *A Summer Bird-Cage* (New York: Popular Library, 1977)—*SBC*; *The Millstone*, retitled *Thank You All Very Much* in its American edition (New York: New American Library - Signet, 1965)—*M*; *Jerusalem the Golden* (New York: Popular Library, 1977)—*JG*; *The Waterfall* (New York: Popular Library, 1977)—*W*; *The Needle's Eye (New York: Popular Library, 1977)—NE*; *The Realms of Gold* (New York: Popular Library, 1977)—*RG*; *The Ice Age* (New York: Popular Library, 1977)—*IA: The Middle Ground* (New York: Alfred Knopf. 1980)—*MG*.

[3]Leonard Woolf provides a moving description of his wife's episodes of self-starvation in *Beginning Again: An Autobiography of the Years 1911-1918* (London: Hogarth Press, 1964), pp. 162-63, quoted in Roger Poole, *The Unknown Virginia Woolf* (Cambridge: Cambridge University Press, 1978), pp. 148-49, and in Phyllis Rose, *A Woman of Letters* (New York: Oxford University Press, 1978), p. 114. Poole notes the inappropriate nature of the treatment administered to Virginia Woolf—including a kind of force feeding—given her aversion to food, while Rose makes the connection between Woolf's anorexia and Mrs. Ramsay's dinner party.

[4]Sandra Gilbert, "Hunger Pains," in the food issue of *University Publishing*, 8 (Fall 1979), p. 11.

[5]*Ibid*, p. 12.

[6]So Drabble has stated to Catherine Stott, *op. cit.*

[7]Judy Chicago, *The Dinner Party* (Garden City, N.Y.: Doubleday - Anchor Press, 1979), p. 19. As recorded in Chicago's journal entries, the change in her conception of her dinner party project over a five month period is similar to the change in Drabble's use of the dinner party since 1962: "all (the women) will ultimately be offered up in the *Dinner Party* metaphor—contained within domesticity, served, and ready to be consumed" (May 9, 1974; p. 22). "First I was going to subtitle it 'Twenty-five Women Who Were Eaten Alive.' Then my concept changed from women who were consumed by history to women who could be models for the future" (October 8, 1974; p. 23).

[8]One is Carolyn Heilbrun, in *Reinventing Womanhood* (New York: W. W. Norton & Co., 1979), pp. 28-29.

Patterns in *The Garrick Year*

Dee Pruessner

Margaret Drabble's novels are usually concerned with the ways that one can build a self, and this process can be described in two fundamental ways. One way portrays life as a journey where one travels toward an identity, and the other describes life as theatre where one can try on various roles.[1] The former process involves a linear, developmental progression, and this is the process that some see at work in *The Garrick Year.* Valerie Myer claims that throughout the novel, Emma Evans changes and grows, that she finally accepts her sexuality and in rescuing her daughter from the Wye River, she is re-born and baptized into a new kind of life, an acceptance of the flesh and the emotions.[2] Others see Emma as coming "to a knowing acceptance of both the value and the limitations of her life with David and the children."[3]

However, the metaphor of life as theatre, where everyone plays a part or observes others playing parts is at least as important to the structure and theme of *The Garrick Year* and is much more descriptive of what actually happens in the novel. One crucial way that Drabble's characters can develop a sense of self is to play act, to use their imaginations to fashion flexible roles which will help to realize and define the self.[4] Roles can be liberating if one is not trapped in them. However, one can refuse to act, or one can hide behind roles and use them as disguises. This process eventually destroys a sense of self, and this is the process that is at work in *The Garrick Year.*

Throughout *The Garrick Year*, Emma observes rather than acts, and to assure her neutral position as observer, she assumes various disguises. We first see her watching television, which reminds her of what she calls the Garrick year, the time she spends in the country with her husband while he is acting in a local theatre. The year was not pleasant for her, and yet she recalls it with amusement and nostalgia. Already, Emma has established herself as an observer, even of her own life; she sits back, with great detachment, and watches. In fact, Emma is very much like the television that she watches. We can easily imagine Emma as a compulsive television watcher, passively absorbing images on the screen. Just as Emma absorbs outside images, so is she absorbed as an image. She has been a model who passively performs at another's direction, and she speaks of the camera as that "gluttonous negative machine"[5] that seems

to devour and to turn life into artifacts, as is the case with her friend, Bob, who takes pictures of seedy old drunks on the street.

Television is safe for Emma because it does not expose the truth. It seems to consume the personality and to hide and distort. Sophy Brent's cake commercial makes the act of eating cake seem glamorous by leaving out the chewing and the crumbs. Emma thinks that Wyndham Farrar, the celebrated director, looks better in real life than he does on television. His face is too complex for the camera. Emma also feels that she can safely hide behind the screen and lose herself. The job she gives up to go to Hereford with David is as announcer on the news program. She is to announce "serious events as well as forth coming programmes....I have a face of quite startling gravity, a pure accident of feature, I believe, and people automatically trust what I say" (p. 11). The facts must be properly packaged for television, and one must always consider the effect on the audience.

If one plays parts for an audience, rather than trying on roles to experiment with various facets of the self, then one is ultimately controlled and created by that audience rather than being created by oneself. This concept becomes clear in David's discussion of acting with one of his colleagues, Michael Fenwick. David claims that acting is "all a matter of truth...you can't tell the truth if you have one eye on how it's being taken all the time, can you?...you can't keep listening for reactions" (p. 73). Fenwick, on the other hand, believes that acting is "basically entertainment...and you can't amuse people unless you pay attention to their reactions. It's like fishing, you give them a bit of line, and see if they're biting, and if they are, you give them a bit more" (p. 73). David's theory demands that "you must always be yourself....there's nothing else you have to offer but yourself, so that's what you have to give" (74). Emma listens to this discussion and seems to side with David even though she does nothing but consider her audience.

We see Emma most clearly combining the roles of audience and performer as she attends the first party for the actors and townspeople of Hereford. Emma had complained about the probable lack of social patterns that she could observe, and now, about to sample some of the local color, she assumes a safe and neutral role. To be sure that she fits no particular category, that she cannot be easily identified, she dresses carefully in an archaic Victorian manner that has a photographic quality. She is satisfied with the end product, herself, and thinks, "When I had finished, I thought I looked wonderful: they would have difficulty in knowing what to make of me, at least" (p. 57). That Emma is dressing for a part to play is made even more clear when Sophy compliments her on her clothes, and Emma wonders why she warms to Sophy's appreciation. "I was confronted once more with the question of audience and performer. And yet the fact that she applauded did in a sense commend her" (p. 78).

118

Emma hides behind her role as wife and mother. The first time she meets Wyndham Farrar at a party, she feels that she does not count because she is pregnant. But she can observe. The second time she meets him, he penetrates her disguise somewhat, and Emma feels threatened. She "felt shaken, as though what he said had been said to me myself, and not to David Evans' wife or to a woman looking at the notice board who seemed from the eccentricity of her hair style to be an actress" (p. 86).

Another of Emma's disguises that is exposed at the party in Hereford is that of "poor little rich girl with a sick mother." Emma seems at the time to almost portray herself as an orphan Annie. She puts the relationship with her mother into story form, wanting to tell people, "Oh, she died in the end" (p. 66). She is using the role of performer here to distance herself from the facts. She casts the story of her mother and herself into stagey terms; she thinks others had a "lurid" pity for her and that the Mary Scotts of the world "must have been perpetually waiting for my own dramatic crib death Brontë fashion in my little crib at school" (p. 68). Emma says that as a child, she "had simply lifted from my background what I thought would be of use: an excuse for mild indulgence, a good sob-story to endear myself to people late on in parties, a harsh degree of anonymity, and a respect for my father," (p. 68) and we might also add, an enormous capacity for remaining a detached spectator on herself and her own life.

Emma continues this childhood role into her adult life as we see in her conversation with Mr. and Mrs. Scott. As an adult, she has been playing before a small, select inner circle, a coterie. She is that "once famous Emma" whose fate is of so much concern to "those Marxists in Rome, those historians and photographers in Hampstead, those undergraduates in two universities" (p. 141). Emma seems unaware, however, that in using her background as a stage prop, she is doing what she accuses Mrs. Scott of doing, leaving too much out. In talking to the Scotts, she is still performing; the props are now her husband and children. And when she storms off after David joins their conversation, she thinks, "I had at least given them their money's worth" (p. 69).

The fact that these roles are essentially lifeless and confining, that they provide Emma with no opportunity to grow, is made clear through Drabble's use of images. Emma is most often associated with technical apparatus of some sort, machines which also perform at another's bidding. Even the associations are made more by way of prose analogies than by poetic images. Emma's emotions are described in terms of machinery. When she meets Wyndham and senses his interest in her, she thinks,

> already I could feel the pointless wheels in that piece of dud machinery beginning to turn, that dud machine, which, like a failed effort at perpetual motion will tick for a little while and then stop and stick and rust (p. 85).

Emma thinks of her marriage to David as "chaining" herself to his wildness; each thought that they would by "that one ceremony strap ourselves to the dusty wheels of the other's headlong career" (p. 32). Emma submits to the "domestic machinery" of her marriage, to the confinement of patterns and roles which she has not created herself, almost as she does to the movement of the train, "that soft repetitive motion against which I could lie limp as a doll...my attempts at rhythm taken over by those crude padded pistons" (p. 43).

As Emma is confined to limited roles, she is also confined to patterns which repeat themselves and which allow her no room to develop or grow, and at the same time we see her essential passivity, her tendency to react rather than to act, as the basis of these patterns. An emblem of Emma's life is found in that second meeting she has with Farrar as she looks at the noticeboard and waits for David to get out of rehearsal. As she waits, she arranges all the spare pins on the board in a neat circle. Farrar walks up behind her and asks, "Do you think I might disarrange your nice little pattern and have a couple of pins?" Emma's response is, "I suppose so...They are hardly mine to withhold" (p. 82). This exchange shows Emma's essential passivity in her equivocal response to Wyndham's request and the sterile, repeating patterns that she forms, not only with pins, but with other people's lives and her own.

One of Emma's most obvious circular patterns is her affair with Wyndham. Emma likes to be driven around the countryside (and even this is circular since they stay within a ten-mile radius of Hereford), but the affair does not "progress" as Emma puts it. Emma's asexuality, her adolescent concept of herself becomes apparent as she perceives her body in pieces: "I soon discovered that anything above the waist, so to speak, I did not mind, but that anything below was out of the question" (p. 168). That Emma is essentially split or separated from her own body is clear, too, when earlier she is out with Wyndham in the car and he asks her to undo her coat so that he can look at her. Emma finds looking acceptable, but not acting. She too looks at herself awhile, and when Wyndham says he likes her breasts small, she comments on them too, as though they were entities distinct from herself, as though she were rating their performance.

This lack of progress or development in her affair with Wyndham is obvious when she later tells David that she had not even been able to make Wyndham important in her life. What she feels for Wyndham is a schoolgirl passion that paralyzes her. She feels that she is strung up between "incredulity and expectation" and that she can "let go of neither" (p. 158). It is significant, too, that Emma only sleeps with Wyndham as their liaison ends, and she suspiciously watches him to make sure that he does not think it is a beginning. Certainly, there is not sense of an end or a beginning to the affair. It is merely one of Emma's circular patterns.

120

The one role that does seem to hold out the possibility of growth and real emotional involvement for Emma is motherhood. Drabble, herself, feels that "the mother-child relationship is a great salvation and is an image of unselfish love,"[6] and Emma certainly feels great love for her children. The strongest, least equivocal statements that Emma makes are in connection with her children; Flora is the joy of her life. But with the note of clear joy is also struck a more somber note. Emma repeats constantly throughout the novel that she has no way to pass the time, that she is bored. She has become an automatic smile. Motherhood, too, can become mechanical, and Emma is as trapped in her role as mother as she is in any of her roles. Her imprisonment is most graphically illustrated as she is pinned by Wyndham's car, an emblem of all that is sexy and high-powered and exciting, to the house that she lives in with her husband and children. She is trapped; she cannot be a sexual person and a mother too. She turns away from David to the baby suckling at her breast, and her half-hearted affair with Wyndham ends because she decides that she cannot sleep with Wyndham and keep an eye on her children. Emma's marriage with David is founded on their common parenthood, and the tenderness that they feel for their children cannot be translated into feeling for each other.

At the beginning of the novel, Emma catalogs the losses that marriage has caused her, and if she qualifies this catalog by saying that she had "childishly overvalued" such things as friends, and income, her independence, and "indefinite attributes like hope and expectation," (p. 11) she is merely using her talent for distancing herself from her own problems. At the end of the novel, she finds a statement by Hume which she feels justifies her own position.

> Whoever considers the length and feebleness of human infancy, with the concern which both sexes naturally have for their offspring, will easily perceive that there must be a union of male and female for the education of the young, and that this union must be of considerable duration (p. 222).

Hume's words comfort Emma and give her "a warm sense of defeat." She comments on how Hume uses words like easily and naturally and disarms "by the apparent mildness of his expectations" (p. 222). But we might also comment on how he uses words like offspring, the young, union of male and female. These are neutral words. Such human and emotional words like marriage, children, babies, husband, and wife are avoided. It sounds like a program for Homo sapiens rather than people. Emma is trapped in a pattern that lets her be less than fully human. What saves her, her children, is also killing her.

Restictive patterns can also be repeated from generation to generation, and one suspects that Emma is also setting up such a pattern.[7] She has a fused and dependent relationship with her daughter. Emma identifies

strongly with Flora, to the point of seeing very little difference between herself and her daughter. Of Flora, she says, "I recognize myself in her at every turn, my own obstinate artifact of life" (p. 47). The point is, that with such stultifying identification, she becomes less than fully alive and growing and becomes an artifact, indeed. Emma even casts her own wounds and disappointments and her own plans for her life into terms she uses to talk about Flora. She compares her affair with Wyndham to Flora's desire to go on the swings and her subsequent despair at having to get off eventually. Emma concludes that Wyndham Farrar "hardly seemed worth the trouble. I watched Flora's screwed, woeful face, and thought, shall I never, never learn. Other people learn. Other people keep away from the swings and the roundabouts" (p. 125). And Emma and David cheer themselves up after the discovery of the other's affair by the thought of a trip to the East Indies. Emma says, "We were cheered by the promise of this grand excursion as Flora is cheered after a fall by the offer of a sweet or a go on the swings" (p. 219).

The persistent comparison of Emma to things that are childish or child-like indicates the extent to which she has been able to grow. Wyndham is right: Emma is childlike. She is ready to take all and give nothing, and she does not participate fully in the relationships with David or Wyndham or even her children. She is too fused with Flora to be able to deal with her daughter as a separate person, and she seems to project her own sexlessness onto her daughter. This pattern becomes particularly clear in the scene where Emma rescues her daughter from the Wye. That Drabble means the river as a symbol of life and abundance is clear from her description of the river as Emma and Wyndham stand looking at it behind his aunt's house.

> We stood there in the thick wet grass staring at the swirling water. The river was full from the continual rain of spring, and it was rushing over the roots of the trees in a solid, eddying mass....It seemed more real than London, the river and the trees and the grass, so much profusion....(p. 150).

But the river is also the "treacherous sylvan Wye" (p. 222) that Julian drowns in and into which Flora falls. While the river and sexuality and procreation are the stuff of life, they can also threaten. One could drown in them, or so Emma sees it. Of course, on a literal level, this is quite true, but on a symbolic level we can see Emma's fear of this life-force. We know that she is split from her own body and sexuality, and she is in a fair way to making sure that the same becomes true for Flora as well. The undercurrent of sexuality shows even in the song that runs through Emma's mind after Flora's accident.

> Mother, may I go out to swim,
> Oh yes, my darling daughter

Oh yes, you may go out to swim,
But don't go near the water.
O mother may I go out to swim,
O yes my darling daughter,
But mind the boys don't see you get in,
Keep right under the water (p. 200).

After Flora's accident, the way Emma describes her marriage changes.

That rocky landscape that I had foreseen had now become the waters' edge
with ducks and mud, and I could not tell if it was in me to patrol the banks for
the rest of my life (p. 200).

Emma seems not to realize that she is not called upon to patrol the banks
for the rest of her life. On a symbolic level, "the child that Emma is pro-
tecting is Emma herself."[8] The pattern of motherhood that Emma lives
allows neither herself, nor one suspects, her child to grow.

Throughout *The Garrick Year*, Emma sees various models around her,
but she can find no way to be herself. As a result, she sees dichotomies
everywhere. She tells the story of David throwing her wealthy friend's
camera through a pub window because he dislikes Bob's tendency to take
photographs of drunks on the street. Emma's position varies according to
whom she is with. "Whenever I am with the two of them (Bob and
David) or talking about one to the other I always find myself in the em-
barrassing position of liking in one man what I love the other man for
condemning" (p. 16). Emma seems to have no opinion of her own.

Emma is in the same kind of trap when she compares Sophy Brent to
Mary Scott as they visit her one afternoon. For her, they represent two
ways to be: Sophy is the very stereotype of a beautiful actress, and Mary
is a quiet, middle-class housewife. Emma finally associates herself with
Sophy, but we know how false this is. Sophy is "stupid and as shiny as an
apple," (p. 101) and completely unselfconscious, unlike Emma, who con-
stantly questions herself and her own motives. Emma seems not to
realize that she could create her own way to be instead of identifying with
one of these two women.

Emma also creates dichotomies in her relationships with David and
Wyndham. She cannot unify the concepts of sex and marriage, and so she
assigns parts to each man accordingly. David consents to leave her alone
sexually since she is tired from having their second child. David seems to
be safe once he is her husband. Even when he is violent, Emma finds safe-
ty and assurance in his role as actor and hers as spectator. After their
argument about going to Hereford, David puts his fist through their
bedroom wall, and Emma and David then hold hands, "joined in admira-
tion for this extraordinary feat" (p. 22). David is a Hercules, and Emma is
lost in admiration at the power that she renounces. Or perhaps David is
an Orpheus, a "man at whose approach graves opened, fountains leapt

123

out of rocks, and trees and women gathered to listen" (p. 22). Later, David plays a Hercules role in rescuing Emma as she is pinned by Wyndham's car. Emma and Wyndham are helpless; they do not know what to do, but when David arrives things begin to happen. David seems to rescue her so that Emma can return to the safety of her marriage.

Wyndham, on the other hand, is much more dangerous to Emma, and she feels quite precarious about his "warlike intention." It is Wyndham who takes her to see the old house at Binneford, with its lush, overgrown garden and the dark, rushing river. When Emma finds a decayed apple on the river bank, it becomes clear that the place is a kind of fallen, mutable Eden. Emma rejects this natural world of growth and decay, change and sexuality, and it is significant that Emma and Wyndham cannot get into the house and it is too damp to make love in the garden.

Because Emma has no essential self, but remains an accumulation of roles, she is not able to connect with the other. It may seem that Emma becomes reconciled to the natural processes, but such is not really the case. After Flora's accident, Emma thinks, "I have two children, and you will not find me at the bottom of any river. I have grown into the earth, I am terrestial" (p. 221). Emma identifies very strongly with places. She rejects the river and chooses to patrol the river banks. She chooses the earth, but her choice reflects her desire not to move. The emphasis is not on mutability, but on rootedness. Emma's tendency to identify so strongly with the earth may indicate her lack of a sense of self, since as Nancy Regan points out, "the flesh we walk around in is itself a location," and the process of establishing a sense of self necessarily involves "distinguishing self from other—*this* place from *that* place."[9] Emma's fear of the river, even before Flora's accident, could well represent the fearsomeness of her " 'natural habitat'—especially of its most natural desires and functions."[10] Emma's anticipation of her own spring, "full of buds and nervous colour, after my impersonal child-bearing winter," (p. 48) is not fulfilled. And if there is any doubt in the matter of Emma's development, it is resolved when she retreats to her mechanical analogies and restates her stoic position which she makes at the beginning of the novel. Now she says,

> I was made of cast iron . . . Things could come and things could go, but I was never going to have a nervous breakdown: the most they could do to me would be to squash me up against a wall with a big car. I stopped worrying, for those few weeks, though I daresay not for good, about whether I was frigid, or trivial, or hard: I just took it, that I was now all these things, and got on with it (p. 200).

Drabble shows us that it is not enough to come to rest at a place of increased acceptance of one's own limitations if one is to develop a self. One must continue to try on roles, to act. But Emma refuses to do this

and as a result, she goes about in circles: spiritual, emotional, and psychological circles. At the beginning of *The Garrick Year*, we are led to believe that Emma's experience is a turning point of some kind, but at the end of the novel she is still a detached spectator on her own emotions. After David has rescued her and Wyndham has left, Emma and David finally talk. She says, " 'I love you, David,' for quite a long time, not particularly because I meant it or felt it, but because I knew that in view of the facts it must be true" (p. 219). Emma and David do not reach a better understanding of each other. They agree that David is selfish and Emma bored, and they plan to go off to the East Indies where their pattern will most likely replay itself. Wyndham, too, is caught in a repeating pattern. Emma thinks that he will go off to London where he will meet another woman, tell her lovely stories, and get upset, and from his letter to Emma we can surmise that this is exactly what he does.

The way in which Emma tells her story also reinforces its non-linear nature. Emma continually uses words like "pointless" and "aimless." Almost every major encounter in the novel, and many of its minor ones, are so described. Emma and David "pointlessly" wander out of the train station together at their first meeting and later get "aimlessly" married. Emma describes her affair with Wyndham as those "days of clandestine pointlessness" (p. 180). Emma's use of the passive voice and the conditional mode emphasizes her essential passivity. For example, after their marriage, Emma and David "got ground down." They are not responsible, somehow, for what happens to them. Thus, they avoid the responsibility of authorship for their own story and deny the linear structuring of cause and effect.

Just as Emma avoids the role of authorship for her own story, she is attracted to the stories of other people that have a surprise ending, a twist to the plot. Perhaps these stories provide her with an escape from her otherwise mechanical life and perhaps because unpredictability releases her from considering the possibility of being responsible for one's own story. For example, Emma's courtship with David entrances her because they had not planned to get married. They decide to marry but have no obvious motive for doing so. Even so, Emma enjoys the idea of having an exciting and unpredictable marriage. The same is true of motherhood for Emma. She says that she had dreaded having children, but Flora turns out to be the joy of her life. "David too reacted overwhelmingly strongly towards the child, and in the shock of our mutual surprise at this state of affairs, we fell once more into each other's arms" (pp. 33-34). It is the surprise ending that is so attractive to Emma.

Emma is also attracted to the story of the wealthy American lady who fancies herself related to Garrick and puts up the money for the festival and for building the theatre in Hereford. Emma confesses that she enjoys that kind of story because "it seems so unlikely, and so often happens"

(p. 60). The story becomes a grotesque farce, however, when Mrs. Von Blerke's plane goes down over the Atlantic as she is on her way to the opening of the festival. Wyndham calls it "the most frightful farce imaginable. Too ghastly for words" (p. 128) and wonders if she has died or if she has survived and is "bobbing up and down somewhere in a small boat in the middle of the ocean" (p. 129). He calls Emma to tell her the story, thinking that she would be interested in it or perhaps amused by the unlikelihood of it all.

Just as Emma rejects stories with linear plots based on cause and effect, she cannot accept or incorporate into her life the natural processes of time—birth, growth, decay, and death. She may recognize the beauty of such a life, but it is not hers. We can see this sense of incompleteness in Emma's description of her house in Islington:

> from the upstairs rooms one could see it (the garden) and all the gardens in a row, and the impression was of old brick and shoots of greenery and grass and daffodils. Our garden was all weeds, but the one next door on the right had been looked after to perfection . . . His garden was a perpetual delight; the grass was mown and even, the flowers grew at every season in every corner, and the walls were covered with every variety of climbing blossoming plant (p. 39).

As beautiful as the back of the house is, "In the street in front of the houses there was nothing but dust and hard brick and dirty children. One would never have guessed what secret foliage grew behind that stony frontage" (p. 39). There is, in other words, a secret garden, but one that is not really Emma's even though she lives near it. Emma's domestic landscape is a split as she is herself, between lush foliage and human sexuality and the dusty stony front of social roles and motherhood and children playing.

In the final scene of the novel, Emma spends an afternoon with her husband and children on Ewyas Harold Common. The scene is particularly peaceful and pastoral until they leave and Emma sees a sheep lying still with a snake coiled at its belly. She decides that "One just has to keep on and to pretend, for the sake of the children, not to notice. Otherwise one might just as well stay home" (p. 223). In fact, Emma does both. She goes nowhere, and it is for the sake of the children. In rejecting the possibility of playing active roles and in hiding behind various disguises, including motherhood, Emma also refuses the possibility of journeying toward an integrated, whole self.

NOTES

[1]For a full discussion of these two metaphors in several eighteenth century works see Ronald Paulson, "Life as Journey and as Theater: Two Eighteenth-Century Narrative Structures," *New Literary History*, 8, No. 1 (Autumn 1976), 43-58.

[2]Valerie Grosvenor Myer, *Margaret Drabble: Puritanism and Permissiveness* (New York: Barnes and Noble Books, 1974), p. 19.

[3]Marion Vlastos Libby, "Fate and Feminism in the Novels of Margaret Drabble," *Contemporary Literature*, 16, No. 2 (1975), p. 178.

[4]For a full discussion of role playing see Alan Kennedy, *The Protean Self: Dramatic Action in Contemporary Fiction* (New York: Columbia University Press, 1974), pp. 1-63.

[5]Margaret Drabble, *The Garrick Year* (London: Weidenfeld and Nicolson, 1974), p. 60. Hereafter, all references to this source will be made in the text.

[6]Dee Preussner, "Talking With Margaret Drabble," *Modern Fiction Studies*, 25, No. 4 (Winter 1979-80), p. 569.

[7]See Dorothy Dinnerstein, *The Mermaid and The Minotaur: Sexual Arrangements and Human Malaise* (New York: Harper & Row, Publishers, 1976) for a discussion of repeating patterns in parent/child relationships.

[8]Joan Manheimer, "Margaret Drabble and the Journey to the Self," *Studies in the Literary Imagination*, 11, No. 2 (Fall 1978), p. 131.

[9]Nancy Regan, "A Home of One's Own: Women's Bodies in Recent Women's Fiction," *Journal of Popular Culture*, 11, No. 3, p. 772.

[10]Regan, p. 773.

Patterned Figurative Language in
The Needle's Eye

Barbara Dixson

Margaret Drabble's *The Needle's Eye* has been much praised: Marion Vlastos Libby calls it "a truly great contemporary novel"[1]; Drabble herself says it is her favorite of her novels[2]; even a rare critic who finds fault with Drabble's other work concedes that *The Needle's Eye* is "a fine novel by any standards."[3] Unanimous in praise, critics offer a variety of views on the novel's focus. Is *The Needle's Eye* primarily about metaphysics? ethics? motherhood? man/woman relationships? materialism? feminism? survival? Each of these themes has been seen as central. Still another critic, Ellen Z. Lambert, asserts that theme is subordinate to mood in Drabble's novels: "her true strength as a writer is a lyric strength."[4] Drabble's own aspiration is to be a "good all-around novelist,"[5] to write well of passion, politics, morals, and social details, to be in control of the sort of language necessary to render these matters in all their complexity.

This, in fact, is precisely what Drabble does in *The Needle's Eye*. Francois Bonfond notes that Drabble normally employs thick texture in seeking truth.[6] *The Needle's Eye* conveys the truth of the lives of its characters, in all complexity. Drabble achieves this not through intricacy of plot—the novel's events could be told quite briefly—but rather through control of language. Figurative language, in particular, is masterfully handled, including symbol, imagery, allusion, and metaphor. The different sorts of figurative language radiate, like cables woven of many strands, from the given names of the novel's characters. Thus themes of love and growth, images of plants, religious language and allusions all point to the female protagonist, Rose Vertue; minor characters are given concise three-dimensional portrayals because of the literary implications of their names; and images of buildings, and the notion of duty refer to the male protagonist, Simon. Consequently, despite its multiplicity, *The Needle's Eye* has a peculiar wholeness, a fullness, a sense of being all of a piece. Drabble creates this coherence through her control of figurative language.

Rose Vertue Bryanston Vassiliou, female protagonist of *The Needle's Eye*, is not named Rose by accident. "The choice of name tends to affect the development of the character," Drabble says, and calls Rose a "faintly symbolic" name. Drabble, as she claims, may not name her characters

"very consciously" (Milton/Drabble, p. 55), but she did receive double honors at Cambridge, where she studied literature and read, as she says, "all of it."[7] Further, *A Writer's Britain* demonstrates her understanding of the entire tradition of English poetry and of the place of growing things in it. The rose is a symbol which not only Drabble but also her audience should recognize instantly: it functions as a symbol at least as early as the Old Testament Book of Solomon; it reaches a medieval peak in the rose which ends Dante's *Divine Comedy*, where it "embraces Mary, Paradise, grace, and Divine Love, and at the same time reconciles these spiritual concepts with the hitherto opposing concept of terrestrial courtly love"[8]; it peaks once more in the twentieth century in Yeats, Joyce, and Eliot, where it balances against the opposing symbol of the wasteland. Barbara Seward says the rose implies love, beauty, life, joy, creation, eternity, and the sorrow of transcience and of love's ambivalence (Seward, p. 6); its petals "embrace the deepest positive values ever held by man" (Seward, p. 1).

This Rose definitely blooms from the soil of the symbolic tradition, as demonstrates the scene in which Simon, beginning to care for Rose, thinking of Rose, about to call Rose, walks out into his January garden. There he sees" a ghostly white crumpled bud of a rose . . . a witness, a signal, a heroic pledge."[9] Much later, Simon concludes that his going in-to the garden is what "had led him here" (*NE*, p. 268), to his involvement with Rose. In a moment of understanding and love, Simon recalls these lines: "sweeter to me the wild rose red, because she makes the whole world sweet" (*NE*, p. 301).

Indeed, it is Rose who makes the world of this novel sweet. She is such a loving person that she is "recognized a mile off'" (*NE*, p. 161). Elaine Showalter calls Drabble "the novelist of maternity"[10]; Rose certainly has maternal love. In fact, Rose's children are at the vortex of this novel's crisis, a custody suit which her ex-husband Christopher is bringing against Rose. She has built her life around her three children; she treats them and talks about them as important, interesting, unique people; they either accompany her or claim a large part of her attention every time Rose appears. Finally, for her children Rose renounces her saintly visions, telling that projection of herself, "You can die for all I care" (*NE*, p. 264); and she also renounces her peaceful life endowed "with a spiritual calm" (*NE*, p. 365). A more loving mother than Rose is hard to imagine.

Towards her friend Emily, too, Rose is loving. These two talk with in-timacy, intelligence, animation. They have long been friends, and they are so close that it is against Emily that Christopher directs his attacks of jealousy. Rose and Emily's friendship brings Joan Manheimer to this con-clusion: "Against the context of a tradition rarely able to credit female relationships with even the small benefice of harmlessness, Drabble's celebration of such relatedness is remarkable; for it alone, she deserves our respect."[11]

Simon too basks in Rose's love. At the end of his first meeting with her, he behaves coldly and wishes to make amends for it: "It would have taken a miraculous generosity to respond . . . but, amazingly, she looked at him again, and smiled with an extraordinary niceness" (*NE*, p. 44). Rose continues to compensate for Simon's coldness with her warmth.

Those who have treated her badly, such as Christopher and her father, Rose has the charity to forgive. About her father, for instance, Rose thinks, "A thousand times one can suffer and resent, but the thousand and first time monotony, however staunchly resisted, becomes endearing after all" (*NE*, p. 323). Towards every person she meets, as a matter of fact, Rose directs her love: towards Maisie with ex-husband trouble, towards the poverty-stricken Flanagans, towards Eileen Sharkey and her pitiful lost dreams, towards the helpless Greek family next door, towards the Ghanaian in the library, towards the Czech fugitive Anton, to whom she makes love out of sheer hospitality, even towards Simon's disagreeable wife Julie. Simon sees Rose to be capable of loving the unlovable and wants her to meet his mother, explaining, "'She doesn't like anyone much. I was thinking more that you might like her . . . It would be good to find someone who might like her'" (*NE*, p. 288).

The effects of Rose's love demonstrate its genuineness. Her children "flourish" (*NE*, p. 358). Emily grows "so beautiful with the years that it was now almost unbearable, one could hardly bear to gaze at her" (*NE*, p. 360). Simon experiences "a re-birth in his nature" (*NE*, p. 154); he takes an interest in life and begins to give love to his children. Christopher tempers his violence. Even Julie improves: "she has managed to become smart, and generous, and worldly. She had become an attractive woman" (*NE*, p. 354).

Rose's name, moreover, resounds beyond her own character and relationships. It harmonizes throughout *The Needle's Eye* with plant imagery, which inevitably suggests forces of life and growth. In decoration, for example, things which are flowery are cozy, homey, warm, including Rose's living room walls and bedroom curtains, the apron of her childhood friend's mother, the chairs in Justice Ward's home, Christopher's shirt, and Rose's childhood bed. Plants are further used for characterization. The child Rose, for example, had a pressed flower collection which so powerfully evoked the lack of living emotion in her life that her new friend Emily wept over the dried plants. Shirley Alford, a tired, honest, motherly woman, is "like an early daffodil, . . . a primrose too much exposed to a rough spring" (*NE*, p. 304). Christopher sends this woman flowers when she delivers her child, a gesture which suggests his sometimes inappropriate but irrespressible life force. Plants are also used to make the abstract concrete, as when Simon compares the drive to seek a better life to "plants in a cellar, laid away until the spring" (*NE*, p. 172), or when violets suggest hope among images of despair (*NE*, pp. 328-9).

Gardens too are positive forces. The gardens of Branston are less so than most, because they are reserved for the rich alone, "static" and "frozen" (*NE*, p. 333); but even there it is in the rose garden that Rose begins to forgive Christopher; and it is the gardener who came closest to being Rose's friend among the adults of her childhood. Rose's backyard garden, however, symbolizes the good things she has cultivated in her life, and Simon's two appearances in his garden suggest the stages of his growing capacity to love. In the only scene in the novel in which Rose and Simon speak their feeling for each other, Simon "thought of the back yard and the geraniums, of his abandoned crazy paving, of Rose's muddy patch behind her house in Middle Road" (*NE*, p. 294).

Finally, plant imagery shows up in counterbalance to the image of the urban wasteland, where Rose has chosen to live so as to share in the common human lot. The fecundity of the city justifies Rose's decision. For example, in Eileen Sharkey's sleezy hang-out, "plants grew out of pots from a topsoil of fag ends" (*NE*, p. 357). The image of life in the wasteland is most vivid in the scene of the chicken and the armchair: on a bombed site "stood an armchair. In the armchair sat a feathery dusty old hen . . . The armchair was rotting and mouldy; grass and weeds grew out of its guts" (*NE*, p. 216). In the company of Rose, Emily, and their children, Simon responds thus to this scene: "So great and innocent a peace possessed him that it seemed like a new contract, like the rainbow after the flood" (*NE*, p. 216). Another conspicuous flower is the London rocket, a very rare plant which "grows on waste patches"(*NE*, p. 218). Because the London rocket has been the object of unsuccessful quests by the two women and their children, it becomes, though "modest and unattractive" (*NE*, p. 218), a near magical symbol of life reviving the city. All these images are unified in "Simon's sudden apocalyptic vision . . . of the day when the world shall turn to grass once more, and the tender flowers will break and buckle the great paving stones" (*NE*, p. 123). Love, embodied in the person of Rose and in all the plant images which resemble her, is, though it might appear fragile, this novel's most powerful force.

The Needle's Eye tackles religious questions in a straightforward manner which few modern novels have dared to attempt. Rose's middle name, Vertue, illumines the idea of divine love already suggested in traditional rose symbolism, and it carries the concept yet further, to consider at length the position of humankind in relation to the divine. On one level, the religious concepts are used metaphorically, to portray Rose as a Christ figure. Pointing out her middle name to Simon, she explains that as a child, "I thought it was a special sign. . . . I thought I was Jesus Christ reincarnated" (*NE*, p.74). The pattern of Rose's life does resemble that of Christ's. She gives her fortune to the poor and lives humbly. She understands, loves, and forgives everyone. She has an apostle with an ap-

propriate apostle's name, Simon, who loves her and follows her, both literally, on walks, and figuratively, in his behavior towards other people. Finally, like Christ, Rose ends by renouncing the thing she desires, her peaceful solitary life with her children, for the sake of others. This image of Rose is recalled throughout the novel: she is "redeeming" (*NE*, p.44); she felt "martyred" (*NE*, p.95); she takes responsibility for every person she meets (*NE*, p.254); she feels like a nun "living in a closed order" (*NE*, p. 148). Almost the final image of Rose, one which stays with the reader, is of her standing between Simon and the sunlight, "haloed . . . in a bright and dazzling outline, . . . encircled by brightness" (*NE*, p. 363). But of course this is a metaphor, not a literal truth: Rose can be grumpy; the halo vanishes when she descends from "the sunny regions" (*NE*, p. 367); the rose has thorns.

On the literal level, Rose is deeply concerned with metaphysical and ethics—what to believe, how to act? "Faith" is a word she says and thinks over and over. She wavers between belief and doubt, at her most positive moments thinking "God was not as careless as he had at times seemed to be" (*NE*, p. 357). These lines from Bunyan, however, mark her median state: "I will leap off the ladder even blindfold into eternity, sink or swim, come heaven come hell, Lord Jesus, if thou wilt catch me, do, if not, I will venture for thy name" *(NE, p. 331)*—a statement of heroic neurotic nonchalance.

"Grace" and "virtue" are two more words Rose meditates upon. Margaret Drabble in an interview with Nancy Hardin distinguishes thus between the two; "Virtue is a kind of morality that requires some effort from the person. Grace is stumbled into and is an accident. It is given."[12] Rose certainly puts forth the effort to be virtuous. Her major problem is in deciding how to act; she agonizes over every decision, major or minor. Her biggest decision is, for the sake of the children and for the sake of Christopher, to take Christopher back. Living with this man costs Rose an "endless, sickening struggle to preserve something of her own" (*NE*, p. 364). Because living with him is so difficult, because she can find in herself no weak motivation for wanting him, she concludes that "her decision to take Christopher back (measured, thus, in terms of anguish, of suffering, of justifying pain) must have been right" (*NE*, p. 365). Rose cares deeply about making the effort to be virtuous.

As for grace, Rose herself feels that she has lost it by returning to live with Christopher: she is aware of "her own lapsing, surely, slowly, from grace, as heaven (where only those with souls may enter) was taken slowly from her, as its bright gleams faded" (*NE*, p. 365). Drabble, however, says that "being in harmony with some other purpose is a state of grace . . . I don't think she (Rose) could lose it, really . . . she's choosing the harder way" (Hardin/Drabble, p. 284). That the halo not only goes but also comes, even at the novel's end, suggests that Rose underestimates her own spiritual health.

Concern for spiritual matters permeates *The Needle's Eye* through its religious language and Biblical allusions. Words like "charity," "faith," and "grace" recur constantly; the book ends with a hope for "every human soul" (*NE*, p. 369); the very title preaches the Christian sentiment that a rich man is no likelier to get into heaven than is a camel to pass through the eye of a needle, and, for a modern audience not necessarily from the Bible belt, the novel explains the parable and its correct interpretation. The main characters speak to each other in quotations from the Old and New Testaments. Simon casually says to Rose, "'To them that have it shall be given'" (*NE*, p. 101). A group at a party debate the relative value of acting in the spirit or by the letter of the law (*NE*, p. 245). Christopher and Rose brawl over the correct interpretation of the parable of the talents (*NE*, p. 80). A cursory count tallies no fewer than twenty-six direct Biblical references. If such a concern for religious matters is atypical of modern novels, the tone towards them is not. Thus Christopher can say "Don't you quote the fucking Bible at me" (*NE*, p. 80) without sounding shockingly profane, and Rose's nervous giggle (*NE*, p. 74) is appropriate in discussing her religious worries. The tone towards religion as toward other issues, then, is realistic. Therefore tone, along with figurative language radiating from Rose's middle name, contributes to the novel's coherence, as do the symbolic suggestions of the rose of time and eternity.

An interesting refinement of *The Needle's Eye* embodiment of positive spiritual forces in organic images is the repeated visualization of souls as birds. Simon's soul, for example, is caught in the net of his life; "her spirit would hunch its feathered bony shoulders, and grip its branch, and fold itself up and shrink within itself, until it could no longer brush against the net" (*NE*, p. 126). Simon on the beach, having forgotten the names of birds which he knew as a child, is aware that he has lost more than mere information, and he is troubled. Rose too is aware of her soul as a bird about to "embark for the final flight" (N.E., p. 304), of her father's soul as a "blundering" *(NE*, p. 316) jay, of transcendence as a "great owl" *(NE*, p. 316) looming over her head. What a pleasure that humor is admitted even to a consideration of souls: those of Simon's sleek upper-class dinner guests hover over the table with the "wails and squawks of sea gulls" (*NE*, p. 169).

The weaving of figurative language in *The Needle's Eye* works not only on a large scale to tie together major themes but also on a small scale to embroider characterization. Rose's ex-husband Christopher appears seldom and has few lines: he gets a limited amount of direct development. However, the legend of Saint Christopher echoes throughout the novel to give this character depth. This is how the story goes: in the days of the early Christians, there was a man of gigantic stature and great strength, who committed himself to Christ because he had "resolved to serve only

Similarly, the child Konstantin has the sort of constant love for Rose that the word "constance" has been suggesting at least since Chaucer's *Clerk's Tale*. The associations of his name make the reader more prone to believe that this boy is "all that one could ever wish him to be" (*NE*, p. 138) and that he would be able to choose the exactly correct course of action at a moment of crisis. With Simon's elder daughter, too, Drabble does this: in a sentence or two, the reader understands young Helen to be lovely and ill-fated. Economy and complexity of characterization, then, are the results of Drabble's richly allusive name choices for her minor characters.

The name of Simon, *The Needle's Eye* male protagonist, functions in much the same way as does Rose's name. The name has symbolic significance in Western culture because Jesus, choosing Simon to be his disciple, says "thou art Peter, and upon this rock I will build my church" (Matthew 16:18). Drabble makes the connection explicit by showing us Simon's thoughts in the novel's opening scene: "there is a feeling in me, in my brain, in my heart, so dull, so cold, so persistent, so ancient . . . I take it out and polish it like an old stone . . . It is called resolution"(*NE*, p. 13). Indeed, a resolute sense of duty is Simon's primary motivation for all his actions. He has chosen his law career out of a sense of duty towards his mother, who is ambitious for him; he has married Julie from duty to her need of him; he dutifully convinces his son that he shares his interest in soccer; he dutifully makes peace after Julie quarrels with him; professionally, he dutifully defends labor against management; even socially, his politeness towards friends and acquaintances stems from his commitment to duty. Images of Simon are dry, hard, and cold; his very mercy is "stony" (*NE*, p. 31).

Simon is a good character. Rose grows to love him: "She desired his approbation, passionately. It was her strongest emotional need"(*NE*, p. 363). The reader also, watching him open up to affection and reach out to his children, feels for him and admires his continuing to behave rightly at a high cost. Because of his positive portrayal, because his prototype Simon Peter is a strongly positive figure, because another prototype, Dr. John Simon, is mentioned as one of Drabble's "heroes of reform and sanitation"[16] in two of her nonfiction books, for all these reasons Simon makes the abstract concept of duty look attractive. Duty becomes a major theme. Rose, deciding what to do, has a vision of leaving her family and going alone into the African desert to serve the poor. Twice before she has been directed by such religious visions; this time, however, she acts in "the dry light of arid generosity . . . Her duty, that was what she had done"(*NE*, p. 365).

As plant imagery throughout *The Needle's Eye* resonates with Rose's name, so building imagery does with Simon's. Simon is the rock on whom to build, and three times, in reference to Simon and Julie's house,

134

the strongest and the bravest . . . He would not promise to do any fasting or praying, but willingly accepted the task of carrying people, for God's sake, across a raging stream."[13] One day he set out to carry a child across; the child got heavier and heavier; and the giant barely made the trip. The child explained, "'I created the world, I redeemed the world, I bear the sins of the world.'"[14] Thus the man was named Christopher, which means Christ carrier.

Christopher Vassiliou similarly undergoes a conversion, but it is Rose whom he loves, to whom he "demonstrated some kind of faith" (NE, p. 95), for whom he grows steady and respectable. Like Saint Christopher, this man refuses to fast: while he and Rose are separated by the law for eight months, he sleeps with other women. The modern-day Christopher is also associated with travel: he has been a van driver and a courier; he is seen in cars; he makes and causes other people to make journeys. Like a saint, he cares nothing for money but is "unworldly" (NE, p. 232). Most explicitly, this man like his predecessor is a child carrier. Simon tries to carry his daughter Kate but finds her too heavy and "did not keep the gesture up for long"(NE, p. 190). Sure enough, the real Christopher does what Simon has not been able to accomplish. When his daughter Maria is tired, he "had at last given in and picked her up. She was sitting on his shoulders, her muddy boots dripping down the front of his shirt"(NE, P. 343).

A reader of The Needle's Eye cannot but sympathize with Rose. Because Rose has fought a long battle with Christopher and is painfully aware of his defects, the reader too is in jeopardy of despising him. But his connection with the legendary Christopher, saintly for all that he started out a rogue, lends to Christopher Vassiliou a redeeming depth. Because of this, the reader can understand how Rose once loved this man and can accept her decision to live with him again. These suggestions of saintliness are actually what "bestowed on him a little of the dignity that she (Rose) truly, deep within herself, feared that he might lack" (NE, p. 364).

The names of other minor characters also do more than merely identify the person. Simon's wife Julie, for one, bears a name which ties her to cavalier lyric poetry. The stock name Julia, like Celia, Lydia, or Phyllis, refers to the very pretty but mindless young object of the poet's desires. Herrick's Julia, for example, has parts that richly please and wears beautiful, glittering silks, but as to what, if anything, lies beneath the smooth surface of that high forehead, the reader has not a clue.[15] This Julie, "at nineteen, has possessed warmth, gaiety, vitality, family feeling, an easy affection, an easy enjoyment"(NE, p. 55). As she approaches middle age, her beauty remains, but her only pleasures consist of spending money and browbeating her husband. The stereotyped mindless Julia allows Drabble very economically to portray this Julie as someone whose highest potential is worldliness.

135

to Rose's house, and to Rose's solitary life, the novel recalls the Biblical warning against building one's house upon sand. Simon is also seen by a minor character as essential to the structure of Rose and Christopher's marriage, where "he's quite happy propping them up" (*NE*, p. 355): Simon thinks that if he divorced Julie he would be acting as did the ancient Mexicans, who "used to cement the foundations of their edifices with the blood of slaughtered children"(*NE*, p. 266). Thus Simon is central to the recurrent metaphor of building.

As a conseuqence, the numerous literal descriptions of buildings all seem obliquely to refer to Simon. House descriptions serve to characterize people. Julie, for example, has decorated Simon's and her house in impeccable, impersonal taste. Rose's house, in contrast, is cozy, cluttered, shabby, comfortable. Christopher's flat is unexpectedly "intimate. It was a brown and shadowy room, comfortable and curiously homely" (*NE*, p. 231)—all of which are qualities shared by the man himself.

Buildings also serve, just as do plants, to make abstract ideas concrete. Rose's childhood fantasy, shared with her lower-class friend Joye, embodies the same nebulously beautiful values the adult Rose still yearns for: "a place of such mystic and visionary loveliness, a thin aspiring castle on the brow of a green hill, a tower above the raging seas, a heavenly city" (*NE*, p. 107). Likewise, the children's school building, to which Rose sends them despite her husband's desire that they should go somewhere more elite, is a "huge Victorian edifice that loomed up, complete with bell and weathercock, against the dirty sky" (*NE*, p. 130). Its solidity, its ordinariness, its accessibility all express the educational values Rose holds to for her children. The Alexandra Palace is perhaps the best example of a building making the abstract concrete. The Palace, with its lions out in front, stands in opposition to Rose's family home, Branston Hall, with its lions, which are "elevated, distinguished, aristocratic, hand-carved, unique"(*NE*, p. 368). But Rose and Simon both see no point to "any virtue, any grace, if it was not of the common lot" (*NE*, p. 301). They both prefer Alexandra Palace, which is "a terrible mess . . . comic, dreadful, grotesque. A fun palace of yellow brick" (*NE*, p. 369). They admire the palace with its mass-produced lion because it is "of the people" (*NE*, p. 369) and "it had weathered into identity" (*NE*, p. 369). Building, then, structures much of the figurative language of *The Needle's Eye*, and all the different buildings use Simon as their common foundation.

"It cheers you up, a nice name, said the old lady" (*NE*, p. 122) to Simon. Names do a good deal more than this in *The Needle's Eye*. Most of the novel's rich figurative language, it seems, radiates as symbol, metaphor, allusion, or image from the given names of the two protagonists, Rose Vertue and Simon, while minor characters generate subordinate strands. As a consequence of this pattern, the novel achieves

a complexity, an economy, and a coherence that a more random use of figurative language would not allow. Woven together, the strands produce a fabric quite different from the original materials. Thus Rose affects Simon, who learns to love, to act not only by the letter but also by the spirit of the law, and to find pleasure in "shabby amusements and moth-eaten modest satisfactions" (NE, p. 219). But Simon also affects Rose: she who has said yes to all her prior visions now turns one down out of her newly buttressed sense of duty. Love and duty, then, are both forces to be respected. Yet ultimately, love is perhaps the stronger, for when the apocalypse comes, "the tender flowers will break and buckle the great paving stones" (NE, p. 123).

NOTES

[1] Marion Vlastos Libby, "Fate and Feminism in the Novels of Margaret Drabble," *Contemporary Literature*, Spring, 1975, p. 176.

[2] Margaret Drabble, in an interview with Barbara Milton, "The Art of Fiction LXX," *Paris Review*, Fall/Winter, 1978, p. 60.

[3] Elizabeth Fox-Genovese, "The Ambiguities of Female Identity: A Reading of the Novels of Margaret Drabble," *Partisan Review*, No. 2, 1979, p. 248.

[4] Ellen Z. Lambert, "Margaret Drabble and the Sense of Possibility," *Univ. of Toronto Quarterly*, Spring, 1980, p. 228.

[5] Nancy Poland, "Margaret Drabble: 'There Must Be a Lot of People Like Me,'" *Midwest Quarterly*, Spring, 1975, p. 263.

[6] Francois Bonfond, "Margaret Drabble: How to Express Subjective Truth Through Fiction?", *Revue des Langues Vivantes*, No. 1, 1974, p. 41.

[7] Iris Rozencwajg, "Interview with Margaret Drabble," *Women's Studies*, Vol. 6, 1979, p. 336.

[8]Barbara Sweard, *The Symbolic Rose* (N. Y.: Columbia Univ. Press, 1960), p. 3.

[9]Margaret Drabble, *The Needle's Eye* (N. Y.: Alfred A. Knopf, 1972), pp. 69-70.

[10]Elaine Showalter, *A Literature of Their Own* (Princeton, N. J.: Princeton Univ. Press, 1977), p. 305.

[11]Joan Manheimer, "Margaret Drabble and the Journey to the Self," *Studies in the Literary Imagination*, Fall, 1978, p. 143.

[12]Nancy S. Hardin, "An Interview with Margaret Drabble," *Contemporary Literature*, Summer, 1973, p. 285.

[13]Alban Butler, *Lives of the Saints* (N.Y.: Benziger Brothers, Inc., 1953), p. 204.

[14]Sabine Baring-Gould, *The Lives of the Saints*, Volume 8(Edinburgh: Ballantyne, Hanson, and Co., 1872), p. 558.

[15]Robert Herrick, in *The Later Renaissance in England*, ed. Herschel Baker (Boston: Houghton Mifflin Co., 1975), p. 185.

[16]Margaret Drabble, *A Writer's Britain* (N. Y.: Alfred A. Knopf, 1979), p. 213.

The Waterfall: The Myth of Psyche, Romantic Tradition, and the Female Quest

Roberta Rubenstein

The Waterfall, Margaret Drabble's fifth novel, is one of her most puzzling and complex works, for a variety of reasons, including its ambiguous moral landscape, its divided narrative voice, and its allusive subtext. Critical analyses have focused on the novel's approach to problems of female identity and sexuality,[1] and its moral perspective.[2] The aspect I intend to explore here is the author's evocative use of myths and allegories of sacred and profane love.

The relationship between sacred and profane has a long history extending back to archaic times. As Mircea Eliade has pointed out, the primitive man's division of time and space into such categories was a means of distinguishing the "real" meaningful plane of experience from the mundane and routine.[3] Under the influence of Christianity, "profane" has come to imply the secular, as distinct from the religious plane of experience. In the latter context, stories which have attained the status of myth generally locate experiences in a framework of meaning whose underlying dimension is timeless, collective, and sacred. In *The Waterfall,* Margaret Drabble structures Jane Gray's spiritual/sexual initiation through references and allusions to romantic lovers of literature and mythology. Of these, the central one, which shapes the opening movement of the novel and is alluded to throughout, is the myth of Cupid and Psyche. The others are the story of Tristan and Iseult (which Denis de Rougement has also termed a myth[4]), of Isis and Osiris, or the dying god who is reborn through the aid of his sister-wife-lover.

The story of Cupid and Psyche appears (among other sources) as a tale within a tale, in *Metamorphosis* or *The Golden Ass* of Lucius Apuleius.[5] The inner story concerns the beautiful Psyche, youngest of three daughters of a king and queen. Psyche's beauty rivals that of the goddess of love, Venus Aphrodite, herself. In anger and jealousy, Venus sends her son, Cupid (also known in Greek and Roman mythology as Eros and Amor) to punish Psyche by causing her to be consumed by passion for a vile man. Meanwhile, Psyche's parents, distraught that their daughter has gained many admirers but no marriageable suitors, sadly carry out the advice of a sacred oracle to sacrifice their daughter to a marriage of death with a monster. Passively Psyche submits to that fate, atop the crag where her sacrifice is to take place.

Instead of falling to her death, however, Psyche is carried gently by the wind to a deep valley, where Eros, struck by her beauty, ignores his mother's mission for him and weds her himself. The young god is an invisible lover, visiting Psyche nightly and cautioning her that she is forbidden to try to learn his identity, and that she must trust him in this matter. Psyche submits once more to her fate, this time to the terms of her bondage of love—until her envious sisters plant treachery in her heart. Made curious to see her lover's true form, she dares the forbidden by looking at him while he sleeps one night, and accidentally burns his shoulder with hot wax from the lamp she has incautiously lit to see him. For her treachery and lack of trust, she loses Eros, and wins him back only after a long and difficult series of ordeals. Ultimately, she is immortalized by Zeus, who allows her into Olympus as Eros' wife.

Drabble's novel does not follow the story exactly, since her intent, it seems, is not to imitate it but to invoke it as a part of the allusive subtext that gives meaning and resonance to Jane Gray's own pilgrimage as a lover. The Waterfall opens with a long section in which the narrator (whom we later learn is Jane Gray, the protagonist, herself) describes Jane's passivity, the deliverance alone in her room of her second child, and the initial phase of her passionate love affair with her cousin's husband, James Otford. The extremity of Jane's inner condition is emphasized in the opening line, with her assertion, "If I were drowning, I couldn't reach out a hand to save myself, so unwilling am I to set myself up against my fate."[6] Immediately the point of view shifts to the third person narrator, with the later elaboration, "There was something sacred in her fate that she dared not countermand by effort....If she was chosen, she was chosen: if not, then she would quietly refrain from the folly of asserting her belief in her election, in the miraculous intervention of fate on her behalf"(p.7).

The language offers a decidedly theological formulation of Jane Gray's condition.[7] Yet the story details her profane initiation into a consuming and adulterous passion. Jane's relationship to James Otford is secular—in that it originates in ordinary circumstantial events that also happen to violate both the sacrament of marriage and its legal and moral obligations. Yet the very intensity of the experience leads Jane to try to describe and legitimize it on some "higher" plane that might transcend such mundane considerations. Hence, the choice of theological language is central to the "argument" Jane presents to justify the other-worldly context of her passion.

Early in the narrative, the likeness between Jane and her mythical counterpart is established. Jane is in labor, awaiting the birth of her daughter. Characteristically, she submits passively:

> Like a victim, she waited: meek, like a sacrifice. From time to time it occurred to her that she ought to feel desolate, abandoned, frightened perhaps, but

she seemed to lack the strength to feel these things And somewhere else, far away, she heard those mighty abstractions crashing on a distant shore: treachery, love, despair. (p. 8)

To be sure, Jane's self-perceived (and described) status as a victim has implications not limited to the Psyche story as other commentators have pointed out;[8] however, her reference to "treachery, love, despair" alerts us to another theme of her dilemma.

Jane gives birth to the child alone in her room, and finds in the birth the elements of her own deliverance, for soon after, her "savior," James Otford, her cousin Lucy's husband, appears. As Jane reflects, "It would be safe to wait, now: it could no longer be missed or avoided. This close heat would surely generate its own salvation" (p.10). Ingeniously, Drabble uses "confinement," "delivery," and "passion" throughout with their dual theological and female—or sacred and profane—connotations.

James and Lucy take turns staying with Jane during the first days after her delivery. Thus it is that James, like Eros, visits his lover at night and leaves during the day. As James' presence becomes more familiar and frequent, Jane discovers his beauty, and gains confidence in his concern for her. Drabble's language carries a dual spiritual as well as literal possibility of meaning: Jane not only "accept(s) his presence" (p.32), but wants him to know that "she had been glad of his coming" (p.32). Further, James' attentiveness makes her feel "no longer bankrupt" but "in possession of gifts" (p.33). Yet, in eventually allowing James to sleep in her bed (though chastely at this stage), she passively acquiesces to the first step in a corrupting infidelity. She feels herself "lost" (p.34); like Eros possessing Psyche, James "sink(s) her downward, anchoring her, imprisoning her, releasing her from the useless levity of her solitude" (p.34). James' god-like quality is emphasized in such details as his touching her hair, "not seeming to mind that it was dirty and smelled of humanity . . ." (p. 34).

In the passage in *The Waterfall* that specifically invokes the Psyche parallel, Jane describes herself (in the third person) observing the "mortal cliff" of James' shoulders while he sleeps. She fears waking him, "afraid that all his revealed beauty might be taken from her for her too great solicitude, as Cupid was from Psyche when she dropped on him the molten wax" (p.35). Though Jane does not literally imitate Psyche's act, it is as if she had, for the next morning, she touches "the burning smooth flesh of (James') shoulder, and at her touch he winced and shook, and started to laugh" (p.36). Later Jane acknowledges her fear that "her passions, if revealed, would in some way scorch and blister and damage their object" (p.40). Like Psyche with Eros, she finds it "hard to look at (James), startled by his supine reduction to accessible humanity, startled by the nearness of his hitherto so distantly and cautiously acknowledged beauty . . ." (p. 36). Moreover, though hardly a literal virgin after two

141

childbirths, Jane is sexually frigid in her now-dead marriage to Malcolm, and feels herself still virginal: "Like a nun, she had held on, in wise alarm, to her virginity: through marriage, through children, she had held on to it, motionless, passive, as pure as a nun, because she had always known it would destroy her, such knowledge" (p.82).

James, enraptured by Jane's loveliness, observes at an early moment in their relationship, "It's like heaven in this room, I couldn't keep away from you . . ." (p. 37). The narrator adds that Jane was "beautiful, with a true sexual beauty, she had always been so, with a beauty that was a menace and a guilt and a burden: her whole life had been overcast by the knowledge of it . . . "(p.37). As Jane and James acknowledge their mutual bondage in passion, James describes his lover as "a prisoner, here, in this bed" (p.38). Jane is willingly confined by desire; she assents with the query, "'And in the end, then, will you rescue me?'" Her lover replies, "Oh yes, when it's time, I'll rescue you" (p.38) —as Eros rescues Psyche at the end of her ordeals.

Like her mythological counterpart, Jane succumbs willingly to her lover's nocturnal visits. "She began to live for his coming, submitting herself helplessly to the current, abandoning herself" (p.39) to drowning—and to her fate—as she had foretold at the novel's opening. James' entry into her life is, as she interprets it, the intervention of fate in the form of a miracle bestowing grace (p.51). She later describes her passion for him as "Dazzling. White" (p.164); she names her daughter Bianca—though before James' arrival she considered the name Viola "from the notion of violation" associated with the child's true father (p.17).

Erich Neumann explains how Psyche's sacrifice is the essential stage in her acquisition of maturity; the two stages of marriage that he describes parallel Jane's relationships with her husband and then her lover:

> The beginning of her love was a marriage of death as dying, being-raped, and being-taken; what Psyche now experiences may be said to be second defloration, the real, active, voluntary defloration, which she accomplishes in herself. She is no longer a victim, but an actively loving woman. Who is in love, enraptured by Eros, who has seized her as a power from within, no longer as a man from without . . . In this love situation of womanhood growing conscious through encounter, knowledge and suffering and sacrifice are identical.[9]

In the early movement of *The Waterfall*—before Jane reveals herself as the narrator—Drabble also alludes to other classical stories of passionate romantic (and tragic) love. The book that James brings to read while he sits with Jane is Zola's *Thérèse Raquin*—the story (as Jane later explains for the uninstructed reader) of "two lovers, who conspire in passion to murder the unnecessary husband, and find, when free, that they have murdered instead their own love . . ." (p. 138). Jane herself is reading Gide's *La porte étroite (Strait is the Gate)*, a novel in which sexual and

142

divine love are intertwined. The protagonist and narrator, Jerome, tells his story of unrequited passion for his older cousin, Alissa, who chooses virtue and love of God over Jerome's worshipful, but earthly, passion. Jane, like Jerome, also desires spiritual virtue, which she hopes to accommodate with her more carnal desires.

Jane also compares her situation with that of other lovers who were cousins, including Galsworthy and Ada, his cousin's wife (p. 252); and Maggie Tulliver, the heroine of George Eliot's *The Mill on the Floss*, who falls in love with her cousin Lucy's man. In that novel, Lucy quite literally drowns. During the course of *The Waterfall*, Jane also refers to other literary lovers, including Romeo and Juliet (pp. 92, 187), Jane Eyre and Rochester (p. 89), and Sue Bridehead of *Jude the Obscure* (p. 161). Further, while Jane and James sleep chastely in the same bed during the prohibited period for intercourse following childbirth, the narrator alludes to other tantalizingly chaste lovers:

> At night they lay there side by side, hardly touching, hot, in the wide, much-slept-in bed: separated by her condition more safely than by Tristram's sword, or that wooden board that the early Quakers of New England would lay as a partition between their beds, in the first weeks of marriage, to prevent too much surprisal, too much shock, *before a more human bond had been established.* (p. 40, my emphasis)

Their proximity provides "(a) prolonged initiation, an ordeal more fitting than human ingenuity could have devised" (p. 40)—an allusion to the divine dimension of their passion.

With such suggestive allusions, Drabble provides the resonant backdrop of what Denis de Rougement has termed "love in the western world"[10] —that intense, passionate, romantic encounter which grows out of, and thrives upon, separation, sacrifice, obstacle, and suffering for its very survival; and which is a courtship not only of love but of transcendence and death. De Rougement calls the story of Tristan and Iseult the "one great European myth of adultery,"[11] the paradigm through which the Western ambivalence about passionate (and illicit) love may be understood. In the composite rescensions of the tale, Tristan, the nephew and loyal liege of King Mark, accidentally drinks a love potion intended for his uncle upon betrothal of the fair Iseult. Iseult also drinks of the potion, and she and Tristan become passionate lovers, somehow managing to disguise and conceal the true nature of their relationship from the trusting Mark even after his marriage to Iseult. The adulterous passion thrives on secrecy, repeated risks, separations, and obstacles. Eventually, however, the relationship is strained by long separations and more strenuous sacrifices, and the lovers begin to lose faith in their love. At that point, doubt gives way to disillusionment, and, through a series of misfortunes abetted by the jealousy of others, Tristan

and Iseult die with each believing the other no longer loved. However, the separate trees planted on their graves grow into an eternal embrace. De Rougement's argument stresses that the story of carnal passion carries with it an esoteric allegory for the mystical relationship between human and divine—a dimension achieved in Drabble's story through the deliberately theological implications of the language. Further, most pertinent in terms of Jane Gray's account of her surrender to fate is de Rougement's equation of passion and sacrifice: "Passion means suffering, something undergone, the mastery of fate over a free and responsible person."[12]

What makes the references to these, and other, literary lovers particularly instructive in *The Waterfall* is the fact that Jane Gray is the narrator of the entire novel, told alternately from the first and third person perspectives. It is thus Jane, the temporarily blocked and divided poet, who quite deliberately arranges her romantic story in the pattern of literary myth and (until late in the novel) tragedy. She invokes Seneca's pronouncement (from Oedipus, another tragedy of incestuous lovers), "Often, in jumping to avoid our fate we meet it" (p. 102). When Jane comes forward after the first long movement of the narrative to reveal herself as the author of the account that has preceded, she confesses, and rationalizes,

> It won't, of course, do: as an account, I mean, of what took place . . . Because it's obvious that I haven't told the truth about myself and James . . . And yet (I) haven't lied. I've merely omitted: merely professionally, edited . . . (T)he ways of regarding an event, so different, don't add up to a whole; they are mutually exclusive: the social view, the sexual view, the circumstantial view, the moral view, these visions contradict each other; they do not supplement one another, they cancel one another . . . They cannot co-exist. And so, because I so wanted James, because I wanted him so obsessively, I have omitted everything, almost everything, except that sequence of discovery and recognition that I would call love. (p. 47).

It is her re-cognition, that is, her re-knowing the meaning of love, that determines the divided form of her narrative; she comes to understand the meaning of her experience in the process of telling her story. Yet even in the language of her confession. Jane insistently qualifies herself. In the alternating narrative movements that follow, she struggles to tell her story, impeded by contradictory visions of her experience and her vacillating impulses towards candor and self-deception. What provides the central tension of the narrative is the ambiguous relationship between sacred and profane love, Jane's uncertainty whether to view her experience as one of transcendence and salvation or damnation. She sees herself as divided between "flesh and mind" (p. 109), body and spirit, or as she phrases it elsewhere, "sublime blood" and "sublimated blood" (p. 115). Paradoxically the healing of that division is also its cause: her

144

"deliverance" by James beginning after her "confinement" and her daughter's birth.

Though James may be her divine deliverer, his divinity is less Christian than pagan. Jane even places him in the framework of Greek mythology: "Perhaps I could take a religion that denied free will, that placed God in his true place . . . himself subject, as Zeus was, to necessity. Necessity is my God. Necessity lay with me when James did" (p. 51). In fact, as the play on words implies, James *is* her God. "I looked into (Necessity's) face and recognized it: it made him human, lovely, perishing" (p. 51). As in the relationships between human and divine, Jane sees James as the one who "redeemed me by knowing me . . ." (p. 52). Yet paradoxically, sexual knowledge corrupts; "he corrupted me by sharing my knowledge. The names of qualities are interchangeable—vice, virtue; redemption, corruption; courage, weakness . . . In the human world, perhaps there are merely likenesses" (p. 52). She refers to the antipodal qualities as "steps on an angel-guarded ladder, ascending to, descending from, some possible heaven . . ." (p. 53). As de Rougement has observed of the great romantic lovers of literature, of whom Tristan and Iseult are paradigmatic, the pair

> imagine that they have been ravished 'beyond good and evil' into a kind of transcendental state outside ordinary human experience, into an ineffable absolute irreconcilable with the world, but that they feel to be *more real than the world*. Their oppressive fate . . . obliterates the antitheses of good and evil, and carries them away beyond the source of moral values, beyond pleasure and pain, beyond the realm of distinctions—into a realm where opposites cancel out.[13]

Later in the same passage in *The Waterfall*, Jane admits that she had hoped to achieve virtue through a kind of self-abnegation, self-negation. But James, piercing that facade, sees through to her "true self" (p. 53). In attempting to devise a "new morality" that will enable her to comprehend the paradox of salvation and damnation—that is, to justify her passionate desire for James in terms of transcendent experience—Jane determines to reconstitute it "in a form that I can accept, a fictitious form . . ." (p. 53). Her admission allies her with the romantic lovers' characteristic pereference for illusion over reality. As de Rougement argues, romantic lovers "love one another, but each loves the other from the standpoint of self and not from the other's standpoint. Their unhappiness thus originates in a false reciprocity, which disguises a twin narcissism.[14]" More than once in the narrative, Jane and James exchange glances through mirrors—suggesting surfaces, reflections, or narcissistic distortions of reality (pp. 194, 254-255). Late in the novel, Jane recalls yet another romantic fable—a Chinese fairy tale involving an illusory blue rose, the token by which the woman in the story will know her true love.

145

Several artificial blue roses are offered to her, but she refuses them. When the man of her desire presents her with an ordinary white rose, she "turns to her astonished court (and) says to them, you are color-blind, this rose is the only blue rose that I have ever seen" (p. 210)

Ironically, in view of her desire to identify herself with tragic lovers, Jane admits to having married Malcolm Gray in the first place to deny herself tragedy, because he was safe. What first attracted her to him was his magnificent voice as a lieder singer. She particularly remembers the song he sang by Thomas Campion on a mythological theme, its words lamenting beautiful classical females who destroyed their lovers, and who resided afterwards in the underworld (pp. 91-92). Identifying herself with such females, Jane feels in retrospect that she murdered Malcolm psychologically by "the lending and withdrawal of (her) beauty" (p. 93). Like Psyche, who visits the underworld twice to perform tasks demanded of her by Aphrodite as punishment for her liaison with Eros, Jane travels with James on their first outing together through the underworld of Blackwell Tunnel, with its "deadly, pallid, fluorescent glare" (p. 88).

Other images of sacrifice and death punctuate the narrative of *The Waterfall*. On the same outing, Jane and James talk obsessively of death and drive down a hill called "Death Hill" (p. 89). A racing car enthusiast, James loves speed, and Jane fears for his life; as their affair intensifies, she even fears her own death. At one point, as they drive at excessive speed, she cries, " 'I'm going to die, I'm going to die . . .' " and James replies calmly, " 'Then let me kill you . . .' " (p. 77). Their exchange is a reversal of the earlier dialogue concerning Jane's "rescue." Moreover, in medieval and later literature, "dying" is a conceit for sexual intercourse. In James' passion for racing (death), and Jane's passion for James (desire for transcendence), she sees the imperative of her situation: she must suffer and be prepared to die for her lover, as the true lover or believer feels he must accept suffering in the name of the object of his worship. (In Christian mythology, passion is the word for suffering, as in the Passion of Christ.) Neumann terms the tale of Psyche "an initiation into the feminine destiny of development through suffering."[15]

Jane stresses that she hopes for more than a "commonplace sacrifice" (p. 103), and avows that "Nobody seems to pay enough attention to (marriage's) immense significance.' (p. 103). She feels as if she is "taking part in some elaborate, delicate ritual, and that if she broke some unknown rule of it . . . she would forfeit (James) for her unwitting transgression." (p. 141)—as did her mythological counterpart. Clearly, Jane seeks an almost superhuman, transcendent love relationship, the kind achieved—at a cost—by classical lovers. As de Rougement insists, passionate love is one of the few human experiences in which the likelihood of suffering is perhaps almost inevitable.

The necessary third element in the tragic triangle (as it appears) is

146

James' wife and Jane's cousin, Lucy Otford. Looking back at the beginning of her childhood connection with Lucy (whom Jane had subsequently aped to the extreme of wanting to *be* Lucy) Jane observes the dramatic potential in their relationship: " 'We were embarking on a drama that would be played out not over that one summer afternoon (when they first met) but over the years, over a lifetime" (p. 121). Her description makes it sound like the fateful first encounter with a lover, not a female cousin. Jane views Lucy as "my sister, my fate, my example" (p. 120)— or, as one might phrase it, her alter ego. However, in contrast to Jane's erstwhile frigidity, Lucy is promiscuous; we learn later that her latest lover during the time period of her husband's affair with Jane is the lover of James' own mother. If Lucy is some sense Jane's double, the fact reinforces even further the curious incestuous connections between the lovers. (Lucy remains conveniently absent during much of the narrative and Jane's all-consuming affair with her husband.)

As the relationship moves toward what is quite literally the climax of the novel, the lovers discuss the technical aspects of love-making, and James observes cryptically,'"not many people care enough, and heaven help those who do'" (p. 155). The heavensent James does "help" Jane, ironically releasing her from the bondage of passivity (and frigidity) into the bondage of passion. After he performs for her an intricate card demonstration called the waterfall, which prefigures their sexual consummation, Jane describes (in her third person voice) the true consummation of their union. Its stages paradoxically connote both birth and death—as well as sacrifice, faithlessness, fear of separation, helplessness, transcendence, drowning. These contradictory emotions are the vocabulary of Jane's ambivalent initiation, recalling the image she has described earlier of the "angel-guarded ladder" with its implications of both ascent and descent.

Orgasm itself is described through an image that evokes Psyche at the moment before her sacrifice from the high crag: Jane feels "her body about to break apart with the terror of being left alone right up there on that high dark painful shelf, with everything falling away dark on all sides of her, alone and high up, stranded, unable to fall" (p. 158). Finally, she does fall; she feels herself "drenched and drowned, down there at last in the water, not high in her lonely place: and she sank her teeth into his shoulder. . ." (p. 159). Like the archetypal first woman, Eve, Jane equates her sexual knowledge with a fall. In mythical symbolism, drowning is a dual image of both death and rebirth.[16]

In a play on words, Drabble uses the languages of both sacred and profane experience: Jane believes that James "had made her, in his own image" (p. 159). She sobs in a "cry of rebirth. A woman delivered. She was his offspring as he, lying there between her legs, had been hers" (p. 159). In their union, they give birth to each other. James—who had undertaken

the "risk," as Jane phrases it, becomes the author of his lover's "sexual salvation" (p. 160). In his interpretation of the Psyche myth in terms of female psychological development, Erich Neumann suggests the sacred context of the union, observing,

> This love of Psyche for her divine lover is a central motif in the love mysticism of all times, and Psyche's failure, her final self-abandonment, and the god who approaches as a savior at this very moment correspond exactly to the highest phase of mystical ecstasy, in which the soul commends itself to the godhead.[17]

Jane, in awe of the intensity of her physical and emotional experience, remarks, "What right had any deity to submit mortality to such obsessive, arbitrary powers?" (p. 160)

As with Jane's bondage through desire and initiation into passion, the Psyche myth underlies other dimensions of the lovers' story as Jane shapes it. James Otford is, for example, like Eros, the only son of a beautiful, arrogant, voluptuous woman who is reputedly the daughter of famous parents (p. 55). As Jane notes, suggestively, of the Otfords, "God knows what circles they moved in . . ." (p. 60). Much later in the narrative she explains how James "couldn't have been anything else, with such a mother and such a home" (p. 247). James' beauty—an unlikely term to describe a man—is emphasized throughout. Jane describes him as "beautiful, like a tree, like a flower, like an angel" (p. 134). Others who know him have compared him to Shelley (p. 62), a resemblance evoking Adonais and, by extension, Adonis, the young sacrificial god of Greek myth who is Aphrodite's lover. When James takes a three-week vacation with his family in Italy, Jane consoles herself with the thought that he is "Less far than Tashkent, or Syracuse, or Athens" (p. 164). From Italy, James sends Jane a card from the place of Shelley's death, noting, "'I trust I shan't follow him'" (p. 165).

These comments, and others, also allude to the dying god of mythology who is seasonally reborn. Jane's first outing with James takes place in early spring; later Jane laments her inability to record their passionate connection accurately, though she feels it to be "the pure flower of love itself, blossoming out of God knows what rottenness, out of decay, from dead men's lives, growing out of my dead belly like a tulip" (p. 89). James professes a nonchalant attitude toward death, referring at one point to the time "'When my body reassembles on the Day of Judgment. Because bodies do, you know. They all come together again'" (p. 152). His assertion comes during a conversation in which Jane defends her passivity—which extends even to her reluctance to cover bread to prevent it from going stale—by claiming, "'I think it's immoral to impede the course of nature . . .'" (p. 152). The stale loaf of bread in question is "as hard as a

brick" (p. 151; it is a brick—what Jane terms "an act of God lying the road" (p. 237)—that causes the nearly-fatal automobile accident later in the story.

The suggestive, if ironic, connections between resurrection, dismembered bodies coming together again, acts of God, and loaves of bread form a cluster of images with resonances in both Christian and pagan mythologies. Without pressing the possibilities too insistently, it is worth mentioning that James loves children, and was attracted to Jane at precisely the peak of the female fertility cycle—childbirth. The bridge between the myth of Psyche and myths of the sacrifical god is not an arbitrary one. The story of Psyche as told by Apuleius occurs within a longer tale, *The Golden Ass*, which concludes with Lucius Apuleius himself being initiated into the cult of Isis; Isis was the goddess of the major female mystery religion of the ancient world. Her followers celebrated the seasonal dying-rebirth of Osiris (known in Greek mythology as Adonis), the brother of Isis whose body was sacrifically dismembered, and which it was the task of Isis to reassemble. Futhermore, as the comparative mythologist Joseph Campbell has pointed, out "The goddess Aphrodite and her son are exactly the great cosmic mother and her son, the ever-dying, ever living god. . . ."[17]

But before James Otford's symbolic death, Jane experiences his temporary absence as a kind of death. It is not long after their mutual sexual rebirth that James leaves her for a vacation in Italy with his family. During his absence, Jane suffers a profound sense of nothingness, terror, and arrest of time—phenomena that can be attributed to the intensity of her dependent identification with her lover, and also likened to a kind of spiritual void or dark night of the soul wherein, as she describes it, "it seemed that I had made no progress, that there was still an eternity to be endured" (p. 166). She thinks of taking her small children for a walk to the zoo, to get herself out of her confined quarters. She visualizes the route to the zoo, which not accidentally includes Bishop's Bridge Road and St. John's Wood (p. 168). (The Christian mystic St. John of the Cross used the allegorical language of love to describe ecstatic relation of the soul to God.)

As Jane passes through the iron-girdered "half-moons" of the bridge and "into the sun," she feels released from her claustrophobic enclosure (p. 169)—ironically on her way to observe animals still subjected to their confinements. The terms of her release are phrased as part of her spiritual pilgrimage, in distinct evocation of the Christian mystics:

> I had found a fitting, unrejecting object for desire. One is not saved from neurosis, one is not released from the fated pattern, one must walk it till death and walk through those recurring darknesses; but sometimes, by accident or endeavor (I do not know which, in writing this I try to decide which), one may find a way of walking that predestined path more willingly . . . one might find a way of being less alone . . . (p. 169).

149

Later, after James returns, he informs her that he would like to take her with him on a trip to Norway, the land of the midnight sun and his ancestral "soul's country" (p. 176), Jane confesses, "I would have gone on that journey no matter how poor a state of health" (p. 182). She pretends surprise when Lucy tells her, during one of their infrequent conversations, of James' impending trip for "God knows" what reason (p. 189). The unrecognized reason underlying the journey seems to be the romantic lovers' need to suffer; as James had earlier written to Jane from Italy, "'You and I will suffer together, darling'" (p. 171).

The conversation that takes place as the journey gets under way is laced with allusions to tragedy, doom, and spiritual pilgrimage, specifically echoing both Othello's and Hamlet's respective postures toward their mortality:

> . . . she said to him, "I could die now, quite happily. I wouldn't much mind if I died now."
> "I'd like to get a little further," he said.
> "We must mention that we may not get there," she said. "If we show ourselves willing, it won't be expected of us."
> "The readiness is all," he said. . . . (p. 194)

Before the couple even leave England, however, they have a major automobile accident, in which James is seriously injured and Jane is barely hurt. Jane interprets the accident as another intervention of fate, "the impact of eternity" (p. 195), and cannot conceal her disappointment that, prepared to die, she was spared death. She feels somehow cheated of the tragic sacrifice that befalls romantic lovers of literature. "I thought that death had visited me in person, as an angel, as a presence, and had denied me the final vision, the final revelation" (p. 197). Elsewhere Jane has likened James to both an angel and presence; the inference is that Jane is unconsciously in love with death—the underside of being in love with Love,[18] and the deeper source of her passivity.

James himself is left unconscious in the accident—in a state of suspended life, like death. Jane assumes that he is actually dead; she takes his warm hand "to pay him whatever rites would come to me before we were interrupted . . ." (p. 199). Once she realizes (through the observation of a passer-by) that James is only unconscious, she vows to "keep faith . . . I would refuse to let him die" (p. 201). While James lies comatose in the hospital, Jane (impersonating Lucy in order to remain with her cousin's husband, though guiltily conscious of her selfishness and treachery) stays in a Trust House (p. 206). Later, more fittingly, she moves to the Saracen's Head, with its appropriately pagan connotations.

In the hotel room with Laurie, Jane is challenged by a task reminiscent both of Psyche's first labor of sorting a huge heap of diverse grains into

150

their respective groups, and of Isis' task of reconstituting Osiris' dismembered corpse. Jane's challenge is the difficult assembly of a child's toy car kit. She confesses, "I had had no idea . . . that it would be such a complicated business, and my heart sank at the sight of the extremely complicated instructions and the heap of minute chrome and plastic parts . . . I nearly gave up at the sight . . . I spent hours poring over the diagram, trying to fit the right bits into the right places" (p. 209). Finally—without aid (Psyche was aided by ants)—Jane succeeds at the task, and the electrical toy car moves "like a beetle" across the floor (p. 209).

Later, Jane overhears the ending of a fairy tale on a children's television program that Laurie is watching, and connects it with one she had known as a child; the excerpt literally underscores her current trial of patience as well as the suggestively sacred framework for her profane situation:

For seven long years I served for you,
The bloody cloth I wrung for you,
The glassy hill I climbed for you,
Will you not wake and turn to me? (p. 211)

Jane thinks of the shirt of James' she wears to sleep in as a shroud, a "last rite performed for him, for love itself" (p. 211). During her enforced wait, she reflects on her relationships with men, and discovers that her passivity carries with it great destructiveness. It is not she, in her abdication of responsibility to fate, but her men who have been sacrificed on the altar of love; both James and Malcolm had "in their respective ways, died for (her)" (p. 212). However, rather than beginning to question her own motives, she begins to question her love for James: "For what, after all, in God's name had they been playing at? . . . What on earth had they thought they were doing?" (p. 213). She adds, "A question of faith it had been— but faith not justified by its object: human love" (p. 214).

Significantly, when Jane voices her passing doubts about her passion for James, she also repudiates his mother, claiming, "What had there been so admirable in James' mother, that figure to whom she had attached such hopeful fantasies, that figure whom she had capriciously elected to redeem the maternal role?" (p. 214) As Neumann has written of the Psyche myth, "Psyche, the human woman, sets herself up against the Great Mother, who, hitherto, in league with her son, had prescribed the destinies of human love."[19] Jane is temporarily unable to sustain the illusion of the perfect lover who—as in the Chinese fairy tale Jane has summarized earlier—perceives the ideal blue rose in the one her lover offers. By contrast, Jane peeks beneath the illusion and sees that what James has given her "had been no miracle, no unique revelation, but a gift so commonplace that it hardly required acknowledgement. An ordinary, white rose, picked from a hedgeful of ordinary indistinguishable

151

blooms, and wilting now, crumpling and browning at the edges, subject to decay . . ." (p. 217).

Yet, just as doubt is an element of faith and decay presages renewal, that very mortality is what makes love possible and real. After her temporary relapse of belief, Jane reasserts, "I identify myself with love, and I repudiate those nightmare doubts" (p. 220). As if in reward for her renewed faith, the dying god James is reborn once again: first, the nurse reports that he is "lightening" (p. 222); then "he was almost alive" (p. 230); and finally, "just over a fortnight after the accident, he took the decisive step into this world" (p. 233). Symbolically, the rush basket Jane uses as a handbag reveals "tender streaks of green" (p. 222) among the neutral straw weave. The image alludes not only to vegetation and regeneration but to the second of Psyche's four tasks: the recovery of some strands of golden wool for Aphrodite, in which endeavor she is aided by a reed.

However, Jane ruefully comes to see that the price of James' recovery is her loss of him. He was only on loan to her; she can never possess him fully. Her recognition of the need for separation from the totality of desire frees her from her almost symbiotic state; she vows to put "her own house in order" (p. 241) after James' full recovery is assured.

Narratively, the shift in Jane's awareness is signalled by the unprecedented shift in point of view—from third to first person—in the middle of a section; at that point, the inner division that has plagued Jane and forced her to split her story into two perspectives is dissolved. She begins to correct some of the fictionalizations of the earlier part of her narrative as she assumes more control over not only her life but her representation of it. Her comments also draw attention to the deliberate artifice and even unreliability of her story: "At the beginning of this book, I deliberately exaggerated my helplessness, my dislocation, as a plea for clemency. So that I should not be judged . . . I don't like guilt, I don't like being human . . . Guilt, the gilded crown of the martyrs" (p. 242-243). Her admission allows the reader to see the true shape of her Psychic inertia—her desire to transcend or escape the human condition by identifying herself quite emphatically with a romantic ideal, while at the same time exploiting her role as a victim of fate. In facing the consequences of her surrender to providence, Jane discovers her circuitous, self-deceptive quest for tragedy and even death as escape from responsibility; she re-phrases her earlier gloss on Seneca in terms of what she has learned from her own experience, stating, "In seeking to avoid my fate, like Oedipus, I had met it. In seeking to avoid the sin of treachery, I had embraced it" (p. 243-244). Neumann's interpretation of the Psyche myth is instructive here. He notes,

Psyche dissolves her *participation mystique* with her partner and flings herself and him into the destiny of separation that is consciousness. Love as an expression of feminine wholeness is not possible in the dark, as a merely un-

conscious process; an authentic encounter with another involves consciousness, hence also the aspect of suffering and separation.[20]

Still, Jane Gray insists on viewing James Otford as a spiritual presence in her life who was sent to transform her: "I regarded James as a miracle . . . He changed me, he saved me, he changed me" (p, 244). Later she adds, pointedly referring to his divine nature, "I did not summon James (that revolution in the elements) from nothing. I did not draw him like a ghost from the outer sky. He pre-existed . . . (h)e made the new earth grow, he made it blossom" (p. 245-246). The accident "had merely been an attempt to attach him more firmly to the human earth" (p. 254). Having been changed by him, she remains in his power to the extent that, as she phrases it, "I would flow in the course that he had made for me" (p. 248).

Ironically, despite Jane's literary pretensions, death was not the outcome of their courtship; their romantic story "resolved into comedy, not tragedy" (p. 250). Some time after the accident, and after James has returned to Lucy as he inevitably must, he and Jane take an excursion together to a real waterfall at the Goredale Scar. Certainly, the image of a "scar" provides a permanent reminder of their passionate union and suffering. However, the setting has changed. They walk through wild pansies called "Heart's Ease"; their love has evolved from the chancy, illusory waterfall card trick that James had performed to a real waterfall, with association with nature, ascent, descent, passion, and "the sublime" (p. 253). That night, after Jane and James sleep together once again, and Jane realizes that she is capable of continuing her treachery, she drinks in the dark from a glass of Scotch which she does not know has been contaminated by talcum powder. It tastes "dreadful, ancient, musty, of dust and death . . ." (p.255)—a reminder of their connection to an ancient tradition: the taste of death is never vanquished, once having been courted by the lovers.

Yet the story does not end with Jane and James' symbolic ascent to the top of the hill overlooking the "Scar." In an ambiguous coda to the narrative, Jane identifies herself with the female lot, conceding that women must indeed suffer a price for love. "In the past, in old novels, the price of love was death . . . Nowadays it is paid in thrombosis or neurosis; one can take one's pick" (p. 256). Pulled back into her deeper nature when James nearly died, Jane gave up birth control pills (a return to the natural cycle of fertility) and later found that she had providentially averted serious complications of thrombosis. Thus, unlike Psyche who is immortalized, Jane is humanized by her initiation into love. Her final words provide the final qualification of her story: "I prefer to suffer, I think" (p. 256).

The paradox of *The Waterfall* remains embedded in her pronouncement: is Jane Gray merely resuming her former role as fate's helpless victim, or has she adapted a more honest recognition that her choices shape her fate, and that she is responsible for them? Further, does her reconciliation with herself reflect the achievement of a "new morality" (as she had hoped) that merges the split between the sacred and profane, acceptable and illegitimate, virtuous and immoral dimensions of her experience? Surely, given the language of spiritual quest and initiation that Drabble employs, we are meant to discover more significance to the story than that, as Virginia K. Beards insists, "better sex makes Jane slightly more functional and diminishes her withdrawal symptoms."[21]

More critically, Elizabeth Fox-Genovese has suggested that for Drabble, "Love, true sexual love, or maternal love, fills the place of salvation But the exclusive, accidental, personal, and even selfish quality of individual fulfillment underscores the limitation of Drabble's vision."[22]

Is *The Waterfall*, then, an ambitious but unsuccessful attempt to resolve a dualism that the author herself was unable to reconcile? Certainly, many of her female protagonists, from Clara Maugham of *Jerusalem the Golden* to Rose Vasiliou of *The Needle's Eye*, face sexual and moral challenges that go beyond their special female circumstances to approach spiritual and transcendent matters. The problem is most succinctly phrased by Jane Gray herself, who questions whether her faith is "justified by its object: human love" (p. 214). In a novel that professes to elevate passion—at least, during its peak—to the level of mystical union (or, conversely, to express a spiritual journey in the imagery of an all-too-human adulterous love affair), one must press this question closely.

One answer lies in Drabble's fascination with the form that the female spiritual quest takes, and the acknowledgement that "A body must take on flesh for us to know it," as Jane Gray observes (p. 244). The struggle in Jane (and her creator) seems to center upon the need to marry the world of material experience and knowledge with some higher transcendent truth. The imagery of the novel strains to equate passion with Passion as dual expressions of a yearning toward the same unity of Being. Yet the reader never entirely forgets (despite the way Jane shapes her narrative) that the transforming experience of Jane's life is still an act of treachery and questionable morality.

That the Psyche myth remains compelling to Drabble as one symbolic expression of the dual feminist and theological possibilities in the female experience of love is suggested by her return to it in her most recent novel, *The Middle Ground*. In that work, the protagonist Kate Armstrong—who appears more psychologically integrated and independent that Jane Gray—struggles to attain a psychic equilibrium in mid-life that can include love and affection without requiring the emotional bondage of "dependence, confinement, solicitude" (p. 239) that define Jane

Gray's liaison with her lover. Late in the novel, after Kate has undertaken her own symbolic journey to the underworld of her past, she enters a museum where she is struck by a painting entitled Psyche *Locked Out of the Palace of Cupid*, or "The Enchanted Castle":

> There sat Psyche in the foreground, in an attitude of despondency, heavy dull, large-limbed, dark, a large woman clearly abandoned, though Kate did not know the story, not having had much of a classical education. In the middle rose the castle, solid, impregnable. And there beyond them, again, the sea, and little white sails free in the wind, in the sunlight. Why did not Psyche look up, and see all that glittering expanse? How could her heart not rise if she were to look up? Why did she sit there so dumbly, so inelegantly, so much of a heap, so intent upon the earth? She should look up, and move, and go. The castle of love was a prison, a fortress, a tomb, how could she not appreciate her luck in being locked out, in being safe here in the open air? Let her rise and go. (Yet in there, locked within, had she not had the illusion of possessing infinite space?)[24]

Interestingly, in the later novel quoted above, Drabble equates the female "Psychic" principle and spiritual progress not with falling but rising, or ascent. Kate's perception of the painting prefigures the resolution of her own inner disharmony, for by the end of the novel, unattached to any man and yet fulfilled within herself and her situation, Kate herself "rises" *MG*, p. 277)—a Psyche liberated from the confinement of passion. As in *The Waterfall*, Drabble equates passionate love with bondage, and suggests that the choice between submission to desire (or "fate") and assertion of autonomous selfhood is the true female dilemma. If, as de Rougement's argument infers, passionate romantic love precludes individual wholeness (since only ecstatic union with the lover provides it), then the traditional female quest for that kind of relationship is doomed to Neumann's biased male view that suffering for love is the female lot, and Psyche's story—notwithstanding its "happy" ending—is paradigmatic.[25]

Jane Gray seems a perfect example of both de Rougement's view of romantic love and Neumann's interpretation of the relation between female passion and submission (as I have tried to show above). In the ancient version, Psyche abandoned herself to what was ultimately a transcendent, fateful liaison. For her willing submission to destiny and suffering, she is redeemed by the reward of immortality, or eternal union with her lover. In Drabble's modern revision, Jane Gray's quest for immortality or transcendence proves to be a pursuit of illusion—a fiction. To be human is to suffer, as both Jane Gray and the later (and older) Kate Armstrong come to recognize. However, Jane Gray's view presumes a world defined by love for a man, even in her eventual acceptance of responsibility for her suffering; Kate Armstrong's does not. The more recent novel suggests that while suffering (and accident, and disease, and tragedy) are still inevitable dimensions of experience, a woman can

155

achieve wholeness not through emotional bondage (no matter how willing) but through a broader human, and reciprocal, connection. As Kate phrases it to Hugo, one of several male friends to whom she is affectionately attached, "'I sometimes think that if so many people weren't leaning on me, from different directions, I might fall over.'" (MG, p. 261).

Jane Gray seems caught at an earlier stage of the female dilemma that Drabble illuminates but does not altogether resolve—though by the conclusion of her story she has begun to recognize the terms of her possible freedom. With *The Middle Ground*, Drabble liberates Psyche and allows her to "ascend," extending the female journey to a fuller discovery of autonomy: the element of spiritual wholeness that results from a woman's affirmation of her own independent humanity.

[1]Virginia K. Beards, "Margaret Drabble: Novels of a Cautious Feminist," *Critique*, 15, no. 1 (1973), pp. 35-47; Elizabeth Fox-Genovese, "The Ambiguities of Female Identity: A Reading of the Novels of Margaret Drabble," *Partisan Review*, 46, no. 2 (1979), pp. 234-48; and others.

[2]Marion Vlastos Libby, "Fate and Feminism in the Novels of Margaret Drabble," *Contemporary Literature*, 16, no. 2 (1975), pp. 175-192; Valerie Grosvenor Myer, *Margaret Drabble: Puritanism and Permissiveness* (London: Vision Press; New York: Barnes and Noble, 1974); Ellen Cronan Rose, "Margaret Drabble: Surviving the Future," *Critique*, 15, no. 1 (1973), pp. 5-21.

[3]Mircea Eliade, *The Sacred and the Profane: The Nature of Religion*, trans. Willard Trask (New York: Harcourt Brace Jovanovich, 1959), p. 28 and passim.

[4]Denis de Rougement, *Love in the Western World*, trans. Montgomery Belgion (New York: Harper and Row, rev. ed., 1956), p. 18.

[5]Erich Neumann, *Amor and Psyche: The Psychic Development of the Feminine; A Commentary on the Tale by Apuleius*, trans. Ralph Manheim (New York: Pantheon, 1956).

[6]Margaret Drabble, *The Waterfall* (1969; rpt. Popular Library, 1977), p. 7. Subsequent quotations in the text are from this edition, referred to by parenthetical page numbers.

[7]Valerie Myer's study of Drabble (see n. 2 above) includes a chapter on *The Waterfall* focusing on the Calvinist framework of the novel's moral scheme.

[8]See particularly Beards and Libby (n. 1 and n. 2 above).

[9]Neumann, p. 79-80.

[10]de Rougement, passim.

[11]Ibid., p. 18.

[12]Ibid., p. 50.

[13]Ibid., p. 39; emphasis in original.

[14]Ibid., p. 52.

[15]Neumann, p. 147.

[16]Eliade, p. 130.

[17]Neumann, p. 140.

[18]Joseph Campbell, *The Masks of God: Occidental Mythology* (New York: The Viking Press, 1964), p. 235.

[19]de Rougement, particularly Chapter Nine: "The Love of Death" (pp. 42-46).

[20]Neumann, p. 92.

[21]Ibid., p. 85.

[22]Beards, p. 40.

[23]Fox-Genovese, p. 237.

[24]Margaret Drabble, *The Middle Ground* (New York: Knopf, 1980), pp. 222-223. (Subsequent references will be abbreviated MG, with parenthetical page number.)

[25]In a provocative and exciting article, Lee Edwards has shown how the Psyche myth can be understood as an important formulation of female heroism. By drawing attention to the unconscious masculine bias present even in Neumann's important interpretation, she liberates the myth itself as a positive statement of female transcendence of patriarchal cultural norms. See "The Labors of Psyche: Toward a Theory of Female Heroism," *Critical Inquiry*, Vol. 6, no. 1, (1979) pp. 33-49.

The Uses of the Past in Margaret Drabble's
The Realms of Gold

Margaret M. Rowe

Early in the action of *The Realms of Gold*, Frances Wingate, Margaret Drabble's protagonist, lectures about her archaeological discoveries in the Sahara. During that lecture "She said a few words about preserving what we have (Carthage, for example) and a few more about finding what we haven't found."[1] In the gerunds "preserving" and "finding" in that quotation, Margaret Drabble offers a key to what is a central concern in her seventh novel: finding and preserving links to the past. In the title, too, Drabble underscores the thematic and structural prominence of the past in *The Realms of Gold*, for in drawing on Keats's "On First Looking into Chapman's Homer," the author provides gloss as well as designation for her novel.

Both the novel and the sonnet are concerned with preserving links to the past: explicitly in the novel through archaeology, implicitly in the sonnet through translation. But even more directly and more consequentially for the personae in the two works, novel and sonnet confront the task of finding links to the past. Both works focus on journeys that provide important perspectives on the relationship between the past and the present. Those journeys, or perhaps more precisely explorations, exist in both novel and sonnet in two time levels which can be labeled distant and immediate. Keats's speaker had made many journeys into ancient literature, "Round many western islands,"[2] in the years before Chapman helped him explore Homer's "Wide expanse." These distant journeys had their significance in helping the speaker see the past; those explorations produced a traveler who had "many goodly states and kingdoms seen." But the immediate exploration produces a more stunning effect; in that journey the speaker is turned into a discoverer, "some watcher of the skies." And it is the immediate journey and its gift of sight that gives the sonnet its center.

So too with *The Realms of Gold* where Margaret Drabble uses literal and figurative journeys thematically and structurally. In the novel, as in the sonnet, the distant journey has considerable significance, but it is the immediate journey and its effect that structures much of the work's action. In *The Realms of Gold*, the distant journey is completed before the novel's opening, while the immediate journey waits for Frances Wingate.

As the novel opens, Frances Wingate prepares to lecture on the past, the distant journey that took her to the wastes of the Sahara and to the discovery of pre-Roman Tizouk. She waits to resurrect for still another audience the city and its inhabitants—"her traders, her merchants, her agents, she had loved and defended them, with their caravans and their date palms, their peaceful negotiations" (p. 31). Through "one flash of knowledge" (p. 30), she had been able to interpret existing evidence and intuit Tizouk's location. In so doing, Frances Wingate secured a reputation and a measure of celebrity as an archaeologist—as a colleague remarks: " 'we all know you're the golden girl, don't we?' " (p. 41).

But the lost world of Tizouk and its celebrated discovery serve now as topic rather than focus for Frances Wingate's considerable energies. She waits to lecture on that distant journey remembering that "People often told her that she must get tired of talking about Tizouk, which always annoyed her, because the truth was that she never got tired of it, she always enjoyed it, it was just that they got tired of hearing about it and assumed in their incorrect sophisticated way that she must be as bored as they" (p. 29). Despite the seeming certainty, however, there is something bored about Frances Wingate, some tarnish on "the golden girl," as she waits to play lecturer. She finds herself alone in a hotel room, drinks too much, and experiences

this indescribable event, which as soon as it had passed would be gone and forgotten, leaving nothing in its wake, though in other ways she could have compared it to a change in the weather, to a feared approaching squall or hurricane, and it was true that the air did grow very dark at that moment, but it would pass (she told herself), and leave nothing, it broke nothing, it hurt nothing, she would be all right soon, inevitably she would be all right. She repeated these words, a careful formula. It grew darker, a kind of blue-gray watery darkness, and she began to moan . . . And yet, she told herself (a little, safe, monotonous voice speaking) it doesn't matter, it doesn't matter, it will pass, up and down, up and down, she walked and walked, and tears rose, she breathed with difficulty, and the hot tears spilled down her cheeks, and she thought that's better, it's nearly over, when the tears come, for though the tears had no healing power, they took off the edge of it, . . . (pp. 9-10)

For Frances Wingate, who brought Tizouk from the sands and secured a professional identity, is in personal turmoil as the novel opens.

Beset by melancholy, bereft of her lover Karel Schmidt, benumbed by alcohol and the pain of an abscessed tooth, she begins to feel her mortality. Like the octopus she sees in a laboratory, an invertebrate who "lived in a square plastic box with holes for his arms" (p. 5), Frances Wingate finds herself in isolation in a strange hotel room, a physical state emblematic of her emotional state: "Now that her younger child was seven, and some of her finer responses were no longer needed. She had felt, had noticed her heart hardening . . . she didn't seem to be develop-

159

ing other, compensatory areas of softness" (p. 9). While like the octopus in her state of isolation, she also recognizes that "Unlike the octopus, she seemed resolved on a course of defying nature" (p. 9). Frances Wingate's isolation is self-willed. Yet while she recognizes her emotional and psychological torpor and vaguely recognizes that it is "Time for some new excursion" (p. 32), the need for that immediate journey does not become concrete until she returns to England.

Upon returning home, a more formidable illness in the form of a breast tumor (benign) threatens her, and she finds "herself turning rather weakly to her family. There was nowhere else to turn. She had no real friends, only colleagues and acquaintances, and she'd lost a lot of these during her years with Karel" (p. 78). But that turning presents its own problems for Frances Wingate née Ollerenshaw. Much as she had associated with the little esteemed Phoenician migrations in the middle Sahara rather than the more illustrious Roman conquests in North Africa, Frances Wingate relates to the exceedingly ordinary paternal Ollerenshaws rather than to the well-known maternal Chadwicks. Her father, Sir Frank Ollerenshaw, had come from a Midlands family and distinguished himself enough to become "vice-chancellor of a fairly new university" (p. 78), but of her paternal family, Frances knows little. She is, in fact, more certain of her men of Tizouk than she is of her chosen family, the Ollerenshaws.

Indeed she describes the Ollerenshaws as one of the "ordinary families. Rat families. Without genius or too much inbreeding" (p. 96). That description is offered to "a psychologist who worked with rats and hamsters" (p. 95) as Frances Wingate spins theories about "the effects of landscape on the soul" (p. 95) to fill up boring moments at High Table. The dinner table conversation, however, spurs her to more serious thought about the pull of the past and the environment on the individual:

> She had been joking, or so she thought: the psychologist's description of his rats and his discoveries about social and antisocial behavior had both depressed and excited her, as did all suggestions of mechanism in behavior, and she had tried to change the subject. But she had not succeeded. The more she thought about it, the more she feared that Stephen (her nephew) was suffering from some incurable and ratlike family disease, yet another manifestation of the same illness that had killed her sister, driven Hugh (her brother) manic to the bottle, . . . She herself suffered from the same thing: it would come over her, periodically, meaninglessly. She had learned to deal with it by ignoring it, . . . but, lying awake at night, feeling the stitches in her once perfect breast, she felt that she would like to know where she began and the family ended. (pp. 97-98)

That reverie animates both curiosity and concern—"she thought with a sudden panic of her own children" (p. 98). As a result, she resolves to go to Tockley, the Midlands home of the Ollerenshaws, and the "new excursion" is begun.

The archaeologist finds little in modern Tockley to interest her:

160

"Nothing was left as it had been. Landmarks had disappeared, new ones in the form of garages and discount stores had risen" (p.111). For Frances Ollerenshaw Wingate, childhood visitor, however, there is much of interest; the return to Tockley offers her an opportunity to sort out memories of the past, to begin to recognize the significance of experiences in her grandparents' world. The easy conclusion about the Ollerenshaws as victims of "the Midlands sickness" (p. 96) that staves off the boredom of High Table is undercut by her memory and experience of place. Remembering Eel Cottage, her grandparents' home, Frances Wingate realizes "It had been the one fixed point of her childhood" (p. 100); as the child of academic nomads, her experience of childhood stability was there in the Midlands cottage. Even more "For Frances, at first, it was like paradise, like the original garden" (p. 102)

The recollections spurred by place, then, suggest more positive elements in the Ollerenshaw connection than either her reverie or conversation with the psychologist would support. There in the midst of the fens, the "reclaimed land" (p. 101), the

> flora varied from section to section: some bits were chocked with duckweed, bright green and thick and scummy, others were clear, with forget-me-nots, and pale yellow comfrey, and even bits of watercress...there were water boatmen, large beetles, tadpoles, frogs, minnows, stickleback, grubs, caddis larvae, water rats, newts, a whole unnecessary and teeming world of creation. (p. 103)

And for Frances, "a speculative child" (p. 103), that variety supported her Edenic view of Eel cottage and its environs.

But as with the first Eden, Eel Cottage is altered by the presence of human beings. "Gran hated nature" (p. 103), and Frances herself grew older and came to see the rooms as "cramped and pokey, instead of deep and comfortable" (p. 105). Thus, for the woman the Edenic world exists only in memory. Yet something of that yearning for Eden remains in the woman who thinks about her work during her visit to Tockley:

> The pursuit of archaeology, . . . is . . . a fruitless attempt to prove the possibility of the future through the past. We seek a utopia in the past, a possible if not an ideal society. We seek golden worlds from which we are banished, they recede infinitely, for there never was a golden world, there never was anything but toil and subsistence, cruelty and dullness. (p. 120)

Banished from the garden,[3] Frances finds it difficult to see the area between "a golden world" and a world of "cruelty and dullness," a difficulty obvious in Tockley and elsewhere.

Something of this difficulty is noticeable in her view of Tizouk and its Phoenician settlers. Drawn to the Phoenicians "because of their bad reputation: no race could be so bad as *that* she had decided while still at

161

Oxford'' (p. 34), she seeks to emphasize the more harmonious elements in her discovery: her Phoenicians were "Men of peace, not war, they had been exchanging useful commodities and works of art" (p. 31). It is more difficult to deal with the evidence of child sacrifice—"innocent children . . . in little jars with Punic inscriptions" (p. 31)—so she does her best at lectures to avoid or at least underplay that element. For her Tizouk, "the city of her imagination" (p. 29), is as close to "a golden world" as she has come and all must be done to guard that image: "And then she moved to her last defense, of her own men, the men of Tizouk, the men who passed through Tizouk. 'What was wrong with trade?' she inquired rhetorically. 'Why should men not be merchants? Which is more civilized, a Roman legion, or a caravan of merchandise?' " (p. 35).

The defense of Tockley is another matter. Ironically, Frances Wingate returns to the Midlands because of the reputation that the Ollerenshaws have in her imagination; as she tells the psychologist, " 'I've often thought that there must be something in the *soil* there, in the very earth and water, that sours the nature. I often think that in our family—we've got some hereditary deficiency. Or excess. I wouldn't know which' " (p. 96). But the perception that makes Tizouk closer to "a golden world" than to a world of "cruelty and dullness" works in the reverse for Tockley. For the child, Eel Cottage was a magic place, but for the woman confronted only with unmediated memories, there is misery, not magic, in the cottage and its locale. Twice in her first visit to Tockley, Frances Wingate's negative view of the Ollerenshaw world allows her to misinterpret what she sees. Once in the countryside

> She was about to turn back, judging that she had let enough time pass, when she saw ahead of her a sight that drew her forward. It was a field full of people, and the vision of it flashed across her unprepared eye, shaking her in a way that she could not comprehend. A field full of people, only women and children, in a bare ploughed field. Stooping and bending under the large sky. They had baskets, they were filling baskets. What were they doing, in that bare field? There were no crops, there was nothing. Small children stooped, women in head scarves, like an ancestral memory. She shivered as she drew nearer, and her first impression dispelled itself—for of course, they were ordinary women and children gathering stones, and when she leaned on the gate and asked the nearest what they were doing, they said they were clearing the new school playing field, and she could see that that was what they were doing, and that they were enjoying it—it was a voluntary effort, a communal effort, and the children were nicely dressed and the women were exchanging jokes as they worked. Why then had she seen something different? For what she had seen had been an image of forced labor, of barrenness, of futility, of toil, of women and children stooping for survival, harvesting nothing. (p. 118)

Her other misinterpretation occurs at the agricultural museum in Tockley:

162

The label attached to the eel stang said, or so she thought, that it was an implement for turning eels in ditches. At the description, she shivered again, and looked again, and saw that it said not turning, but trapping: it was a useful implement, for trapping eels. She felt an unaccountable relief. She had a vision, she had to admit to herself, of old men pointlessly turning over eels in ditches in meaningless labor, just as those women and children in the field had appeared to her, at first sight, as an allegory of pointless rural toil. (p. 119)

In both instances, Frances Wingate's "unprepared eye" keeps her from comprehending what she sees.

Aural comprehension is not any more keen in Frances Wingate. She has one conversation in her first visit to Tockley, a conversation with Mr. Bazeley, an old friend of her grandparents. He speaks of missing her Gran, and Frances who remembers his visits when the old people "sat in companionable silence" (p. 116) cannot understand him. "How could she know whether he spoke with passion, with loss, with respect, with duty? He spoke a foreign language, the signs of which she could read less well than the signs of a Punic inscription or Latin text" (p. 117). She is not prepared to hear Mr. Bazeley any more than she is prepared to see the eel stang or the communal act at the playground.

For in the first stage of her return to the Midlands, Frances Wingate is too much the outsider, a position underscored by Drabble who has her character looking in rather than within Eel Cottage. Years earlier, a tutor at Oxford had advised her "to see life as a cycle, not as a meaningless succession of mutually exclusive absolute states" (p. 8), advice which Frances thought she had accepted. But her return to Tockley demonstrates a mechanistic rather than an organic view of life, particularly in relationship to family. She is too committed to finding evidence to support her diagnosis of "the Midlands sickness," too willing to alter what she sees to fit her theory. Only in the second stage of her exploration, when she returns as a family member to deal with a family crisis, does her way of seeing family and countryside change. Only then does Tockley offer up the artifacts necessary to supplement memory and to educate her "unprepared eye." In the first journey, Frances is much like Keats's speaker in the sonnet's octave, a traveler; the second journey transforms her into a discoverer.

Between first and second journeys, however, Frances Wingate returns to Africa to participate in a conference in Adra, a newly formed African state in search of a past and a future. Fittingly, in the course of that visit Frances, too, confronts something of the past and the future. She discovers a cousin, David Ollerenshaw a geologist, and because of him begins to question her certainty about "the Midlands sickness." David extends her knowledge of the family past with details about family feuds; at first, Frances Wingate is willing to dismiss that kinship as "Bad blood" (p. 258) until she thinks of David himself

. . . and of how surprised she had been to discover their relationship; the truth
was (she might as well admit it) that she'd been astonished to learn that any
member of the Ollerenchaw family apart from her father had ever made it to
grammar school, let alone to university. Her mother had always taken the line
that no good thing could come out of Tockley: the Ollerenshaws had been
written off as peasants and shoemakers and shopkeepers, and Frances would
never have thought of looking for a cousin among them, would never have
dreamed of finding as acceptable a cousin as David. (p. 266)

But the surprise of David Ollerenshaw is much less dramatic than the
surprise of Great Aunt Con,[4] whose death brings Frances Wingate back
from Adra. Spurred by a confusing series of telegrams, one of which sug-
gests ominously that she *"Better Home Home"* (p. 261), Frances under-
takes the second journey to Tockley, a journey that brings her home in
the fullest sense.

After learning from her parents and newspapers about the death of her
Great Aunt Con whom she never knew, Frances goes to Tockley to cope
with the sudden celebrity of the Ollerenshaws. Aunt Con, who had lived
her life as an eccentric recluse in her cottage near Tockley, had in her
death from starvation won attention and notoriety for the family. Her
starvation coincides with an inquiry by the *Sunday Examiner* into "the
deaths of various old ladies from various causes" (p. 264). Con Olleren-
shaw with her connection to Frances Wingate's prominent parents and
lesser known relatives near Tockley gives the paper a chance to instill a
human element into the statistics, and the exposé is on.

Frances Wingate's first visit to Tockley came after a recuperative
period at her parents' home; this time her parents, Lady Ollerenshaw
shocked into hysteria and Sir Frank into greater silence, turn to her. She
becomes caretaker rather than patient: "Frances, rinsing out coffee cups,
saw herself an an adult, her parents declining feebly to the grave. The
matriarch, arranging funerals. It was a role she might have expected, but
it seemed to have come to her rather suddenly" (p. 284). In such a role
and knit more and more into the fabric of the Ollerenshaw family, a new-
ly found cousin and aunt, Frances Wingate returns to the Midlands.

This journey, however, proves more fruitful to Frances Wingate,
Ollerenshaw and archaeologist, than did the first. Mays Cottage, Con's
home, has not undergone the cosmetic changes that overtook Eel Cot-
tage. Rather, Mays Cottage is a rich find for Frances who comes upon the
cottage at dusk and discovers "It was like Sleeping Beauty's terrain," on-
ly to quickly remember that "it was no sleeping beauty . . . discovered
there" (p. 292). She sees immediately that Mays Cottage is "The Real
Thing," not the haunt of a witch or a monster, but the place where "Con-
stance Ollerenshaw, her great-aunt, had lived and died" (p. 295).

Like Tizouk "miraculously preserved by the fine dry sand" (p. 39),
Mays Cottage had been protected: "Nature had gently enfolded it, had
embraced it and taken it and thicketed it in, with many thorns and briars:

164

nature has wanted it, and had not rejected it" (p. 295). And like Tizouk which let Frances Wingate fill "matchboxes and cigarette packs, and little plastic bags . . . (with) relics, dried and preserved and hidden by the sand for millennia" (p. 30), Mays Cottage offers its relics:

> Bits of paper, letters, photographs, medals, buttons, sewing eggs, bobbins, brooches, rings, old tickets, coins, pins, and bits and pieces of a lifetime—of more than a lifetime, she realized, as she started to go through them, for here were records going back into the dim reaches of the dusty Ollerenshaw past, before dead Constance had been born. Illspelled letters in spidery script announced a death in the family in Lincoln in 1870, a birth in Peterborough in 1875. Nearly as indecipherable as hieroglyphics, nearly as sparse in their information as Phoenician shopping lists, they contained a past, a history. (p. 295)

In the first stage of her return, Frances Wingate could not understand Mr. Bazeley; indeed "a Punic inscription" was more familiar than the language of the Midlands. In the second stage, both family records and Phoenician lists demand understanding before giving up their secrets.

What Mays Cottage offers then is nothing less than "a past, a history": a family record of happy and sad, slothful and striving, mad and sane Ollerenshaws. A past with many more complicated human turnings than the mechanistic "Midlands sickness" would allow. Old Aunt Con proves to be much more than the village eccentric that neighbors, and family, thought her;' she was a young woman of promise whose love affair with a married man produced a child who died in infancy. Her reclusiveness had been her protection against the world. Yet even to the end she had made distinctions about those things she valued. Frances Wingate discovers "a little bundle of love letters, tied with a blue ribbon. She (Con) had not used these to light the fire: she had not, in her final hunger, eaten those" (p. 297). The exploration at Mays Cottage leads to discoveries about other Ollerenshaws as well. Through those discoveries, Frances recognizes that her father's rise in the world was not the "freak escape" she had always thought. In the past

> there had been other Ollerenshaws who had climbed too. They had learned to write their names, they had managed to rise above twelve shillings a week wage, the suppers of dry bread and onions. And as a proof of their success, Joshua Ollerenshaw, shoemaker, had managed to buy the tied cottage from the estate, in 1880, . . . They had risen from the slavery of agricultural labor: they had become shoemakers, smallholders, small shopkeepers. Ambition had propelled them, as it propelled her and her father. (p. 296).

Thus, for Frances Wingate the return to Tockley and, in particular, the exploration of Mays Cottage leads to a new view of family and her part in it. (As a consequence of Aunt Con's death, she discovers another cousin, Janet Bird, with whom she finds much in common.) The distant journey

165

to Tizouk offered Frances Wingate a chance to give back part of the African past to Africans; the immediate journey to Tockley offers her a chance to reclaim a familial past. For in her own way, Frances Wingate is like Joe Ayida, Adran Minister of Culture, through whom "she had glimpsed what it must be like to have lost one's past, and to stand on the verge of reclaiming it" (p. 220). Through the distant journey to Tizouk, she secured a public identity; through the journey to Tockley, she better understands her private identity: "It was not quite as spectacular a rediscovery and reclamation as Tizouk, but it offered many private satisfactions . . . (p. 347).

But learning "where she began and the family ended" is not one of Frances Wingate's "private satisfactions" since so mechanistic a view of history and human personality is undercut in the exploration of Tockley and elsewhere in the novel. There are no easy labels to explain the discoveries made in distant and immediate journeys: neither "child sacrifice" nor "the Midlands sickness" explains much about Tizouk or Tockley. So much of the past cannot be explained and so much of the present cannot be understood by Frances Wingate— or the novel's narrator[5] who admits even "Omniscience had its limits" (p. 332).

At best, Frances Wingate moves from a negative, absolutist estimate of the Ollerenshaws as "mentally unbalanced all of them, melancholics and suicides and witches, and now, in this newer generation, nomads, alcoholics, and archaeologists, with death running in their veins" (p. 266) to a more organic view of her family. With the lack of hope that drives her nephew Stephen to suicide, there is the hope that helps her cousin Janet Bird survive a bad marriage; with Gran's "grudge against life" (p. 106), there is old Con's response to a baby: "the sight of him seemed to satisfy her" (p. 279). Tockley is neither "a golden world" nor a world of "cruelty and dullness" and Frances Wingate concludes when she buys Mays Cottage as country home for her extended family: "it may not be paradise, but it suits me" (p. 347). Once found, a place of value ought to be preserved.

NOTES

[1]Margaret Drabble, *The Realms of Gold* (1975); rpt. New York: Popular Library, (1977), p. 32. All subsequent citations in the text are to this edition.

[2]John Keats, "On First Looking into Chapman's Homer," *Selected Poems and Letters*, ed. Douglas Bush (Cambridge, Mass.: Riverside Press, 1959), p. 18. All subsequent quotations in the text are from this edition.

[3]For a perceptive discussion of Drabble's use of garden imagery in the six novels written before *The Realms of Gold* see Valerie Grosvener Myer's "Landscape, Greenery, Gardens," in *Margaret Drabble: Puritanism and Permissiveness* (London: Vision Press Limited, 1974), pp. 157-169.

[4]For Ellen Cronan Rose, Great Aunt Con is the mother figure for whom Frances searches; see chapter 5 of *The Novels of Margaret Drabble* (Totowa, N. J.: Barnes & Noble Books, 1980), esp. pp. 100-105. My own reading gives greater emphasis to place (Mays Cottage, etc.) and its influence on personality.

[5]Drabble's narrator is an interesting "character" on *The Realms of Gold*; in the quotation that follows this note in the text and elsewhere in the novel (e.g., the characterization of David Ollerenshaw, pp. 174-175 and p. 179) the narrator stesses the limits of knowledge for both characters in and narrator of novels. For another, less favorable, view of Drabble's narrator in *The Realms of Gold*, see Joan Manheimer, "Margaret Drabble and the Journey to the Self," *Studies in the Literary Imagination*, XI, No. 2 (Fall 1978), 139-140. Ms. Manheimer and I disagree generally on the effectiveness of the narration in the novel, and most specifically on the characterization of Frances Wingate whom she sees as a character without limitations: "Frances has everything: a glamorous career, four spunky, obligingly independent and unobtrusive children, the love of a good man; even her tumor is benign," 140. I think Frances Wingate's characterization is more complex.

The New Victorians: Margaret Drabble as Trollope

Morton P. Levitt

"Of all modern authors," John Bayley concedes, "the closest to Shakespeare is certainly James Joyce, but for all its marvellous and intricate power to move us *Ulysses* is leaden with its own art, sunk in its richness like a great plum-cake."[1] And, he continues, speaking of Joyce's major Modernist contemporary in England, "'What is it, life?' Virginia Woolf is continually asking She creates because she is unable to be, and her creations cannot therefore, to most persons, appear as an adequate representation of being."[2] Woolf and Joyce, like the great Modernist novelists of the Continent, believed that their revolution against Victorian values and modes was being conducted in the cause of a new reality, a new state of being, on behalf of a life lived beneath the old surface of characterization and plot and within the humanist tradition.[3] They have been accused instead—by two generations of English critics and novelists—of repudiating not merely the surface of fictional life but life itself as it is lived by the mass of men and women and as it must be portrayed by the mass of novelists. The Great English Tradition, opened by F. R. Leavis to the foreigners Conrad and James and to the radical Lawrence, is irrevocably shut against the far more alien and threatening Joyce and Woolf.[4]

In the process, half a century of the history of the novel—and, one might argue, the finest half-century at that —is neatly excised from the English experience. Few English critics show much interest in Joyce;[5] Woolf is rarely taught in the universities of England;[6] and, as for Samuel Beckett, who follows them, he is almost universally assumed to be a French novelist and therefore beyond the need for critical consideration. Kingsley Amis,[7] William Cooper[8] and Cooper's master (and Leavis' enemy) C. P. Snow have led the fight against what they have termed, in near unanimity, "idle experimentation" (which seems to include all narrative forms devoid of omniscience), opting instead to reinstate in their fiction traditional (i.e., Victorian) conceptions of narration, characterization and plot. In their formulation, experiment inevitably negates character and event; traditional characterization, plot and omniscience are the apotheosis of form in the novel (so that experiment leads inevitably to formlessness as well); such form is somehow the equivalent of morality in the novel; and such a view of morality is the only possible valid statement of humanistic concern for the novelist.

Snow speaks, in a sense, for them all: "Looking back," he wrote in 1953, "we see what an odd affair the 'experimental' novel was. To begin with, the 'experiment' stayed remarkably constant for thirty years. Miss Dorothy Richardson was a great pioneer, so were Virginia Woolf and Joyce: but between *Pointed Roofs* in 1915 and its successors, largely American, in 1945, there was no significant development. In fact there could not be because this method, the essence of which was to represent brute experience through the moments of sensation, effectively cut out precisely those aspects of the novel where a living tradition can be handed down. Reflection had to be sacrificed; so did moral awareness; so did the investigatory intelligence. That was altogether too big a price to pay and hence the 'experimental' novel . . . died from starvation, because its intake of human stuff was too low."[9] *Ulysses* and *Finnegans Wake*, the entire mature canon of Woolf, all the volumes of *A la recherche du temps perdu* after *Swann's Way, Joseph and his Brothers* and *The Magic Mountain*, virtually all of Kafka—not to speak of Faulkner, Nabokov, Hemingway and Beckett—eliminated all in the cause of "reflection," "moral awareness" and "the investigatory intelligence," in other words, of the simple joys of omniscience. It is in this context that Margaret Drabble has come to be one of the most admired novelists of the day in England.

Drabble is no ideologue, and she is a far better writer than Snow, less simplistic in her view of the world, less impassioned in some anti-Modernist crusade. Yet her novels fail for much the same reasons as his, for her work is founded on the same unyielding belief that the Modernist experience in fiction is an irrelevancy and that an earlier, Victorian form is most appropriate to convey the nuances of contemporary life. As Trollope criticized Dickens and Thackeray for not being omniscient enough, [10] so Drabble outdoes her contemporaries in the willful, even flaunting use of Victorian omniscience. It is a perspective of certainty that simply cannot communicate convincingly her uncertain contemporary worldview—that blurs her worldview. There is no way in which a Victorian narrative mode can be made appropriate—without a massive infusion of irony (as in B. S. Johnson's *Christie Malry's Own Double-Entry*) or an elaborate, functioning self-reflexive apparatus (as in John Fowles' *The French Lieutenant's Woman*)—to so contemporary a subject matter as hers. It is a mistake to misplace our sympathy for her feminist-humanist goals; Drabble's novels fail, despite their subject, because their forms and functions are so patently unsuited to one another.

"I see my characters as glued together by personality," Drabble has said.[11] "I feel myself to be and I often think that surely it would be more dignified to fly into a thousand pieces in this situation and give up. But in fact I'm incapable of it. I will go on relentlessly to the end, trying to make sense of it, trying to endure it or survive it or see something in it. I don't

divide. I often wish I could." This divisible world, in each of Drabble's novels, is seen from an essentially unitary vision; the self torn between vision and self, ready "to fly into a thousand pieces" yet somehow "glued together by personality," is seen through a single, undivided, unambiguous lens; the subjectivity which links Drabble to her characters, the objectivity with which she views herself, are both lost in the totally omniscient narrative perspective through which she views characters and self, the world without and the world within. Her words speak of a worldview that is surely appropriate to a post-Modernist writer; the points of view of her novels are deliberately and grossly pre-Modernist. Her sense of irony is at no time directed at this paradoxical split—it is never even seen as a split; she refuses, unlike Doris Lessing and Fowles, to make use of the reflexive potential within such a frame of contemporary characters, contemporary awareness and Victorian voice (no narrative sin in itself, to be sure, yet Drabble seems sometimes to raise reflexive possibilities in order to ignore and reject them); she denies all claims that her technique might well be influenced, however indirectly, by the Modernist example;[12] she wills to out-Trollope Trollope. Her characters, as a result, fail to convince us that they are capable of speaking on their own or of leading lives of their own independent of their creator, and that we should be concerned about such voices and lives.

The Waterfall (1969) is that rare Drabble novel in which the protagonist appears to speak for herself. Jane Gray's narration begins in the third person, with seeming objectivity, often concerned with memories of her past, and then shifts suddenly to the first person, as she presumably grows more willing to deal with her subjective needs in the present. Yet the third-person account is not really objective ("She felt so strongly about the child: she loved him, and yet she knew that because he was hers he was doomed. She had felt this before he was born . . ."—p. 92),[13] and the first-person narrator may not really be Jane ("How I dislike Jane Austen. How deeply I deplore her desperate wit. Her moral tone dismays me . . . Morals and manners: I leave it to Jane Austen to draw those fine distinctions."—pp. 65-7). Underlying all, first-person and third-, intensely involved and purportedly aloof, is the omniscient voice of Margaret Drabble, merely pretending to speak through her heroine.

Although there is nothing in the account of her life to indicate that Jane Gray is a professional novelist—indeed, to suggest that she is capable of any act of willed creativity—we are evidently meant to assume that she is the one who is writing this novel and commenting on it throughout. But we recognize that the novelist's voice in The Waterfall is that of the novelist, Drabble. It is she who confides in the reader directly about her technique, who admits deception in speaking of this life, who explains, finally, the shift from third-person to first-person narration and back. "Lies, lies, it's all lies. A pack of lies. I've even told lies of facts, which I

had meant not to do. Oh, I meant to deceive, I meant to draw analogies, but I've done worse than that, I've misrepresented. What have I tried to describe? A passion, a love, and unreal life Reader, I loved him, as Charlotte Brontë said" (pp. 98-9). "I began the last paragraph with the word 'firstly,' so I must have been intending to begin this with 'secondly,' but I can't remember what it was or if I can it was too embarrassing and I've repressed it. Anyway, I'm tired of all this. It has a certain kind of truth, but it isn't the truth I care for. (Ah, ambiguity.)" (p. 156). "There isn't any conclusion. A death would have been the answer, but nobody died. Perhaps I should have killed James in the car, and that would have made a neat, a possible ending. A feminine ending?" (p. 280). She has omitted; she has distorted; she has attempted through this fiction to find some meaning in life and then has rejected that meaning: "the only moral of it (a weekend with James in Yorkshire) could be that one can get away with anything, that one can survive anything, a moral that I in no way believe (and if I did believe it I couldn't tempt providence by asserting it)" (p. 286). She is in control of her material, yet not quite in control.

She has endeavored to seek objectivity but has given it up ("I tried, I tried for so long to reconcile, to find a style that would express it, to find a system that would excuse me, to construct a new meaning, having kicked the old one out, but I couldn't do it, so here I am, resorting to that old broken medium"—p. 51); yet even subjective narration does not quite serve when the subject is too intimate, its psychological potential too threatening: "I am getting tired of all this Freudian family nexus, I want to get back to that schizoid third-person dialogue" (p. 155). No matter in which person she speaks, Jane Gray speaks with the voice of Drabble, a ventriloquist's dummy.

But this is hardly unique and hardly reprehensible in itself. Why, then, the labored pretense that the protagonist writes her own story? Why create such an elaborate reflexive frame if no use is to be made of it? We recognize that Jane Gray is more than reliable spokesman yet less than autobiographical creation; her story, we assume, is a fiction and not an account of Drabble's own life, although its theme (of an emerging female consciousness) is obviously important to Drabble. All of this would be clear without the mass of reflexive references. Why is it necessary to rub our (Modernist) noses in such a mass?

Self-reflexivism, when it works (as in Gide, Borges, Nabokov, Fowles and Barth), can offer a rich potential of insight and discovery into the nature of identity in general and of the novelistic identity in particular, of the interaction between fiction and life, of the act of writing and the act of living a novel about a novelist's life. There is nothing of this, obviously, in *The Waterfall*. It is a highly subjective mode, this reflexive technique, an outgrowth of the intensely self-aware Modernist use of point of

view. It is also the sole Modernist technique which has been substantially expanded in this period post-Modernism. Drabble appears to know the vocabulary, and she evidently believes that its use will help lead her character to some sort of increased self-awareness. Yet she makes no real effort to facilitate that process through the reflexive technique; we get only the vocabulary and none of the substance; no new discoveries about art or life or their inter-connection; no new knowledge (or self-knowledge) concerning her characters; no relation at all to the development of character or theme. Behind her elaborate reflexive frame, Drabble coyly reverts to her role as omniscient/omnipotent author; Jane Gray, her puppet, is no more capable of writing her life than she is of acting it. The unused self-reflexive frame simply accentuates her failures in life.

Jane Gray's is one of those lives in which a woman meanders—lazy, desultory, a presumed victim of fate—through marriage, through motherhood, through a strangely uninvolving affair with the husband of her closest cousin. Throughout her life she has emulated, in a determinedly lesser way, the life of her cousin, Lucy Otford. When James Otford brings her for the first time the posibility of passion, she responds for the first time—so at least she tells us—with passion. Having lost control of her life for no discernible reason, she is said to re-assert it for no better reason. Yet we are shown no truly passionate acts; we are shown virtually no acts at all. We must presumably accept her word and that of the author: a toy of fate, in her own mind, she remains a toy of her creator. We acknowledge the significance of the theme of the emerging female consciousness in a world long dominated by males, the central theme of all Drabble's work, but we are totally unmoved by this coyly omniscient account of this desultory, passionless life. Drabble's omniscience is but one more assertion of Jane Gray's dependence. It is not merely inappropriate in a general way to the contemporary setting; the omniscient technique of *The Waterfall* specifically and directly contradicts and undermines the intended theme of the novel. The Victorian technique determines, in the end, that the theme too shall be Victorian.

It is a problem that we meet in all of Drabble's fictions, although in somewhat different forms. In *The Realms of Gold* (1975), for example, there is none of the reflexive vocabulary, no pretense at all that the protagonist is concerned with writing her own story. Drabble does not lurk now in the background of characters and events; she is present at the center, all-knowing and all-powerful, manipulating her people and their lives and endeavoring as broadly to manipulate us as well. Her narrative is filled with parentheticals setting forth the true facts: "The true explanation never crossed her mind" (p. 76);[14] "She did not succeed. She had too strong a sense of reality" (p. 77). She juggles her characters and our ability to view them: "Remember him, for it will be some months

172

before he and Frances Wingate meet again" (p. 51); "They had never met, and were not yet to meet" (p. 99). She speaks directly to us, in her own voice, of her plans for her characters and their lives and of her own evaluation of them as characters: "The truth is that David was intended to play a much larger role in this narrative, but the more I looked at him, the more incomprehensible he became, and I simply have not the nerve to present what I saw in him in the detail I had intended. On the other hand, he continues to exist, he has a significance that might one day become clear, and meanwhile he will have to speak, as it were, for himself" (p. 176); "And that is enough, for the moment, of Janet Bird. More than enough, you might reasonably think, for her life is slow, even slower than its description, and her dinner party seemed to go on too long to her, as it did to you. Frances Wingate's life moves much faster. (Though it began rather slowly, in these pages—a tactical error, perhaps, and the idea of starting her off in a more manic moment has frequently suggested itself, but the reasons against such an opening are stronger, finally, than the reasons for it.) Because Frances Wingate's life moves faster, it is therefore more entertaining. We will return to it shortly, and will dwell no longer on its depressing aspects. It is depressing to read about depression" (p. 175).

Drabble assumes—and she assumes that we will assume—that this is merely a fiction, not to be taken too seriously, surely not a substitute for and rival to life. Thus she is willing to rest the resolution of her action on the coincidence of a lost and then suddenly found postcard. ("And to those who object to too much coincidence in fiction, perhaps one could point out that there is very little real coincidence in the postcard motif, though there are many other coincidences in this book"—p. 218). She is willing too, in a pretty pink bow of a Dickensian final chapter, to take us some years into the future to keep track of her characters. Her omniscience is so obtrusive at times as to appear almost parodic. But the sense of self-satire which works so well in a similar situation in *The French Lieutenant's Woman* is absent here. There is humor here and self-awareness, but no parody. ("It is depressing to read about depression.") We are meant to take the technique seriously, as if, somehow, we were Victorian readers and Drabble were truly Dickens or Thackeray or, more likely, Trollope—but, of course, with much less naturalness and a greater sense of tradition, since she has obviously read Dickens and Thackeray and Trollope, and she is obviously not of their time. The effect is terribly disjointing. Thematically, *The Realms of Gold* is concerned with a changing Britain, with a kind of cultural progression in which generations, classes and sexes confront one another, effect some change but as yet reach no resolution; technically, it would obviate all change, a self-satisfied return to tried and presumably true and sorrowfully inapt narrative modes.

173

It is clear by the time of *The Ice Age* (1977) that there is a basic Drabble mode which allows only minor variations and whose development is limited to thematic issues. There are, on the surface, however, some changes: the protagonist of this book is a man; the concern with the moral state of Britain is still more pronounced ("A huge icy fist, with large cold fingers, was squeezing and chilling the people of Britain, that great and puissant nation, slowing down their blood, locking them into immobility, fixing them in a solid stasis, like fish in a frozen river The flow had ceased to flow"—p. 50);[15] the problems of individual identity are restricted no longer to women but are extended also to men, indeed, to the nation as a whole. But the coy Victorian narrative tricks remain. The omniscience is still ostentatious; whatever irony there is, like point of view, is imposed from without; technique by now seems totally mannered: "It ought now to be necessary to imagine a future for Anthony Keating. There is no need to worry about the other characters, for the present. Len Wincobank is safe in prison: when he emerges, he will assess the situation, which will by then have changed, and he will begin again. He will make no more such mistakes. As he will say to the prison governor on the day of his release, I have learned my lesson. Max Friedmann has been, throughout, dead; Kitty Friedmann will not alter Evelyn Ashby, who has not been allowed to appear, will not remarry; she will grow eccentric and solitary . . ." (p. 205).

In this sad, almost will-less moral state, most individuals seem incapable of change, whereas change for the people as a whole—as exemplified in a series of old houses and new housing developments (the metaphor of *Brideshead Revisited* updated)—is likely to be deleterious, although positive change is seen as possible for some individuals and even perhaps, in the future, for the nation as a whole. Drabble offers no monolithic view of affairs, private or national, and no simplistic thematic solutions. Yet her technique could hardly be more simplistic. In each of these novels, she has something challenging to say about the nature of human relations—about the changing attitudes and roles of women, in particular—in a world that is most uncertain. But her technique speaks of a world that is almost totally at odds with her theme, that could not be more certain. Unlike Snow and Cooper, Drabble is surely not unaware that the world will never again be as simple as it may have seemed in Victorian times. She seems far less concerned than they are with simply reconstituting the past and with waging war on the Modernists. But her point of view is painfully similar to theirs—it may even be worse since her voice seems so much more conscious and knowing. Perhaps she desires to contrast the certainty of an omniscient point of view with the instability of contemporary life and misjudges the effects of her technique; perhaps she is simply a lazy writer who wishes to avoid the strain of writing through more limited narrative perspectives. It is dif-

174

ficult, whatever her reasons, to justify so incongruous a usage: that narrative technique, like theme, should be appropriate to its time seems not to concern Drabble at all.

The Modernists believed that the novel was a significant art form and its practitioners dedicated and professional craftsmen. Many contemporary British critics and novelists reject this approach as elitist; they would appear to opt for a kind of amateur author, for whom the novel is but one human activity among many. At the end of *The Ice Age*, we are shown a vision of this ideal post-Modernist novelist: the hero is in an East European prison, where he has found both his God and his art— neither, perhaps, to be taken too seriously, since he knows so little about either and since the narrator is silent on our expected response: "Anthony Keating is writing a book, while he is in prison. He is not the first prisoner to spend his time in this way, and will not be the last Anthony's book is not very well written because he is not a very good writer. But he writes for himself. He has lost interest in any market" (p. 247). Perhaps intended as commentary on the supposedly solipsistic Modernist author, he speaks, in fact, for the anti-Modernist, post-Modernist school: an imprisoned amateur, without practiced audience, without skill, without a subject that he understands very well or that we are likely to be concerned much about, very likely without a narrative technique that deserves consideration: what more fitting image could Drabble give us of her fictional generation?

Trollope, in his time, exaggerates the omniscient technique because his view of human relations (between man and man, between man and society, among author, hero and reader) presupposes a universe in which everything is, if not quite known, at least knowable, in which certainty and direction underlie all. Victorian omniscience, even in so extreme a form, is most appropriate to ours: in Drabble's fictions, it is at best an anachronism, unwittingly parodic, while at worst it undercuts, even destroys her intended post-Modernist themes of uncertainty and misdirection. This is Trollope revisited, to be sure, but, in the context of a new time for which his vision and narrative technique are woefully unsuited, it is also Trollope demeaned.

NOTES

[1]John Bayley, *The Characters of Love* (New York, 1960), p. 285.

[2]John Bayley, *Tolstoy and the Novel* (London, 1966), p. 59. Malcolm Bradbury adds that Woolf "not only tends to poeticize modernism, but also to feminize and domesticate it" *Possibilities: Essays on the State of the Novel* (London, 1970), p. 191.

[3]". . . if a writer were a free man and not a slave," Virginia Woolf writes in "'Modern Fiction" in 1919, "if he could write what he chose, not what he must, if he could base his work upon his own feeling and and not upon convention, there would be no plot, no comedy, no tragedy, no love interest or catastrophe in the accepted style, and perhaps not a single button sewn on as the Bond Street tailors would have it. Life is not a series of gig lamps symmetrically arranged; but a luminous halo, a semi-transparent envelope surrounding us from the beginning of consciousness to the end." *The Common Reader*, First Series (New York, 1953), p. 154. The reaction against Woolf is very likely based on such critical statements rather than on the evidence of her novels.

[4]*Ulysses*, says Leavis, is "a dead end, or at least a pointer to disintegration," as he holds up Lawrence against Joyce as one who speaks "for life and growth, amid all this mass of destruction and disintegration." *The Great Tradition* (New York, 1967), pp. 26, 260. But then we remember that Woolf, too, was rather scornful of, if somewhat intimidated by *Ulysses*.

[5]In a book called *Unofficial Selves*, with the sweeping subtitle *Character in the Novel from Dickens to the Present Day* (New York, 1973), Patrick Swinden makes two passing references to the Stephen Dedalus of *A Portrait of the Artist as a Young Man* and none at all to Leopold Bloom or *Ulysses*.

[6]But, a student at Edinburgh University assured me after a lecture, Woolf's novels continue to be read outside the classroom.

[7]"The idea about experiment being the life-blood of the English novel is one that dies hard," writes Amis. "'Experiment,' in this context, boils down pretty regularly to 'obtruded oddity,' whether in construction—multiple viewpoints and such—or in style; it is not felt that adventurousness in subject matter or attitude or tone really counts. Shift from one scene to the next in midsentence, cut down on verbs or definite articles, and you are putting yourself right up in the forefront, at any rate in the eyes of those who were reared on Joyce and Virginia Woolf and take a jaundiced view of more recent developments." *The Spectator*, 200:565 (2 May 1958), as cited in Rubin Rabinovitz, *The Reaction Against Experiment in the English Novel, 1950-1966* (New York, 1967), pp. 40-1.

[8]Cooper is so mediocre a novelist that one hesitates to cite him even paradoxically. But his *Scenes from Provincial Life* (1950) is so often cited as a pioneer in the war against the Modernists that one feels compelled to allow him to speak for himself: "'Aren't the French wonderful!'" he writes. "Who else in these days could present a literary *avant-garde* so irredeemably *derriere*! *Avant-garde*—and they're still trying to get something out of Experimental Writing, which was fading away here at the end of the thirties and finally got the

176

push at the beginning of the fifties. What a *garde!* . . . The impulse behind much Experimental Writing is an attack from the inside on intellect in general, made by intellectuals so decadent that they no longer mind if intellect persists—in fact some of them sound as if they would be happier if it didn't." "Reflections on Some Aspects of the Experimental Novel," *International Literary Annual*, No. 2, ed. John Wain (New York, 1959), pp. 29, 36.

[9]C.P. Snow, London *Sunday Times*, 27 December 1953, as cited in David Lodge, *The Novelist at the Crossroads* (Ithaca, 1971), p. 18.

[10]As Trollope writes in *Barchester Towers* (1857), "But let the gentle-hearted reader be under no apprehension whatsoever. It is not destined that Eleanor shall marry Mr. Slope And here, perhaps, it may be allowed to the novelist to explain his views on a very important point in the art of telling tales. He ventures to reprobate that system which goes so far to violate all proper confidence between the author and his readers, by maintaining nearly to the end of the third volume a mystery as to the fate of their favourite personage. Nay, more, and worse than this, is too frequently done. Have not often the profoundest efforts of genius been used to baffle the aspirations of the reader, to raise false hopes and false fears, and to give rise to expectations which are never to be realised? And is there not a species of deceit in this to which the honesty of the present age should lend no countenance? Our doctrine is, that the author and the reader should move along together in full confidence with each other." (New York, 1950), pp. 342-3.

[11]In "An interview with Margaret Drabble," conducted by Nancy S. Hardin, *Contemporary Literature*, XIV (1973), p. 282.

[12]One critic has written convincingly of the shift in point of view in *The Waterfall*—from third-to first-person narration—as a means of delineating character development: "Narrative technique thus helps define heroine and conflict." Virginia K. Beards, "Margaret Drabble: Novels of a Cautious Feminist," *Critique*, XV (1973), p. 44. Drabble herself speaks of this shift as coincidence, as almost an accident. See Hardin, p. 293.

[13]All references are to Margaret Drabble, *The Waterfall* (New York, 1969).

[14]All references are to Margaret Drabble, *The Realms of Gold* (New York, 1975).

[15]All references are to Margaret Drabble, *The Ice Age* (New York, 1977).

The Middle Ground

Gail Efrig

The Middle Ground, Margaret Drabble's latest of nine novels, demands, by its very title, a retrospective. Apparently able to see her own work with that distinctively objective yet affectionate eye she brings to the study of the whole of English literature, she has surveyed her past, and presumably envisioned her future; this book is the middle ground a resting point, an uncontested area for assessment and renewal. If the title is an indication that she had done this kind of wide scale look at her own work, that is perhaps the last definite remark she gives us about the book's purpose. We are now on our own with it, and with our memories of her past work, to make of it what we can. What does The Middle Ground have to say about Margaret Drabble's past and future? I should like to suggest that it is the middle ground of a field much, much larger than Drabble's own career, a field no less than all English fiction by women. That is not to say that the novel itself is a momentous affair; its 280 pages hardly qualify it as a magnum opus. But Drabble's work as a whole marks a new step in the history of women's writing, and I would like to use an examination of this book to examine that larger question, "When will women's fiction come within the mainstream of British literature?" Virginia Woolf in 1921 put that question in its most eloquent form in her expanded essay whose title answers the question. To women of her era who asked, Woolf answered that only with a room of one's own can one hope to achieve the goal. Nor did Woolf think that the task would be accomplished by the first woman who did have psychic and physical space, and the leisure and money to sustain them. The joining-in would be the result of years of accumulated experience by a whole class of women who could work thus, who would gradually build up a climate, an atmosphere in which this ideal woman writer of the future, "Shakespeare's sister" Woolf called her, would flourish.

The demand for a place in the mainstream, or more consistently the lament that such a place seemed unreachable, has been heard from women writers for generations. It may well be that some of the earliest, Aphra Behn and Ann Radcliffe, just took the money and ran. Since, as the literature anthologies always put it, Aphra Behn "was the first English woman who ever earned her living with her pen," it may be that financial exigency kept her too busy to speculate on her place in any English tradi-

tion, short as it was at the time.[1] As the text puts it, "Mrs. Behn takes her place in our literature as a writer who just missed the highest achievement of which she was capable because she failed to understand and correctly define her genius. But her failure was not remarkable. The only wonder is that, working under the conditions in which her lot was cast, she should have been able to accomplish so much."[2] So much, indeed, for Aphra Behn. Isn't it remarkable that she managed to achieve anything? The tradition is defined by Defoe, Fielding and Richardson. Behn and Radcliffe are outside it.

The next significant women are Fanny Burney, Maria Edgeworth and Jane Austen. The first of these, our old text taught us, "established the kind of fiction in which women have since particularly excelled."[3] And though Wagenknecht was laudatory about Austen, about the Brontes, and about Eliot, the same refrain is heard. To say of Austen that in her writing she never dropped a stitch is as cutely dismissive a notice as one could write. Would anyone say of Hardy that in his fiction he never made a mistake in addition, never hammered a nail in crooked, never dropped a pitch? Women writers keep asking, "When will you stop considering us as women writers, and treat us as one of you?" and critics keep saying, "As soon as you stop writing the kind of fiction in which women particularly excel."

English fiction has usually dealt with variations on a theme: How does an individual live rightly within a society which may contradict his instincts or even his experience of truth? Fielding, Scott, Dickens, Thackeray, Trollope, Hardy, James, Conrad, Lawrence, Joyce—their constant theme has been the adjustment of the individual to society, the social accommodation possible within the limits of what a man understands to be demanded of him by some higher force or power, by God, the fates, brotherhood, truth. And women writers, whose subjects tend to be domestic and "trivial," are thought not to be dealing with that theme. Even Woolf found the great women guilty of a failure of wholeness, a kind of partial, timid, obsequious self-effacement, or, as in the case of Emily Bronte, the shrill, defensive voice which can too readily identify the "minority writer." In the essay Woolf insists that the woman writer of the future should not abandon that particular vision, insight and sensitivity which are hers because of her female experience, but should at the same time be unhampered by the various limitations of that experience. Women writers, therefore, are called upon to transcend the tradition in order to become a part of it.

A Victorian writer in whom I am particularly interested, Elizabeth Gaskell, did seem to sense the imperative of the tradition, but met it in typically feminine way. Her first novel, *Mary Barton*, sets out to be a full-blown social novel, in which she will explore the relationship of the Manchester millhand John Barton to British society in the hungry forties.

In fact, she wishes to describe and discuss the nature of the two worlds, the rich and the poor, and the effect of this fragmenting division on the mind and spirit of her chosen central character. But as she attempts to describe relations between masters and men at one point she writes, "I am not sure if I can express myself in the technical terms of either masters or workmen, but I will try simply to state the case on which the latter deliberated."[4] This backing away from the responsibility to the subject matter, on the strength of feminine ignorance, is at the root of the failure of the book to be all it might be. Meaning to write an important book about contemporary life, Elizabeth Gaskell is hampered by her experience of being a woman perhaps, but even more so by her perception of the expectations placed on her by that experience. So she picks ways of going at her subject which are inferior ways, sentimental bilge about fainting sweethearts, co-incidences and far-fetched plot lines that would have made Dickens cringe (and possibly did), apologizing all the time for being unable to write the strong novel she felt and meant.

What has this to do with Margaret Drabble? I believe that she is the writer, or at least the beginning of the writers we are waiting for. In some senses, she writes the novels Mrs. Gaskell would have written had she had a room of her own in the twentieth century. Fully engaged with all of woman's experience, imbued with sensitivity to human needs, conscious of the tenderest images of loss and love, Drabble is able to connect these to the larger view, to the relation of the individual to society, not weakened by incapacity of understanding or expressive skill, not seeing herself hampered or stunted, or burdened or held back; here at last the woman writer moves fully into the tradition.

In *The Middle Ground* we see these qualities strongly, though tightened up and somewhat refined from their appearance in *The Ice Age*, her previous novel. Kate Armstrong is not as educated as Frances Wingate, of *The Realms of Gold* (1975), and not as idealistic as Rose Vassiliou of *The Needle's Eye* (1972), but she has recognizable similarities with what Paul Grey in *Time* called "The Drabble woman," even those as far back as Emma Evans in *The Garrick Year* (1964).[5] Certainly woman's experience has been Kate's: she has undergone struggle with her parents over her unwillingness to achieve, she has married, she has borne and raised three children to teenage, made herself a career as a popular feminist writer, divorced, had one long and satisfying affair and a clutch of short disastrous ones. All of these experiences have happened to Drabble heroines in previous books. This book begins after Kate has undergone, unwillingly though voluntarily, the abortion of a spina bifida baby. And at this point, the forward motion of her life seems to stop. "Her implacable progress has been halted . . . and the past no longer seems to make sense, for if it did, how would it have left her here, in this peculiar draughty open space?"[6] Here in the middle ground, "an empty plain" (p.

77), she feels abandoned by the kindly spirits who have attended her hitherto successful existence, and at forty-one asks the question, "What on earth should one do next?" Because Drabble herself is forty-one, and because her Drabble woman has grown old along with her (Emma Evans was twenty-six), some critics tend to assume that Kate's question is Drabble's, that she herself is in an empty space, waiting to know what to do. Phyllis Rose, in a review generally laudatory about Drabble but critical of this book, calls it "not so much balanced as immobilized," and criticizes what she calls its "narrative paralysis."[7]

It is quite true that the book contains less action, and far less plot, than previous Drabble novels. But the decision to rely not on plot, but on questions and answers, and on the space between those two, is in this case a sound decision. The stasis in the book is a necessary one, but it represents Kate's paralysis, not Drabble's. For the question "What on earth should one do next?" is, significantly, emphatically, not a woman's question. Kate is suffering through an emptiness, but it is not just her own. It is not there because somebody doesn't love her, or because she doesn't love somebody. It is not there because she is oppressed by a society which rejects her sex. It is not there because she feels that her life has been wasted on babies and domestic trivia without an opportunity for fulfillment. Kate's emptiness is the emptiness of the good human secularist in modern Britain. Rose points out in her review that Britain itself is becoming Drabble's central character. But "protagonist" would be the better word, for it is indeed a Britain struggling. This book continues the examination of British society that began with *The Needle's Eye* (much more than a story about a divorce and custody case), continued with *The Realms of Gold*, and became more pronounced in *The Ice Age*, perhaps because in that book the main character was a man. Drabble began her career with intensely written accounts of female experience, but she has stepped, cheerfully and resolutely, out of the enclosed box of that experience without leaving the intensity behind.

One detail in which Kate may indeed speak for Drabble bears on this point. It is Kate's amused yet weary recognition that women's issues, to which she is so closely tied by her journalistic success, now bore her to tears, or to laughter. In an early scene Kate makes the somewhat petulant remark to her friend Hugo that she is "as bloody sick of bloody women as you are . . . sick to death of them" (p. 4). But later, in an important scene where the modern international tangle of misunderstanding and misapplied good will is embodied in a curious, comic after-theatre dinner party, and Kate is being beseiged by the fervid bitterness of an English-born American feminist, the narrator, reporting Kate's reaction, says that "Linda Rubenstein seemed to consider her own tangential debate the only important debate of history" (p. 99). The woman question is identified here as "tangential," even by Kate, the thoroughly modern woman's

woman. Quite possibly Drabble herself, who even in 1973 was identified by Virginia Beards as a "cautious feminist" has no longer any need for that label at all.[8]

What is decidedly not tangential is the wider debate within which that question of what one should do is only a private and personal manifestation. How will the goodness of the world go on, attacked as it is by misunderstanding, mindless brutality, violence and even terrorism? "The best lack all conviction/While the worst are full of passionate intensity": Yeats' words come irresistibly to mind, as slogans, graffiti, headlines and appeals pour out this intensity over every surface of Kate's life. She looks on, notes, observes, without the conviction or the nerve to combat the flood. A great deal of the novel is given over to scenes in which Kate attempts to read herself, and to find out what she should do in the future by a re-evaluation of her past. Filled with productive and fecund imagery, the thirty-four page scene in which she revisits the sewage bank in the area she lived in as a child explores that area's connection with her mother and father, her pathetic, hate-ridden brother, and her own miraculous happy escape from Romley. The scene however shows that her escape only brings her around to her beginnings, for as it ends she finds herself realizing that her present balance is precarious, and of her past she says, "I should never have looked. I should never have looked. I should never have looked" (p. 134).

She goes on looking though, and what forward motion the narrative has is derived from her work on a television documentary, titled "Women at the Crossroads." To do this she revisits her old school, talking to the girls and interviewing some of her classmates. But the whole endeavor is unsatisfying to Kate. The battles she fought for women in her earlier career have not changed the essentials. People are oppressed, people are fearful, people struggle, and the odds get longer all the time, Kate feels, on their success. Good becomes increasingly difficult to achieve; in fact it seems more often to produce or provoke the very evil it sought to destroy.

In several incidents and characters, Drabble recapitulates this theme. Kate's friend Hugo Mainwaring is an ex-war correspondent, "ex" because he has just had his arm blown off in an ambiguous episode in Kurdistan. His reaction to this accident is to be secretly glad that he no longer is obligated to do the necesary task that was his. Someone else will have to gather the information and background on critical situations that will enable rational and well-intentioned readers to understand their world. Hugo's refusal to go on with his good work is well-presented by his refusal even to consider an artificial arm. He has withdrawn, in his middle ground, from the struggle, and the accident has provided him with the means to make his separate peace an honorable one.

Ted Sennett, Kate's lover before the book begins, is an internationally known research biologist who spends his life tracking down diseases for

the World Health Organization and other such groups. But he believes in an apocalyptic world epidemic, brought on by increased air travel (even by travelling WHO biologists), stronger mosquitos and rats, lab-produced tissues and cultures. Curing disease leads directly to the causing of disease. Ted's wife Evelyn is Kate's closest friend, an upper class social worker, an example of the best person that British society can produce. Near the end of the book, Evelyn, visiting a client, is nearly blinded in a knife-throwing, hot-oil flinging battle between a pathologically dependent, half-witted teenage lesbian and the drugged-out Jamaican bloke she spends her time running to and from. Evelyn mourns and worries that her presence in the room may actually have provoked the ruckus, and that, meaning only to do good, she has caused the mess.

Reflecting on this violent episode, connecting Evelyn's wounding in a good cause with her own abortion, Kate asserts that in that act she had denied her essential, maternal nature, even though it was a right action by every standard she knows. *"Doing the right thing has destroyed me,"* reads the text, in italics, a sentence which may be the epitaph of Britain itself when its history is written at the end (p. 235). But a better epitaph, on the whole, than the one Kate earlier despaired might be hers: *"A Nice Woman"* (p. 115, also in italics). If this is Kate's progress, then it is, if not optimistic, at least noble. Better to recognize the sources of one's destruction in the difficult good one has achieved than to take some feeble pleasure in having been merely nice.

But the book ends, not with an epitaph, but with a party, a party Kate and her children give to celebrate a number of coincident events— Evelyn's coming out of the hospital, Kate's son's nineteenth birthday, Hugo's decision to reenter the world of his professional life (signalled by his acceptance of a prosthetic hand), the departure with his fiancee of Kate's long-term house guest, her Iraqui lecturer/conscience. Filling up the guest list and the food pantry and clearing out lots of carefully nurtured rubbish in preparation for this event, Kate answers the book's question at least tentatively. For this party is not whistling in the dark. It is not an assertion that though the ship is going down we can all gather and dance on the deck. To be human is to go through the middle ground, even perhaps with one's society, and to step beyond that daughty open space into a future.

The future, personal and national, is quite clearly the subject of the party, a point made inevitable when Kate, in an excess of good spirits, goes to buy flowers for the house. She does so on the advice of her daughter. "'Go and arrange the flowers,' said Ruth, 'That's what people are supposed to do before parties.' Ruth was doing *Mrs. Dalloway* for A level" (p. 268). At the florists' Kate does buy flowers, but she is captivated by a "tree in a pot, a green flourishing tree." She buys it, and asks the shop assistant about its longevity:

"If you look after it," said the woman, "it will outlive you."

"That's what I want," said Kate, "a tree that will outlive me." (p. 272) The tree is a bay, and there can be little doubt that it stands for England. On a gold medal cast for Queen Elizabeth I in 1588, to celebrate the defeat of the Armada, the queen's goldsmith modelled the island planted with a large bay tree at its center. *Non ipsa pericula tangunt:* No dangers touch her, says the motto; the bay is eternal. And it is significant that in this book the final symbol is not the gritty stone lion on which Rose Vassiliou places a caressing hand at the end of *The Needle's Eye*, hard to love but "toughly weathered into identity."[9] Green, glossy, flourishing, a small sensation, the bay tree lives and breathes. More than a promise or a hope, it is life itself.

As Kate sits upstairs deciding what to wear for her party, these are the book's last lines:

> A child calls her from downstairs. The doorbell rings. The telephone also rings. She hears her house living. She rises.

The future, though unknown, is not unfamiliar; it will consist of the loves, the obligations, the living which have sustained Kate in the past. In a review she wrote of Elizabeth Gaskell's collected letters in 1966, Margaret Drabble somewhat unpresciently wrote that what attracts the reader of the letters is "the way in which the writer belongs to and is a part of her times."[10] This statement is quintessentially true of Drabble herself. Chronicler of her own society, Drabble may witness a secularist world revivified by a spiritual awakening, or going on through an ever-darkening experience of decay. But whatever happens to British society as it moves beyond its middle ground should provide us with good Drabble novels in the future, novels by which a woman writer joins fully the tradition of British fiction.

NOTES

[1] Edward Wagenknecht, *Cavalcade of the English Novel* (New York: Holt and Company, 1954), p. 20.

[2] Wagenknecht, p. 23.

[3] Wagenknecht, p. 135.

[4] Elizabeth Gaskell, *Mary Barton* (London: Chapman, Hall, 1848) Rpt. W. W. Norton, 1958, Chapter XV, p. 163.

[5]Paul Grey, "Sisters and Strangers," *Time*, Vol. 116, No. 11, 15 September 1980, p. 98.

[6]Margaret Drabble, *The Middle Ground* (New York: Knopf, 1980), p. 13. Further references will be cited by page number in the text.

[7]Phyllis Rose, "Our Chronicler of Britain," *New York Times Review of Books*, Vol. LXXXV, No. 36, 7 September, 1980, p. 1, 32-33.

[8]Virginia K. Beards, "Margaret Drabble: Novels of a Cautious Feminist," *Critique: Studies in Modern Fiction*, Vol. 15, No. 1, 1973, pp. 35-47.

[9]Margaret Drabble, *The Needle's Eye* (New York: Popular Library Edition, 1977), p. 382. Originally published by Alfred Knopf, 1972.

[10]Margaret Drabble, "Sense and Sensibility," *Manchester Guardian Weekly*, Vol. 95, No. 22, Dec. 1, 1966, p. 11

A Bibliography Update

(1977 -1981)

Dorey Schmidt

The most complete bibliography of Margaret Drabble's works and criticism is found in the following collection:

Stanton, Robert J. *A Bibliography of Modern British Novelists.* Troy, NY: Whitston, 1978, pp. 181-213, 1082,

which contains 346 items, both primary and secondary. However, in the intervening years, additional materials have accumulated. I have used the same divisions Stanton uses: first, primary works; then secondary works on general topics, and finally, secondary works on specific Drabble titles.

PRIMARY WORKS:

Books:

The Ice Age. London: Weidenfield and Nicolson, 1977; New York: Knopf, 1977; New York: Popular Library, 1977.

The Middle Ground. London: Weidenfield and Nicolson, 1980; New York: Knopf, 1980.

A Writer's Britain: Landscape in Literature. London: Weidenfield and Nicolson, 1979; New York: Knopf, 1979.

For Queen and Country: Britain in the Victorian Age. Seabury Press, 1979. (Juvenile)

Other:

"Muck, Memory, and Imagination." *Harper's Magazine* (Jul 1978), 82-4. Review of John Irving's *The World According to Garp.*

"Heroes of the Mundane." *Book World* (21 Oct 1979), 1,4. Review of John Updike's *Problems and Other Stories.*

SECONDARY WORKS:

General:

Amodio, Bonnie A. S. "The Novels of Margaret Drabble: Contradictory, Hallucinatory Lights." *DAI* 41: 2116A.

Campbell, Jane. "Margaret Drabble and the Search for Analogy," in Campbell, Jane and James Doyle. eds., *The Practical Vision: Essays in Honor of Flora Roy.* Waterloo, IA: Wilfred Laurier University Press, 1977.

Cooper-Clark, Diana. "Margaret Drabble: Cautious Feminist (interview)," *Atlantic,* 246 (Nov 1980), 69-75.

Fox-Genovese, Elizabeth. "Ambiguities of Female Identity: A Reading of the Novels of Margaret Drabble." *Partisan Review,* 46 (1979), 234-48.

Gagliardi, Cesare. "'Educated Women' e istintualita' nel romanzo di Margaret Drabble." *Lettore di Provincia,* 29-30: 89-97.

Ginden, James. "Three Recent British Novels and an American Response." *Michigan Quarterly Review,* 17 (1978), 223-46.

Joseph, Gerhard. "Antigone as Cultural Touchstone: Matthew Arnold, George Eliot, Virginia Woolf, and Margaret Drabble." *PMLA,* 96 (Jan 1981), 22-35.

Kawamoto, Shizuko, "Austen to 5-nin no Musumetachi: Novel of Manners no Dantu." *Eigo Seinen,* 123: 445-48.

Korenman, Joan S. "The Liberation of Margaret Drabble." *Critique,* 21 (Fall 1980), 61-72.

Lambert, Ellen Z. "Margaret Drabble and the Sense of Possibility." *University of Toronto Quarterly,* 49 (Spring 1980), 228-51.

Lay, Mary M. "Temporal Ordering in the Fiction of Margaret Drabble." *Critique,* 21 (Fall 1980), 73-84.

Manheimer, Joan. "Margaret Drabble and the Journey to the Self." *Studies in the Literary Imagination,* 11, (Fall 1978), 127-43.

Milton, Barbara. "The Art of Fiction (interview)," *Paris Review*, 20 (Fall 1978), 40-65.

Poland, Nancy. "Margaret Drabble: 'There Must Be a Lot of People Like Me.'" *Midwest Quarterly*, 16 (Spring 1975), 255-67.

Preussner, Dee. "Talking with Margaret Drabble (interview)." *Modern Fiction Studies*, 25 (Winter 1979/80), 563-77.

Sale, Roger H. "Huxley and Bennett, Bedford and Drabble," in Sale, Roger. *On Not Being Good Enough: Writings of a Working Critic.* Oxford, 1979, pp. 93-105. rpt. from *Hudson Review*, 28 (Sum 1975), 289-293.

_____. "Williams, Weesner, Drabble." op cit, pp. 42-53.

Rozencwajg, Iris. "Interview with Margaret Drabble." *Women's Studies*, 6 (1979), 336.

Showalter, Elaine. "Beyond the Female Aesthetic: Contemporary Women Novelists," in Showalter, Elaine, *A Literature of Their Own: British Women Novelists from Bronte to Lessing.* Princeton: Princeton University Press, 1977.

Whittier, Gayle, "Mistresses and Madonnas in the Novels of Margaret Drabble." *Women & Literature*, I (1980), 197-213.

Stephens, Evelyn D. B. "The Novel of Personal Relationships: A Study of Three Contemporary British Women Novelists." *DAI*, 38, 290A-91A.

Toyoda, Akimoto, "Margaret Drabble no Buntai." *Eigo Seinen*, 124: 337-39.

STUDIES AND REVIEWS OF INDIVIDUAL WORKS:

The Millstone

Anon. "The Millstone." *Observer (London)*, (6 Mar 1977), 22.

Butler, Colin. "Margaret Drabble: *The Millstone* and *Wordsworth*." *English Studies*, 59 (1978), 353-60.

Firchow, Peter E. "Rosamund's Complaint: Margaret Drabble's *The Millstone,"* in Morris, Robert K. ed., *Old Lines, New Forces: Essays on the Contemporary British Novel, 1960-1970.* Rutherford: Fairleigh Dickinson University Press; London: Associated University Presses, 1976.

Noguchi, Kenji. "Margaret Drabble's *The Millstone." Studies in English Literature and Language* (Kyushu University, Fukuoka, Japan), 26: 51-58. In Japanese, English summary.

Spitzer, Susan. "Fantasy and Femaleness in Margaret Drabble's *The Millstone." Novel,* 11 (Spring 1978), 227-45.

Jerusalem the Golden

Anon. *"Jerusalem the Golden." New York Times Book Review* (21 Aug 1977), 33.

The Waterfall

Anon. "The Waterfall." *New York Times Book Review* (20 Nov 1977), 69.

Rose, Ellen Cronan. "Feminine Endings—and Beginnings; Margaret Drabble's *The Waterfall." Contemporary Literature,* 21 (Winter 1980), 81-99.

The Needle's Eye

Anon. *"The Needle's Eye." Publishers' Weekly,* 211 (31 Jan 1977), 74.

Hasler, Jorg. "Margaret Drabble, *The Needle's Eye."* in Lengeler, Ranier, ed. *Englische Literatur der Gegenwart, 1971-1975.* Dusseldorf: Bagel, 1977.

Manheimer, Monica Lauritzen. "The Search or Identity in Margaret Drabble's *The Needle's Eye." Dutch Quarterly Review for Anglo-American Letters,* 5, pp. 24-35. Drabble's comments, pp. 35-38.

Arnold Bennett

"The Drabble Biography." Review article. *The Arnold Bennett Newsletter* 1 (1975), 2-10.

The Realms of Gold

Davis, C. A. "Unfolding Form: Narrative Approach and Theme in *The Realms of Gold.*" *Modern Language Quarterly,* 40 (Dec 1979), 390-402.

Dibbell, Carola. "*Realms of Gold.*" *Village Voice,* 20 (24 Nov 1975), 50-51.

Little, Judy. "Humor and the Female Quest: Margaret Drabble's *The Realms of Gold.*" *Regionalism and the Female Imagination,* 4 (Fall 1978), 44-52.

Sharpe, Patricia. "On First Looking Into *The Realms of Gold.*" *Michigan Quarterly Review,* 16 (1977), 225-31.

Sullivan, Walter. "Gifts, Prophecies, and Prestidigitations: Fictional Frameworks, Fictional Modes." *Sewanee Review,* 85 (Jan 1977), 116-20.

Miscellaneous reviews of *The Realms of Gold:*

Maclean's, 88 (17 Nov 1975), 84-87.
America, 136 (29 Jan 1977), 81.
Observer (London), (17 Apr 1977), 28.
Observer (London), (26 Jun 1977), 29.
Critique, 38 (Aug 1979), 7.

The Ice Age

Bell, Pearl K. "The English Sickness." *Commentary,* 64 (Dec 1977), 80-83.

Ellman, Mary. "Seven Recent Novels." *Yale Review,* 67 (Sum 1978), 592-95.

Duvall, E. S. "*The Ice Age.*" *Atlantic,* 240 (Dec 1977), 108.

Gussow, Mel. "Margaret Drabble: A Double Life." *New York Times Book Review* (9 Oct 1977), 7,40.

Harris, Lis. "Hard Times." *New Yorker,* 53 (26 Dec 1977), 66-8.

Howard, Maureen. "Fiction Chronicle." *Hudson Review,* 31 (Spring 1978), 184-5.

Jones, D. A. N. "Age Concern." *Listener*, 98 (1 Sep 1977), 282-3.

Sullivan, Walter. "Documents from the Ice Age: Recent British Novels." *Sewanee Review*, 86 (Apr 1978), 320-25.

Miscellaneous reviews, of *The Ice Age:*

> *Books and Bookmen*, 23 (Jan 1978), 40.
> *Booklist*, 74 (15 Sep 1977), 138.
> *Book World* (23 Oct 1977), E1.
> *Book World* (11 Dec 1977), E2.
> *British Book News* (Jun 1981), 328.
> *Canadian Forum*, 57 (17 Nov 1978), 40.
> *Christian Science Monitor*, 70 (21 Dec 1977), 19
> *Christian Science Monitor*, 71 (8 Jan 1979), B5.
> *Contemporary Literature*, 19 (Jan 1978), 45.
> *Harper's Magazine*, 255 (Oct 1977), 87.
> *Illustrated London News*, 265 (Nov 1977), 103.
> *Kirkus Reviews*, 45 (15 Aug 1977), 866.
> *MS*, 7 (Jul 1978), 29.
> *National Review*, 29 (23 Dec 1977), 1504.
> *New Leader*, 61, (30 Jan 1978), 21.
> *New Statesman*, 94 (9 Sep 1977), 343.
> *Newsweek*, 90 (17 Oct 1977), 114.
> *New Republic*, 177 (22 Oct 1977), 28.
> *Observer (London)*, (4 Sep 1977), 24.
> *Observer (London)*, (18 Dec 1977), 21.
> *Publishers' Weekly*, 212 (29 Aug 1977), 353.
> *Publishers' Weekly*, 214 (16 Oct 1978), 120.
> *Progressive*, 41 (Nov 1977), 55.
> *Saturday Review*, 4 (20 Aug 1977), 63.
> *Saturday Review*, 5 (7 Jan 1978), 39.
> *Times Literary Supplement* (2 Sep 1977), 1045.
> *Time*, 110 (17 Oct 1977), 106.
> *Virginia Quarterly Review*, 54 (Sum 1978), 93.

The Middle Ground

Boston, Richard. "A Knight's Tale." *Punch*, 279 (9 Jul 1980), 144.

Cox, Shelly. "*The Middle Ground.*" *Library Journal*, 105 (Aug 1980), 1658.

Donaghue, Denis. "*Middle Ground.*" *New York Review of Books*, 27 (20 Nov 1980), 27.

Jones, D.A.N. "Deliberate Mistakes." *Listener*, 104 (3 Jul 1980), 24-5.

Lively, Penelope. "New Novels." *Encounter*, 55 (Nov 1980), 61-2.

Lucas, John. "Endlessly." *New Statesman*, 100 (11 Jul 1980), 55-6.

Merkin, Daphne. "Constricted Expectations." *New Leader*, 63 (22 Sep 1980), 12-13.

Rose, Phyllis. "Our Chronicler of Britain." *New York Times Book Review*, 85 (7 Sep 1980), 1,32-3.

Slung, Michelle. "A Case of Deep Boredom with Feminism." MS, 9 (Nov 1980), 37-8.

Miscellaneous reviews of *The Middle Ground:*

> *Best Sellers*, 40 (Nov 1980), 269.
> *Books and Bookmen*, 25 (Jul 1980), 41.
> *Booklist*, 76 (15 Jul 1980), 1638.
> *Books of the Times* (NY), 3 (Nov 1980), 540.
> *Book World*, 10 (14 Sep 1980), 3.
> *British Book News* (Oct 1980), 629.
> *Commonweal*, 108 (13 Feb 1981), 91.
> *Guardian Weekly*, 123 (13 Jul 1980), 22.
> *Harper's Magazine*, 261 (Oct 1980), 90.
> *Illustrated London News*, 268 (Sep 1980), 89.
> *Kirkus Reviews*, 48 (15 Jul 1980), 924.
> *Maclean's* 93 (29 Sep 1980), 56.
> *National Review* 33 (20 Mar 1981), 307.
> *Newsweek*, 96 (6 Oct 1980), 95.
> *Observer (London)* (29 Jun 1980), 29.
> *Observer (London)* (13 Jul 1980, 29.
> *Progressive*, 45 (Jan 1981), 56.
> *Publishers' Weekly*, 218 (25 Jul 1980), 144.
> *Quill and Quire*, 47 (Jan 1981), 32.
> *Spectator*, 245 (5 Jul 1980), 21.
> *Times Literary Supplement* (11 Jul 1980), 772.
> *Time*, 116 (15 Sep 1980), 98.

For Queen and Country

Annan, Noel. *"For Queen and Country." New York Review of Books*, 26 (19 Jul 1979), 16.

Davie, Donald. *"For Queen and Country."* Inquiry, 3 (21 Apr 1980), 27-8.

Wroughton, John. "Life as it Really Was." *History Today*, 30 (Mar 1980), 47.

A Writer's Britain

Arden, John. "Inclosure like a Buonaparte." *New Statesman*, 98 (7 Dec 1979), 903-4.

Beer, Patricia. "Literary Cats." *Listener*, 103 (17 Jan 1980), 94-5.

Miscellaneous reviews of *A Writer's Britain:*

Books and Bookmen, 25 (Apr 1980), 52.
Booklist, 76 (1 Feb 1980), 750.
British Book News (Feb 1980), 114.
Christian Science Monitor, 72 (19 Dec 1979), 17.
Choice, 17 (Jul 1980), 670.
Guardian Weekly, 121 (11 Nov 1979), 21.
Observer (London) (18 Nov 1979), 38.
School Librarian, 28 (Jun 1980), 207.
Wilson Library Bulletin, 54 (Jan 1980), 340.
Wall Street Journal 194 (3 Dec 1979), 24.

CONTRIBUTORS

PAMELA S. BROMBERG is a professor in the Department of English, Simmons College in Boston, Massachusetts.

CHARLES BURKHARDT, professor of English at Temple University, is the author of books on Charlotte Brontë, Ada Leverson, and Ivy Compton-Burnett.

JOANNE V. CREIGHTON has published books on William Faulkner and Joyce Carol Oates, as well as articles on Margaret Drabble in scholarly publications. Professor Creighton teaches at Wayne State University.

ARNOLD DAVIDSON's works include numerous articles in Canadian and other scholarly journals. "Parables of Grace in Margaret Drabble's *The Needle's Eye*" was originally published in longer form in *Kobe College Studies* 27, no. 2 (1980), 15-29.

BARBARA DIXSON is on the faculty of the Department of English at Auburn University.

GAIL EFRIG is an assistant professor at Valparaiso University, and serves as book editor for *The Cresset*, the university's review of literature, arts and public affairs.

MORTON P. LEVITT has published books on James Joyce and Nikos Kazanzakis, teaches at Temple University, and is currently writing a book on the connections between contemporary fiction and the Modernist tradition.

SUZANNE HENNE MAYER is a free-lance writer who teaches creative writing at Spoon River College, Macomb, Illinois.

MARY HURLEY MORAN'S book on Margaret Drabble, *Existing Within Structures: The Fictional World of Margaret Drabble,* is scheduled for Fall 1982 publications as part of the Crosscurrents Series put out by Southern Illinois University Press. This article is an adaptation of a portion of that work.

DEE J. PRUESSNER interviewed Margaret Drabble for *Modern Fiction Studies*, Winter 1979-80.

MARGARET MOAN ROWE is a professor in the Department of English at Purdue University.

ROBERTA RUBENSTEIN is Professor of Literature at American University in Washington, D.C., where she is also co-ordinator of the women's studies program. Her publications include essays on Virginia Woolf, Margaret Atwood and John Fowles.

JUDITH RUDERMAN, director of continuing education at Duke University, publishes in the area of women's literature and women's studies.

DOREY SCHMIDT, editor of *riverSedge*, a literary journal, is also an editor of the Living Author Series at Pan American University, where she teaches women's literature.

NORA FOSTER STOVEL has taught at universities in Canada and the United States. Her dissertation is on Margaret Drabble's symbolism.